FRIEDRICH

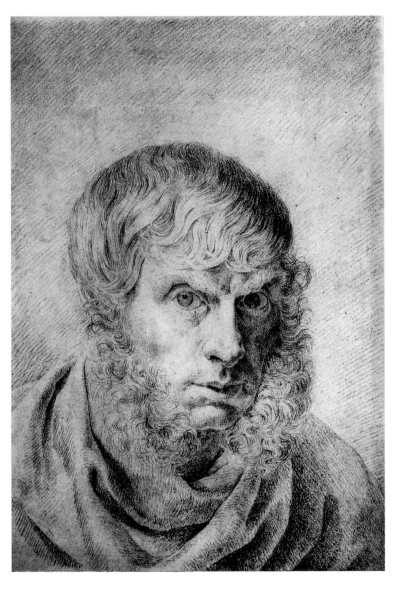

CASPAR DAVID
FRIEDRICH

BY

WIELAND SCHMIED

TRANSLATED FROM THE GERMAN BY
RUSSELL STOCKMAN

HARRY N. ABRAMS, INC., PUBLISHERS

Editor, English-language edition: James Leggio
Designer, English-language edition: Ellen Nygaard Ford

Frontispiece:
Self-Portrait. c. 1810. Crayon, 9×7⅛″ (23 ×18.2 cm).
Kupferstichkabinett und Sammlung der Zeichnungen,
Staatliche Museen, Berlin (B-S 170)

Library of Congress Cataloging-in-Publication Data

Schmied, Wieland, 1929–
 Caspar David Friedrich / by Wieland Schmied.
 p. cm.
 Includes bibliographical references.
 ISBN 0–8109–3327–6
 1. Friedrich, Caspar David. 1774–1840—Criticism and inter-
pretation. 2. Landscape in art. 3. Romanticism in art—Germany.
4. Friedrich, Caspar David, 1774–1840. I. Title.
ND588.F75S36 1995
759.3—dc20 94–30547

PHOTOGRAPH CREDITS

In the following photograph credits, numbers refer to plates: Schloss
Charlottenburg, Berlin: 30; Staatliche Museen, Kupferstichkabinett,
Berlin: 47; Staatliche Museen, Nationalgalerie, Berlin: 4; Staatliche
Museen Preussischer Kulturbesitz, Nationalgalerie, Berlin: 27, 40;
Staatsbibliothek Preussischer Kulturbesitz–Bildarchiv, Berlin: 21; Stick-
elmann, Bremen: 15, 33; Rheinisches Bildarchiv, Cologne: 5, 37, 64;
Hans Petersen, Copenhagen-Hornbaek: 2; Deutsche Fotothek, Dres-
den: 7, 13, 44, 51; Kramer, Deutsche Fotothek, Dresden: 25, 34, 42, 46;
Pfauder, Staatliche Kunstsammlungen, Kupferstichkabinett, Dresden:
43, 48; Liselotte Witzel, Essen: 23; U. Edelmann, Frankfurt am Mein:
38; Ralph Kleinhempel, Hamburg: 3, 6, 22, 28, 35, 36, 50, 52, 55–61,
65; Niedersächsische Landesgalerie, Hanover: 19; Stiftung Pommern,
Kiel: 31; Foto Sandig, Umschlagabbildung, Museum der Bildenden
Künste, Leipzig: 32, 53, 62; Kunsthalle, Mannheim: 15, 54; Nasjonal-
galleriet, Oslo: 16; O. Vaering, Oslo: 49; Staatliche Schlösser und
Gärten, Potsdam-Sanssouci: 18; National Gallery, Prague: 45; Carlfred
Halbach, Ratingen: 14; Sammlung Georg Schäfer, Schweinfurt: 41; The
State Hermitage Museum, St. Petersburg: 65; Graphische Sammlung,
Staatsgalerie, Stuttgart: 8, 39; Bildarchiv der Österreichischen Nation-
albibliothek, Vienna: 10; Kunsthistorisches Museum, Vienna: 1, 11, 12,
29; Kunstsammlungen, Weimar: 9, 24; Photo Wullschleger, Win-
terthur: 20, 26.

CONTENTS

PREFACE

The first edition of this book appeared in German in 1975. In writing it, I was able to incorporate new information published only a few years before by Werner Sumowski, in 1970, and to make use of the abundant source material presented in the catalogue raisonné by Helmut Börsch-Supan and Karl Wilhelm Jähnig in 1973. (Catalogue numbers from the latter work are indicated throughout the present volume by the prefix *B-S.*) At the same time, I drew on my impressions of the two major exhibitions in Hamburg and Dresden in 1974, both accompanied by excellent catalogues, commemorating the two-hundredth anniversary of Caspar David Friedrich's birth. My book was well received by reviewers and the public alike. A second edition, with only minor additions and corrections, followed in 1976, a third in 1980. For the present edition, the first in English, I have once again reviewed the entire work in the light of current scholarship and thoroughly revised certain portions of it. Recent writings by Peter Märker, Peter Rautmann, Gerhard Eimer, Karl-Ludwig Hoch, and Tina Grütter provided interesting insights. With regard to specific details, I have benefited from conducting courses and seminars on Friedrich and the Romantic movement at the Akademie der Bildenden Künste, Munich. I must make it clear, however, that the revisions are intended only to clarify my earlier ideas; in its essentials, the book is unchanged. Several of the picture descriptions have been rewritten and the plate section has been expanded by the addition of two color reproductions (*On the Sailboat* and *Sisters on the Harbor Promenade*). I have also added three black-and-white reproductions and a selection of important statements by Friedrich himself.

W.S.

CASPAR DAVID FRIEDRICH

Caspar David Friedrich is a singular figure in the art of Romanticism. He was for early-nineteenth-century Germany what Eugène Delacroix was for France or J. M. W. Turner for England. Philipp Otto Runge is equally distinguished, to be sure, but he did not live to create a large body of work. In Germany the period belongs to both, just as in France it was shared by Delacroix and Théodore Géricault, and in England by Turner and John Constable.

Friedrich holds a special fascination for modern viewers, however, and to explain this phenomenon it is not enough simply to point to the painterly qualities of his work and its unusual subject matter or to the unique conception of landscape painting that he developed. One must also say something about his exalted goals as an artist and his uncompromising pursuit of them. His works are a blend of calculation and asceticism, or of "exactitude and spirit," to borrow a phrase from the protagonist of Robert Musil's novel *The Man without Qualities*. Exactitude and spirit are the essence of Friedrich. It is a combination that has lost none of its appeal.

There are a number of aspects to Friedrich's modernity, and over the years critics have often focused on one or the other of them to the exclusion of the rest. Today we seem to be most fascinated by his concept of landscape, which was virtually ignored for many years. We marvel at his understanding of nature as a dynamic process, something he could only attempt to capture in contrasting pairs of pictures or in cycles.

For Friedrich the painter the ultimate challenge was to portray a world subject to unceasing change: Heraclitus' *panta hrei,* a nature constant only in its flux. At first glance his skills might have seemed inadequate, incapable of expressing such complexity, whether he viewed the processes of nature as linear—that is, leading toward some desirable end state—or cyclical, caught in an endless round of repetition. Since the formal talent at his disposal in his painting was fundamentally a static one, characterized by "exactitude and spirit," it seemed best suited to portraying fixed objects, giving them a special luminosity within the context of a composition. It hardly gave him the means to depict a violent nature or vibrant sensations. Friedrich did not have the command of colors, the temperament, or the sense of line of a Delacroix. Nor was he a Turner, who could wholly surrender himself to moody visions of light. Least of all could one compare him to Vincent van Gogh, who revealed his own inner turmoil in his images of nature or, rather, who saw nature racked and illumined by the same turmoil he felt in himself. Friedrich was anything but an expressionist.

With his essentially static sense of form, Friedrich could suggest the dynamic force permeating all of nature only by training himself to perceive nature as a sequence of states, and depicting it as such. He discovered that it was possible to present successive natural states or phases as separate pictorial planes, placed one behind the other, or juxtaposed, in pairs of pictures. In this way he could convey either a clear progression or a change within a closed cycle.

Friedrich's characteristic work, conceived in this manner, has undergone a fundamental reevaluation over the past twenty-five years. In the period immediately after World War II, scholars tended to be wary of his work, sensing that it had been compromised by the attempts of Nazi ideologues to exploit it. It was never wholly forgotten, nevertheless, as even a cursory glance at the vast Friedrich bibliography makes clear. The two-

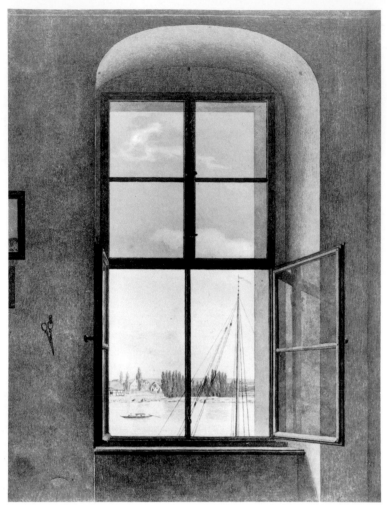

Fig. 1. **View from the Artist's Studio (Right-Hand Window).**
c. 1805–6. Pencil and sepia, 12¼ × 9½″ (31 × 24 cm).
Kunsthistorisches Museum, Vienna (B-S 132)

called "Die Frühromantik und die Grundlagen der 'gegenstandslosen' Malerei" ("Early Romanticism and the Foundations of Non-Objective Painting"), Klaus Lankheit had argued that Friedrich's paintings are a decisive step in the direction of abstract art, comparing Friedrich to Kandinsky. Twenty-four years later, in New York, Robert Rosenblum found links between Friedrich and Mark Rothko, and described what he termed the "Northern Romantic tradition."

Scholars have come a long way in their study of Friedrich since Sigrid Hinz first made her compilation of his drawings (now in need of revision) and produced a somewhat flawed first publication of his complete graphic works; since the research of Werner Sumowski; and since Helmut Börsch-Supan's catalogue raisonné (based in part on research by Karl Wilhelm Jähnig). They have brought to light surprising facts, found previously unrecognized connections, revised datings, and advanced new interpretations. The last two decades have deepened and re-

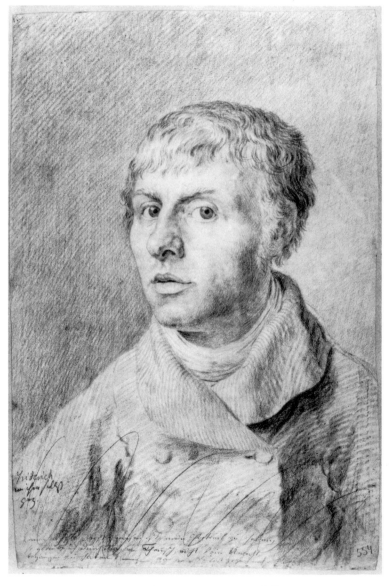

hundredth anniversary of Friedrich's birth, in 1974, was the occasion for unprecedented scholarly discussion, much of it stimulated by the comprehensive exhibitions devoted to him that year at the Kunsthalle, Hamburg, and the Gemäldegalerie, Dresden, which together attracted half a million visitors. These had been preceded in 1972 by a highly regarded exhibition at the Tate Gallery, London.

There were several significant aspects to this new interest in Friedrich's painting. For one, the response of the public was greater than ever before. For another, his works captured the imagination of a number of artists, who were suddenly inspired to far-ranging debate of Friedrich's ideas. One finds evidence of this new interest in artists as varied as Joseph Beuys, Gotthard Graubner, Gerhard Richter, Günther Uecker, Markus Lüpertz, Konrad Klapheck, Anselm Kiefer, and Gerhard Merz. Max Ernst paid his own homage to Friedrich's *Monk by the Sea* (plate 7), and Horst Janssen produced a suite of inspired engravings on the subject of Friedrich's relationship to Runge.

Finally, increasing numbers of scholars were attracted to his works. To be sure, a few interesting articles had come out in the early postwar years. In 1951, for example, in a remarkable essay

Fig. 2. **Self-Portrait.** 1800. Black crayon, 16½ × 10⅞″ (42 × 27.6 cm).
Royal Print Collection, Copenhagen (B-S 36)

fined our understanding of Friedrich in ways we could scarcely have hoped for. For this we are indebted chiefly to Peter Märker, Peter Rautmann, Gerhard Eimer, Norbert Schneider, Karl-Ludwig Hoch, Tina Grütter, and Hans Dickel, to name but a few (see the Selected Bibliography).

Nevertheless, Friedrich scholarship is still faced with enormous tasks. In the last few years previously unknown works have been discovered and published (most recently the original version of *Winter Landscape* of 1810–11), startling new attributions have been advanced, and Friedrich's authorship of works generally thought to be his has been called into question. Debate over these new revelations is by no means finished. It may be decades before his oeuvre has been fully catalogued (we now know roughly 180 paintings of the possibly 300 that Friedrich created) and certainly before his intellectual development has been explored in all its complexity and the full import of his work revealed.

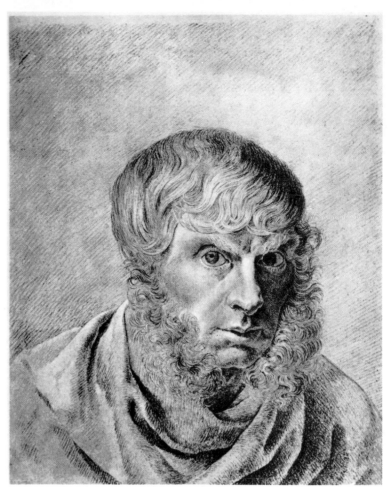

Fig. 4. **Self-Portrait.** c. 1810. Crayon, 9 × 7⅛″ (23 × 18.2 cm). Kupferstichkabinett und Sammlung der Zeichnungen, Staatliche Museen, Berlin (B-S 170)

Friedrich's Changing Fortunes

Friedrich's rise to fame has been full of reversals, and misunderstandings have played a part in it from the beginning. It was certainly a misunderstanding on the part of the Weimar Kunstfreunde (Friends of Art)—Johann Wolfgang von Goethe and Heinrich Meyer—when in 1805 it awarded Friedrich half of the prize of 120 ducats for the drawings he had submitted. It was looking for something altogether different: truth to nature in the classicist mode, treatment of a prescribed subject matter according to conventional rules of aesthetics. It had turned away Philipp Otto Runge somewhat earlier with the comment, "We urge the artist to undertake serious study of antiquity and of nature as the ancients saw it." The theme of the 1805 exhibition was "The Life of Hercules," and Friedrich had clearly ignored it when submitting his sepia *Pilgrimage at Sunset*. For this reason the remaining 60 ducats were awarded to a Cologne painter by the name of Hoffmann for his work entitled *The Augean Stables*.

Weimar's opinion of Friedrich was soon to change. In its preview of the coming year in the *Jenaische Allgemeine Literatur-*

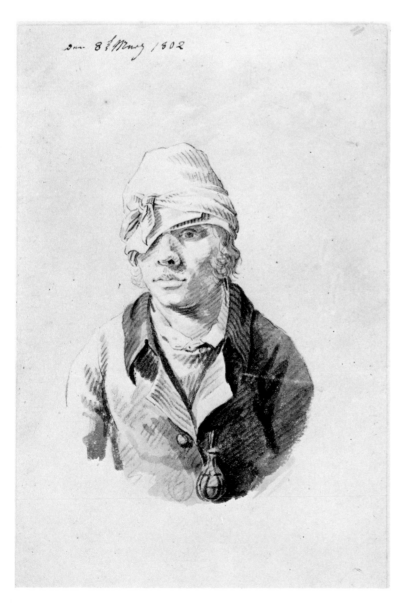

Fig. 3. **Self-Portrait with Cap and Visor-Flap.** 1802. Pencil and ink, 6⅞ × 4⅛″ (17.5 × 10.5 cm). Kunsthalle, Hamburg (B-S 72)

Zeitung of 1809, the Kunstfreunde was still encouraging to him. After praising the landscapes he had submitted for exhibition, it wrote: "Let us hope that Herr Friedrich continues unhindered along the path he has so felicitously chosen." But by 1815 Goethe was sorely tempted to smash Friedrich's pictures against the edge of his table, for he found they could be viewed "just as well upside down." It may be that Goethe was provoked to such a violent response because he really did perceive what was revolutionary and new in Friedrich's art. But the attack on the painter in 1817, ostensibly from the pen of Heinrich Meyer, was again based on a misunderstanding. In it Friedrich was discounted as an advocate of the type of reactionary religious painting celebrated in Wilhelm Wackenroder's *Outpourings from the Heart of an Art-loving Friar* (1797) and practiced by the Nazarenes in Rome—though it was admitted that Friedrich's

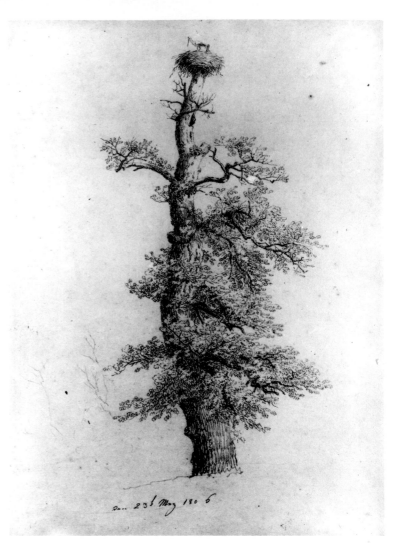

Fig. 6. **Old Oak with Stork's Nest.** 1806. Pencil, 11¼×8″ (28.6×20.5 cm). Kunsthalle, Hamburg (Not in B-S)

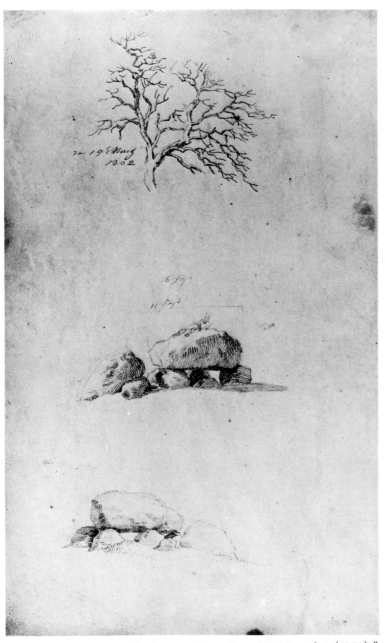

Fig. 5. **Two Cairns near Gützkow and Branches.** 1802. Pencil, 14⅛×8¾″ (36.2×22.3 cm). Wallraf-Richartz-Museum, Cologne (Not in B-S)

predilection for "mystical and allegorical landscapes" was perhaps less offensive than the Nazarenes' sterile imitation of medieval German style. In 1805 Weimar's worthies had praised Friedrich especially for his "craftsmanship, neatness, and diligence," but now they denounced him, along with his "comrades in taste," for "neglecting the rules of art."

The early enthusiasm for Friedrich's sepia drawings among his friends in Greifswald and Rügen was also largely the result of a misunderstanding. Gotthard Ludwig Kosegarten, Johann Gottfried Quistorp, and Carl Schildener found his work so appealing in part because it depicted familiar motifs from their own surroundings, but also because of its seemingly conventional style and the streak of sentimentalism that was still in evidence.

By January 1809, however, when Councillor Basilius von Ramdohr attacked the *Tetschen Altarpiece* (plate 5), there was no longer any room for misunderstanding. For Friedrich had meanwhile left behind the sentimentalism of his beginnings and evolved a transcendental style of painting with, as Adam Müller put it in his *Essay on Landscape Painting* (1808), "something reli-

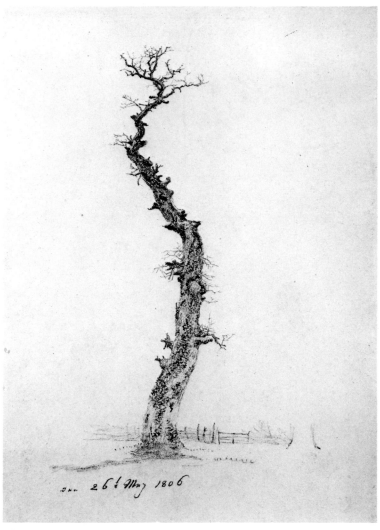

Fig. 7. **Study of Tree.** 1806. Pencil, 11×7 ½″ (28.1×19.1 cm).
Kupferstichkabinett, Dresden (Not in B-S)

the same meeting the Danish sculptor Bertel Thorvaldsen was unanimously rejected). Visitors to his studio revealed an astonishing understanding of his work. Critics, though occasionally objecting to this or that detail, alternately praised his paintings' spiritual content, their emotional power, their faithfulness to nature, and their perfect craftsmanship. He was recognized and accepted as a "brilliant oddity." In 1812, Achim von Arnim wrote to Brentano: "This time Friedrich showed himself to be more complex, yet I discovered even more in him, and clearly felt that all that is strange in him is not merely a pose, but rather something rooted in his nature." Even in 1809 C. A. Böttiger had praised the melancholy in the "apparent barrenness" of Friedrich's landscapes, and Helmina von Chézy had called him "the most imaginative landscape painter of our time."

A number of these early writers tried to suggest what Friedrich was about by way of comparisons. As early as 1807 one of them referred to him as "the Jean Paul of painters," and repeatedly, in a reflection of the rage at the time, his art was described as "Ossianic." "Friedrich's paintings resemble Ossian's poetry in numerous ways," said the *Journal des Luxus und der*

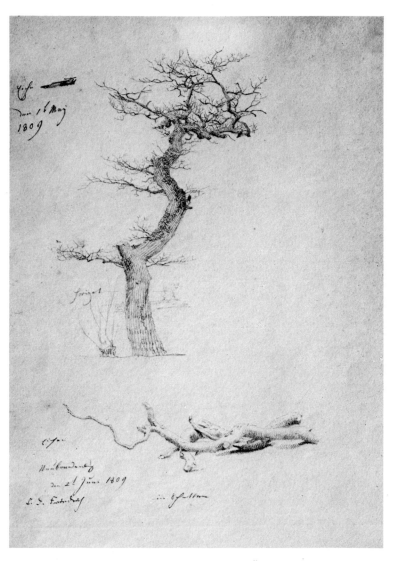

Fig. 8. **Studies of Oak.** 1809. Pencil, 14¼×10¼″ (36.1×26 cm).
Graphische Sammlung, Staatsgalerie, Stuttgart (Not in B-S)

gious at its core." Even so, it is unlikely that Ramdohr suspected what a flood of testimonials for Friedrich his attack would unleash. They came not only from artist colleagues like Ferdinand Hartmann or Gerhard von Kügelgen, but also from the Phoebus circle gathered around Heinrich von Kleist, Adam Müller, and Rühle von Lilienstern. Kleist himself wrote his famous "Sensations on Viewing Friedrich's Seascape" as a substitute for a piece in a more humorous and ironic vein by Clemens Brentano and Bettina von Arnim. Though he categorically rejected it, Ramdohr was actually the first to describe correctly what was new in Friedrich's art. And Kleist was the first to record a deep emotional response to one of Friedrich's paintings.

Friedrich had already attained the height of his fame by 1810. The Ramdohr controversy had brought him notoriety. His paintings were being admired in academy exhibitions in Berlin and Dresden, many of them even finding buyers. Each time a new Friedrich painting arrived—often as not belatedly—the public turnout was enormous. He was elected a member of the Berlin Academy with a scant majority of five votes to four (at

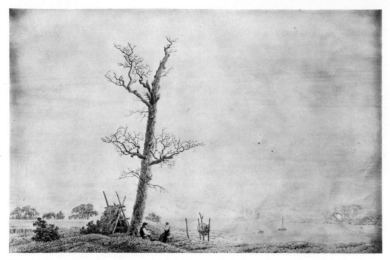

Fig. 9. **Summer Landscape with Dead Oak (Autumn Evening by the Sea).** 1805. Pencil and sepia, 16 × 24⅜″ (40.5 × 62 cm). Staatliche Kunstsammlungen, Weimar (B-S 125)

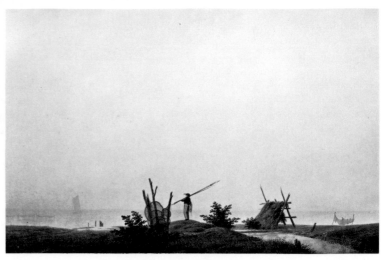

Fig. 11. **Seashore with Fisherman.** 1807. Oil on canvas, 13⅝ × 20″ (34.5 × 51 cm). Kunsthistorisches Museum, Vienna (B-S 158)

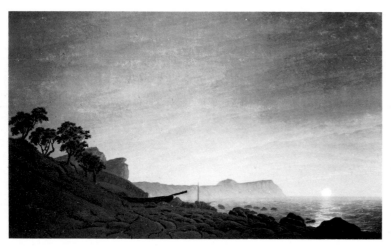

Fig. 10. **View of Arcona with Rising Moon.** c. 1805–6. Pencil and sepia, 24 × 39⅜″ (60.9 × 100 cm). Albertina, Vienna (B-S 128)

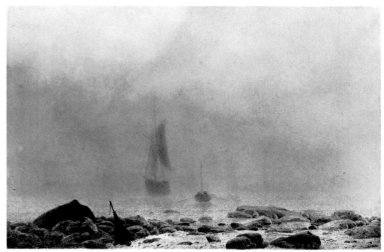

Fig. 12. **Fog.** 1807. Oil on canvas, 13⅝ × 20½″ (34.5 × 52 cm). Kunsthistorisches Museum, Vienna (B-S 159)

Moden in 1816, "especially in their profundity, their fervor, and their delicacy." By 1818 the comparisons had become even more ambitious. In that year the *Wiener Zeitschrift für Kunst, Literatur, Theater und Mode* chose to rank him alongside Claude Lorrain and Salvator Rosa: "Now, however, one must include him among the greatest landscape painters who ever lived," Four years later, though, the same journal was already indicating a change in taste. "Are these still true landscapes, or what?," its reviewer complains. "His art verges altogether on the province of poetry." People tended to juxtapose the "poetic" Friedrich to the "realist" Johan Christian Clausen Dahl. From the moment Dahl arrived in Dresden, Friedrich came to be thought of, to his increasing disadvantage, as the Norwegian painter's opposite number. Fifteen years later, again in the same journal, Friedrich is no longer placed in such exalted company. The following notice is now quite typical: "Some of the leaves by Pro-

fessor Friedrich and Emmeline Messerschmidt are very nicely drawn."

Before critics finally reached the point of dismissing his works with a single line, they had successively accused him of mysticism, barrenness, a forced originality, insufficient fidelity to nature, and lack of skill. The suspected political content of pictures like *Ulrich von Hutten's Tomb* (fig. 24) also tended to cause offense in the 1820s. Though greeted with enthusiasm in 1814, Friedrich's brand of patriotism was now in short demand. Nor was there much call for his symbolism, which was now increasingly perceived as antiquated. The meditative images and suggestive atmosphere once so greatly admired were soon found to be only "vague poetic ideas" and emptiness. As late as 1822 one writer was still able to find praise for "our brilliant landscape painter Friedrich," yet by 1826 even a reviewer formerly well disposed toward the artist found himself no longer

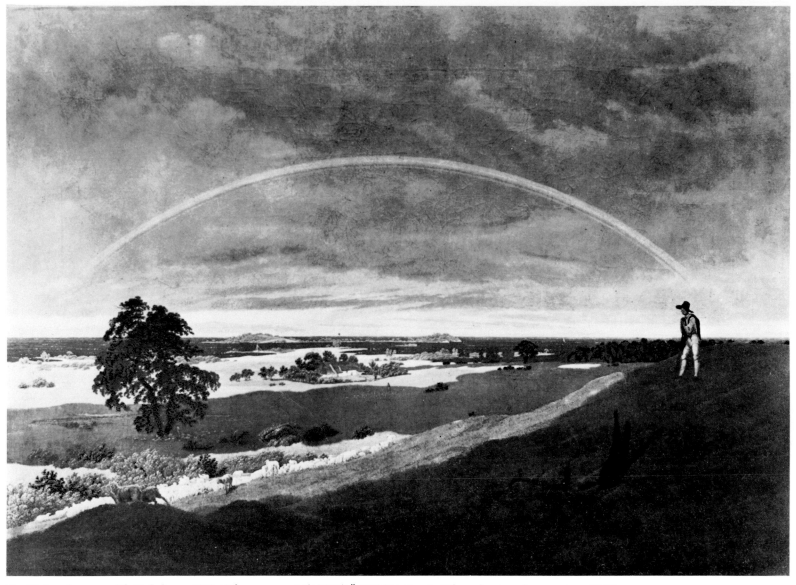

Fig. 13. **Landscape with Rainbow.** 1810. Oil on canvas, 23¼×33¼" (59×84.5 cm). Whereabouts unknown since 1945. Formerly Staatliche Kunstsammlungen, Weimar (B-S 182)

capable of extracting "any profound aesthetic interest at all from his monotonous subjects." The critics became more cutting, more brutal—or ignored him altogether, turning their attention to newer artists. What praise there was tended to be couched in the past tense, with his more recent work seen as evidence of decline.

Occasionally reviewers still mentioned Friedrich as a precursor of Karl Friedrich Lessing, who had meanwhile taken his place in the forefront of the movement for the revival of landscape painting, skipping quickly over Friedrich's darker visions of nature to concentrate on the questions of the day.

When Friedrich died in 1840 he was already virtually forgotten. Obituaries dwelt on his idiosyncracies, his melancholy, and his kindness. One newspaper felt it necessary to explain to its readers who Friedrich actually was: "This artist caused something of a stir about thirty years ago, for in a total depar-

ture from the accepted style of that time he was the first to imbue landscape with emotional and allegorical significance. It was a great pity," the critic concludes, mistaking the change in public taste for a change in Friedrich himself, "that with his gloomy melancholy he later became too one-sided."

Whenever there was reason to remember him, writers generally resorted to personal anecdotes. In the *Blätter für Literarische Unterhaltung* in 1843, as in Ursch-Greber's *Allgemeine Enzyklopädie der Wissenschaften und Künste* in 1849, he appears as an old crank, praised more for his generosity than for his art. The major art histories would completely ignore him until 1909. Wilhelm Lübke, Robert Dohme, and even Richard Muther and Albert Kuhn do not so much as mention his name. Adolf Rosenberg's three-volume *Geschichte der Deutschen Kunst* includes two other painters by the name of Friedrich but no Caspar David. He is not even mentioned in a history devoted

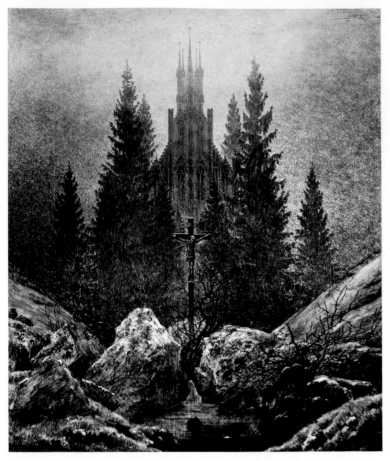

Fig. 14. **Crucifix in the Mountains.** c. 1812. Oil on canvas, 17½ × 14¾" (44.5 × 37.4 cm). Kunstmuseum, Düsseldorf (B-S 201)

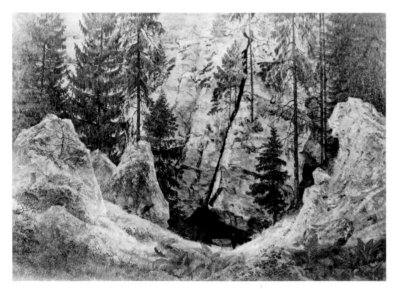

Fig. 15. **Rocky Gorge (Grave of Arminius).** c. 1813–14. Oil on canvas, 19¼ × 27½" (49 × 70 cm). Kunsthalle, Bremen (B-S 206)

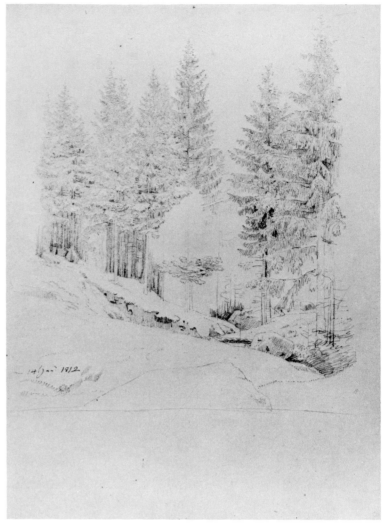

Fig. 16. **Firs at the Edge of the Forest.** 1812. Pencil, 14 × 10⅛" (35.5 × 25.8 cm). Nasjonalgalleriet, Oslo (Not in B-S)

exclusively to the art of Pomerania that Franz Kugler produced in 1840. Other art histories refer to him only in passing, without saying a thing about his work. In 1876, Franz von Reber characterizes him as a follower of Ludwig Tieck's fictional hero Franz Sternbald: "The musicality and lyricism that had driven the Romantic poets to the point of morbidity and obscurantism ... was now to infect landscape painting as well." In 1881, Anton

Springer is even more concise: "Even the most gifted of them all, the landscape painter Kaspar D. Friedrich, was wont to lose himself in abstract, formless conceptions." In Hugo Kleinmayr's 1912 study *Die Deutsche Romantik und Landschaftsmalerei*, Friedrich is dismissed in a single sentence.

Such was posterity's judgment for more than half a century following Friedrich's death. Then he was rediscovered. In fact his rediscovery was triggered from abroad, when the Norwegian historian Andreas Aubert set out to write a monograph on his countryman Dahl. While researching his book, Aubert carefully retraced the painter's steps in Germany, hoping to find out more about Friedrich at the same time. But in the early 1890s no one knew a thing about Friedrich. It was as though he had never lived.

Wilhelm Niemeyer recounts in an abbreviated form a story Aubert had related to him:

His search began in Berlin. There weren't any pictures by the artist in the Nationalgalerie, and the curators of the collection knew nothing about him. He then went to Dresden, the city in which both Friedrich

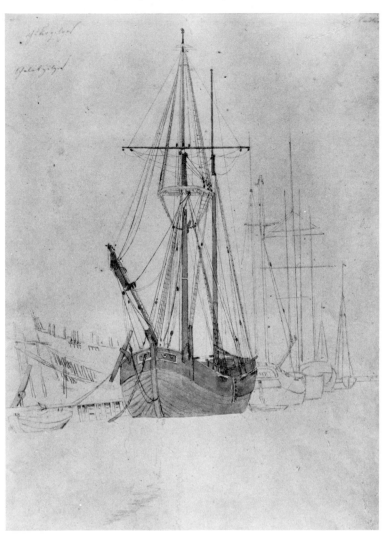

Fig. 17. **Brigantine in Harbor.** 1815. Pencil and watercolor washes, 14 × 10″ (35.8 × 25.3 cm). Kunsthalle, Mannheim (Not in B-S)

immediately, and cried out: "That's Two Men Contemplating the Moon! There are Cairn in Autumn and Cairn in the Snow. And look! Here's his Hayers at Rest!" And that is how Caspar David Friedrich was rediscovered.

The story is not entirely accurate. The Nationalgalerie, Berlin, did own a pair of pictures from the Wagener collection at that time, The Solitary Tree (plate 29) and Moonrise by the Sea (plate 30). It may be that the works were not on display, but they do appear in Max Jordan's official inventory and would certainly have been in the storerooms. It would have been easy enough to find out. Monk by the Sea (plate 7), which had still been on public display in Berlin in 1866, hung in the Stadtschloss. Though certain details may have been embroidered, the story nevertheless does indicate how little was known about Friedrich's work in the early 1890s.

The time was obviously right for Friedrich's rediscovery or the Norwegian scholar's visit would not have had the result that it did. By then the last points of reference used to classify Friedrich, his "opposite number" Dahl and his "successor" Karl Friedrich Lessing, no longer loomed so large in the contempo-

and Dahl had worked. Again it was the same story: not a single Friedrich painting hung in the gallery, and just as in Berlin the people in charge told him he must be mistaken, there was no German artist of that description. Then came the dramatic moment that led to Friedrich's rediscovery. Aubert had become somewhat heated. He berated the gallery's curator: "Have you Germans completely lost your minds? I can trace Friedrich's life in Dahl's letters. I know from these letters the titles and subjects of the paintings Dahl admired. Yet you Germans deny the very existence of such an artist and tell me that I'm wrong?" In his excitement he shouted and pounded on the table, at which point the German also lost his temper and shouted back. They had created quite a scene, and the gallery attendants could not help but overhear them. Suddenly there was a knock at the door, and the old lobby attendant whose job it was to announce visitors stepped in. "Excuse the interruption, but I heard the gentlemen discussing Friedrich. Begging your pardon, Herr Direktor, but the gallery does own some Friedrichs. When I first came to work here forty years ago they were still on display. They're now in the storeroom. I can show them to you if you like." Taken aback, the two gentlemen followed the old man to the storeroom, where he led them up to a group of smaller old paintings. Aubert recognized them

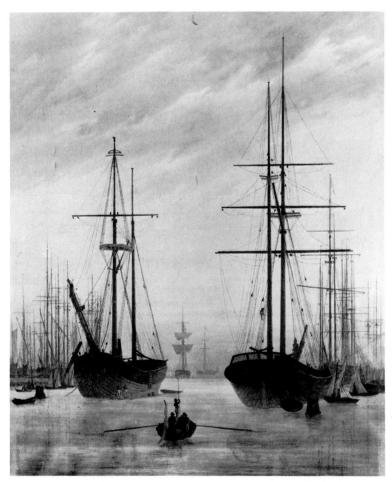

Fig. 18. **View of a Harbor.** 1815–16. Oil on canvas, 35½ × 28″ (90 × 71 cm). Verwaltung der Staatlichen Schlösser und Gärten, Potsdam-Sanssouci (B-S 220)

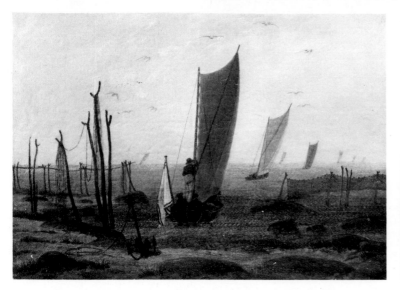

Fig. 19. **Morning (Boats Heading Out to Sea).** c. 1816–18. Oil on canvas, 8⅝ × 11⅞″ (22 × 30.2 cm). Niedersächsische Landesgalerie, Hanover (B-S 234)

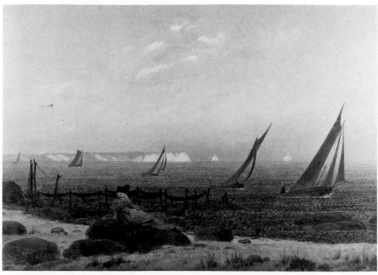

Fig. 20. **Woman by the Sea.** c. 1818. Oil on canvas, 8¼ × 11⅝″ (21 × 29.5 cm). Stiftung Oskar Reinhart, Winterthur (B-S 245)

rary consciousness. Accordingly, in the larger context of German Romanticism Friedrich once more appeared as the isolated figure he had been in life, and could thus be thought of more properly in connection with figures like Novalis, Runge, and Tieck, or Friedrich Schelling and Friedrich von Schlegel.

The public had to some extent been prepared for Friedrich's rediscovery both by Symbolism, with its delight in hidden meanings and generally gloomy subject matter, and by the emergence of Art Nouveau, which sought to revitalize modern life. Industrialization had pitted an upper class of ostentatious moguls against an increasingly exploited proletariat. The social tensions and crass commercialism of the fin de siècle had forced the middle class to retreat, by way of reaction, into a new inwardness. Given the pessimistic view of culture in the period, it is not surprising that Friedrich's paintings appeared to be an especially appealing version of Rousseau's siren call, "Back to Nature."

Scholars found various ways to explain Friedrich's appeal. Some found that he had anticipated the Impressionists, practicing a kind of plein-air painting inside his studio, while others focused on the accuracy of his details, and accordingly sought to link him to naturalism. Yet it was as a painter of spiritual states that Friedrich was initially perceived and accepted. Cornelius Gurlitt's discussion of him in his *German Art of the Nineteenth Century* (1899) is an important example of how Friedrich was then understood. For the first time in decades Friedrich's work is there treated at length, and one painting, *Cairn in Autumn,* is given a full-page reproduction. Gurlitt's knowledge was nevertheless extremely scanty; he refers to the painter as "Kaspar Daniel" Friedrich and indicates that he had moved to Dresden as early as 1795 and become a teacher at the Academy

in 1817. He also confuses Ramdohr with "Rumohr." He appears to have based his entry on little more than Carl Gustav Carus's brief commemorative essay "Friedrich the Landscape Painter" (1841), with its quotations of Friedrich himself, Tieck's "A Summer Journey," and the inaccurate biography from the 1817 edition of the Brockhaus *Conversations-Lexicon.* Though Gurlitt's errors are significant, his attempt at a reappraisal of Friedrich is what really matters. Following Julius Langbehn, he takes a stand against "the unnatural and overrefined," against rationalism and materialism, against the "chaos of commercialism." Friedrich therefore strikes him as a definite confederate and authority. He praises his "austere melancholy," the "simplicity of his motifs," his "honest submission to his feelings," and "the immediacy to nature" that allowed him to perceive "the simple with such grandeur, the trivial with such eloquence." In so doing he compares him to Constable. Gurlitt is more interested in Friedrich's opinions than in his work: "It is not what he achieved that makes him so appealing, but what he tried to achieve." Ominously, we here see the first appearance of a Friedrich image rooted in the irrational, one that would cloud and even obscure his work for decades.

That was in 1899. Three years later we find Ferdinand Avenarius's *Kunstwart* asking, "Caspar David Friedrich? Who was he?" Then follow reproductions of two of the Dresden paintings, *Two Men Contemplating the Moon* (plate 19) and, once again, *Cairn in Autumn.* Friedrich is described as a "wild revolutionary of art," whom the older generation of his time preferred to ignore. "Yet in the prevailing academic drought, the youth of that period sensed something altogether new in his paintings." Public response to this article was immense—much to the editors' surprise. "The paintings we published some time back by

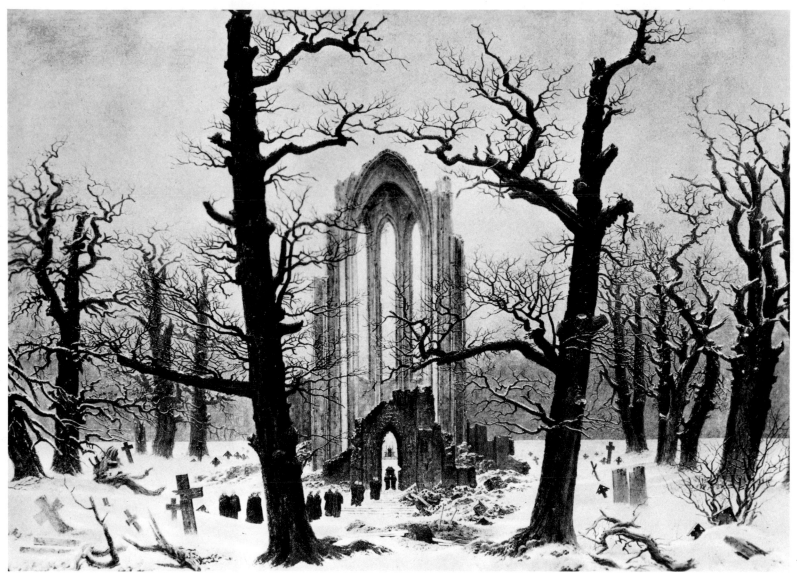

Fig. 21. **Monastery Graveyard in the Snow.** 1817–19. Oil on canvas, 47⅝×67″ (121×170 cm). Destroyed 1945. Formerly Nationalgalerie, Berlin (B-S 254)

Caspar David Friedrich have aroused greater interest than we ourselves could have anticipated, not only among the general public, but also among artists, scholars, and dealers. We first heard of Friedrich through Ludwig Richter, who sought to prove the point that even a highly proficient artist could be forgotten if he was born at the wrong time. But now, after nearly a hundred years, it appears that this precursor of Schwind and Böcklin, a painter who once antagonized a stuffy older generation and thrilled a yearning youthful one, shall once again find admirers."

The exhibition of a century of German art, 1775 to 1875, mounted by Alfred Lichtwark, Woldemar von Seidlitz, and Hugo von Tschudi and presented in Berlin in 1906 was designed to provide a new view of that era, and in it Friedrich was restored to his "deserved place of honor" (in the words of Georg Fuchs). Represented by thirty-six pictures, he was one of the dominant painters in the show. The only artists with a

greater number of works on view were Arnold Böcklin, Anselm Feuerbach, and Wilhelm Leibl. The exhibition's curators tried to redefine and reinterpret the artistic tradition of a hundred years in the light of Impressionism and modernism— but cautiously, for this meant easing aside a great quantity of patriotic daubing and celebrated historical painting. Furthermore, it meant risking the wrath of the imperial household; Tschudi's fight over his rearrangement of the Nationalgalerie reveals how resistant to change the Hohenzollerns could be. There were also the academies to consider, which were by no means pleased to hear Tschudi complain of "a dry formalism that had lost all sensitivity to the appearance of nature." Finally, it was necessary to tread lightly inasmuch as Böcklin was central to the exhibition, an artist who had come to represent at that time, only a few years after his death, the very antithesis of modernism—or at least to the many critics who agreed with Julius Meier-Graefe. Caspar David Friedrich could now be

judged alongside Böcklin, and to many his work may well have seemed more modern, more clearly a part of the future.

Ferdinand Laban hailed the rediscovery of Friedrich as the exhibition's greatest achievement, and Richard Hamann, Heilbut, and Louis Réau tended to agree with him. Reevaluation of Friedrich was now permissible; the spell had been broken. Museum curators began buying his pictures once again—most notably Alfred Lichtwark, who acquired no fewer than seven Friedrich paintings for the Kunsthalle, Hamburg, between 1905 and 1907. The critics began taking him seriously, praising his atmospheric effects, his coloristic qualities, and his feeling for nature, though maintaining reservations about his allegorical dimension. Scholars first set out to clarify the historical connections and only gradually turned to the investigation of specific problems.

And Friedrich became popular. Now rehabilitated, he was ripe for commercial exploitation. The firm of Seemann, in Leipzig, soon flooded the market with prints, and the *Tetschen Altarpiece* (plate 5) and *The Solitary Tree* (plate 29) found their way into Germany's parlors and bedrooms. The demand for Friedrich's works was so great that Seemann's own artists were required to produce variations to meet every need; the *Tetschen*

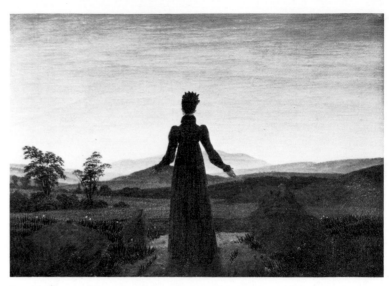

Fig. 23. **Dawn (Woman Facing the Setting Sun).** c. 1818. Oil on canvas, 8⅝ × 11¾″ (22 × 30 cm). Museum Folkwang, Essen (B-S 249)

Altarpiece, for example, was reworked to make it available in a more popular horizontal format, simply adding typical Riesengebirge scenery as needed. The philistines had discovered a new icon. They felt him to be a major witness against the chaos of commercialization and the ravages of industrialization, yet he was himself subjected to the very processes he was enjoined to combat. The *Kunstwart* had wondered whether the artist might be able to win new admirers after a hundred years. In reality, he won too many.

The more popular his work became, the more it was given an ethnic tinge. To some extent Andreas Aubert was to blame. The Norwegian was himself highly nationalistic and took great pride in the pioneer achievement of his countryman Dahl. By analogy, he projected some of this patriotic sensibility onto Friedrich. He paid particular attention to Friedrich's pictures from the period 1810–14, when the wars of liberation against Napoléon found reflection in his work. Aubert died in 1914. His notes on Friedrich, the fragments of what was to have been a first monograph on the artist, were published in 1915, in the midst of World War I. The volume was unfortunately subtitled *Gott, Freiheit, Vaterland* ("God, Freedom, Fatherland," a slight variation on the popular slogan "God, Kaiser, Fatherland"). Others were quick to take up the tune, exaggerating and coarsening it. Kurt Carl Eberlein bears the distinction of having sounded the ethnic fanfare the loudest. His magnum opus from 1940, *Caspar David Friedrich, der Landschaftsmaler*, is wholly indebted to the woolly ideology of Alfred Rosenberg, as spelled out in his *Myth of the Twentieth Century*.

Eberlein's lurid prose is now unreadable. Berthold Hinz, in his study *Caspar David Friedrich und die deutsche Nachwelt*, rightly devotes an entire section to German Fascism's exploitation of Friedrich. It is a dismal chapter indeed. Yet in the very same

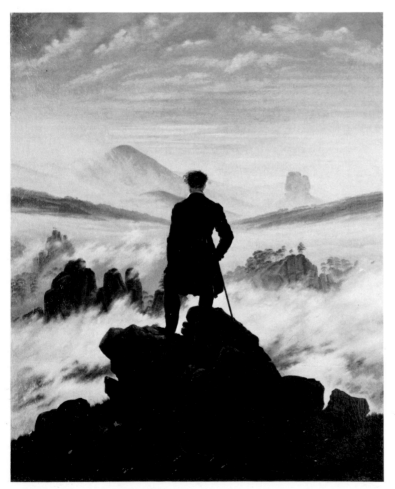

Fig. 22. **Hiker above the Sea of Mist.** c. 1818. Oil on canvas, 37⅜ × 29½″ (94.8 × 74.8 cm). Kunsthalle, Hamburg (B-S 250)

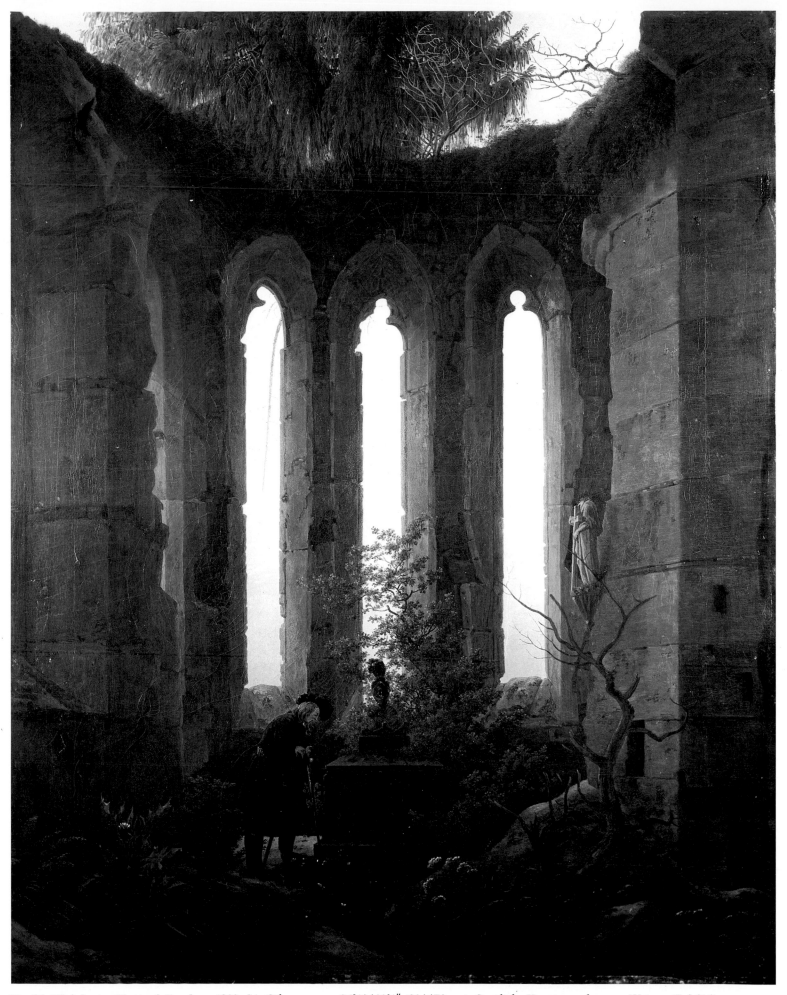

Fig. 24. **Ulrich von Hutten's Tomb.** c. 1823–24. Oil on canvas, 36⅝ × 28¾″ (93 × 73 cm). Staatliche Kunstsammlungen, Weimar (B-S 316)

period, in 1938, Herbert von Einem produced the first truly comprehensive Friedrich monograph. His magisterial work is utterly free of the bias of the period, and in its essential features, aside from its chronology of the paintings, it is still valid today. Of the earlier studies, only Willi Wolfradt's book from 1924 continues to be somewhat current. Unorthodox in both its structure and approach, it was long undervalued in scholarly circles. And yet it presented a number of original observations about the formal organization of Friedrich's pictures that are still worth considering. Somewhat later, in 1931, Alexander Dorner added a good deal to our understanding of Friedrich's spatial organization and pictorial form, as did Börsch-Supan, of course, with his 1960 dissertation. Friedrich scholars did not begin making any substantial contributions to the literature again until some years after the war. The most important of these are the publications of P. O. Rave, Walter Scheidig, Ludwig Grote, and Klaus Lankheit.

We have already touched on the progress of Friedrich scholarship in the last decade, but the work of several scholars should be specially noted. One of the most prominent younger scholars has recently subjected Friedrich to a dubious christological interpretation, going through the oeuvre and, so to speak, sprinkling holy water on Friedrich's motifs. Friedrich will weather this approach, as he has others. Werner Sumowski's book offers a wealth of new discoveries and insights; we are bound to hear more from him. We are indebted to Willi Geismeier, Jens Christian Jensen, Hans H. Hofstätter, and Gerhard Eimer for their brief but well-formulated essays incorporating the most recent scholarship. The catalogue raisonné by Börsch-Supan and the catalogue of the Hamburg exhibition by Werner Hofmann will remain indispensable sourcebooks.

The history of Friedrich's public image is one of alternating drought and abundance. Periods in which his work was most firmly rejected and almost completely forgotten have been followed by others in which his pictures, though felt to be disturbingly mysterious, have been widely popularized. Decades that registered no response at all have given way to decades in which the response has been confused and contradictory. Over a century and a half ago the benighted Basilius von Ramdohr wrote that Friedrich's art "appeals to the larger crowd." At the time he was grossly exaggerating, for the artist enjoyed only a handful of followers, but today his pronouncement is unquestionably true; Friedrich does appeal to the masses. More than 200,000 visitors thronged the Kunsthalle, Hamburg, to see his pictures in only seven weeks. The exhibition had to be closed time and again because of overcrowding, while more people stood outside for hours waiting to be admitted and countless others had to be turned away. There is something odd about this Friedrich mania. As we have seen, his rediscovery around the turn of the century was occasioned and encouraged by all sorts of misunderstandings; how could his popularity today be otherwise?

Romantic Landscape Painting

Nothing seems so indicative of the change that occurred in art around 1800 as the new respect accorded to landscape. In his *Ardinghello*, Johan Heinse had already predicted that "landscape painting will ultimately displace everything else" while Jacob Hackert's "On Landscape Painting," published by Goethe from the author's posthumous papers, grants it an equal place among the arts. It was Runge, perhaps, who sensed most clearly that the future belonged to landscape—and who saw what a significant break with tradition this would really mean:

Again we are witnessing a demise; we have outgrown the religions that evolved out of Catholicism, abstractions are dying out, everything is more passionate and freer than before; everybody is pushing toward landscape, searching for something certain in this uncertainty, not knowing how to begin. Mistakenly, people continue to take up historical subjects and become confused. Is it not possible that in this new art we might reach a peak perhaps even more splendid than any of our previous ones?

Though he so clearly saw what was coming, Runge, as we know, did not embrace it. It is as though he was incapable of producing pure landscape without the mediation of figures. The uncertainty that Runge speaks of is precisely what the painter Carl Grass stressed in an essay published in 1809 in the *Morgenblatt für gebildete Stände*. For him it was part of what made landscape painting such a difficult concept, and to some extent it was also what made the genre full of opportunity:

Is this not precisely the art in which an infinite amount of work remains to be done, in which genius can still blaze its own trails—even if they are not entirely new? Is it not the one requiring endless study, and one which by its very nature is less likely to be exhausted than any other?... It embraces everything that presents itself to the eye, and through it we catch a glimpse of a seemingly new world within the existing one.

In his *Laocoön* (1766), Gotthold Ephraim Lessing had still relegated landscape painting to the lowest rank among the arts, and even as late as 1825 Peter von Cornelius saw it as only "a kind of moss or twining growth upon the great trunk of art."

Opposite page:
Fig. 25. **Cemetery Entrance.** 1825 (unfinished). Oil on canvas, 56¼×43¼" (143×110 cm). Staatliche Kunstsammlungen, Gemäldegalerie, Dresden (B-S 335)

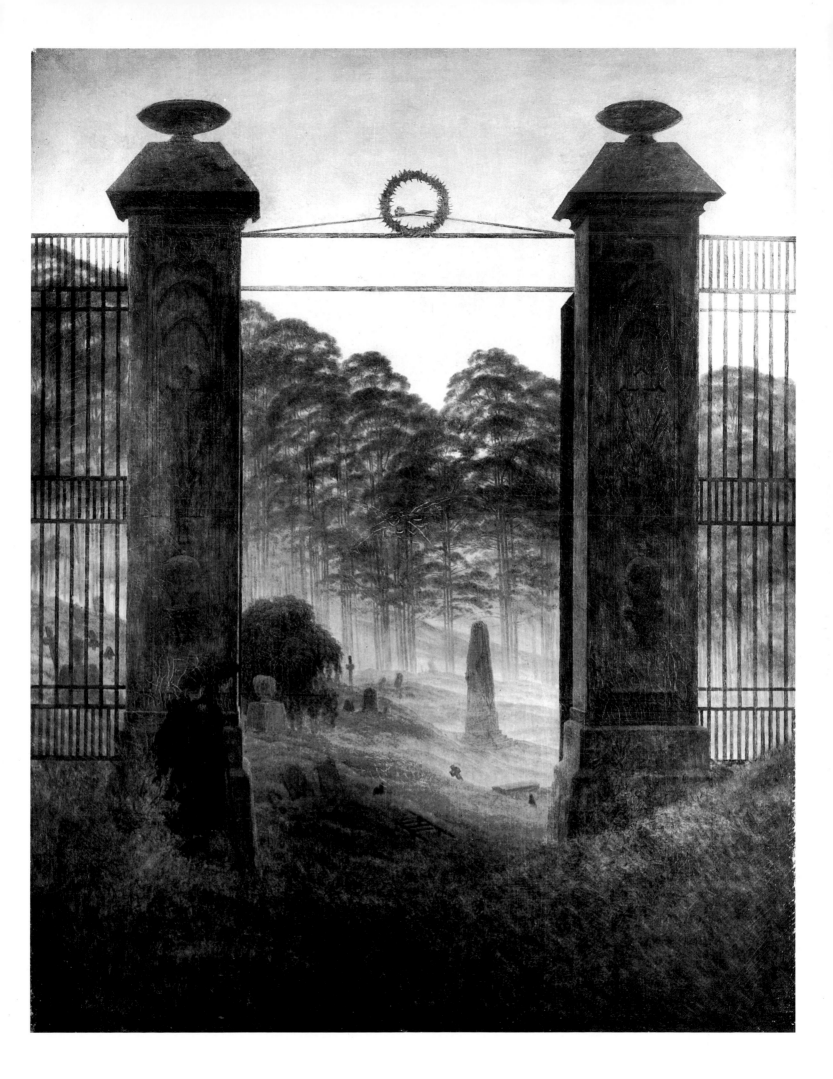

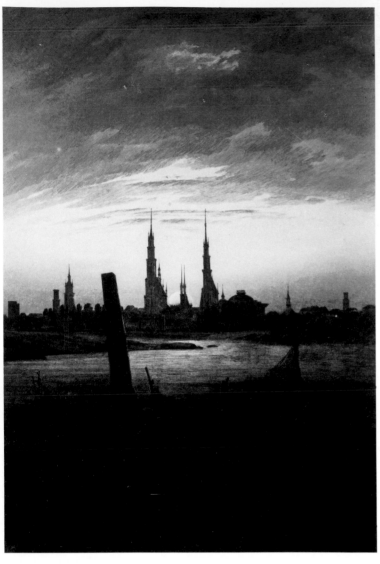

Fig. 26. **City at Moonrise.** c. 1817. Oil on canvas, 18 × 13″ (45.8 × 33 cm). Stiftung Oskar Reinhart, Winterthur (B-S 227)

Striking indications of the Romantics' religious approach to landscape are their acceptance of landscape paintings as altarpieces, serving as images of the divine in traditional church settings, and their sense that the natural landscape is itself a shrine, a fitting place for divine worship. Friedrich Schleiermacher put it this way: "The whole of religion is also present in nature, but in the infinite character of its totality, of the one and all."

Such a concept of nature opened up unlimited possibilities for the artist. The new mental faculty that Ruskin claimed humanity had acquired with landscape was for the Romantics not only a perception of the divine in all of the visible world but also a full and candid knowledge of the self. The "new world" that Grass felt he could catch sight of in landscape was in fact the world of the self.

As early as 1785, the hero of Karl Philipp Moritz's novel *Anton Reiser* had already felt that in the face of nature he was thrown back on himself. He sensed, for example, that a line of widely spaced trees offered a reflection of his own solitude and argued that in nature his own fleeting sensations took on permanence, majesty, even holiness. A few years later, in 1798, Tieck's hero Franz Sternbald confesses: "I think I see how you

Yet it was to become the one great artistic breakthrough of the nineteenth century. With it, as John Ruskin insisted, humanity acquired virtually a new mental faculty.

Romantic, realist, and Impressionist artists, and even the painters such as Paul Cézanne, van Gogh, and Georges Seurat who broke free of Impressionism, all expressed themselves primarily in the medium of landscape. It even provided important inspiration for a Symbolist like Odilon Redon. One can trace the philosophical development of the nineteenth century in all its contradictions by studying what landscape meant to these different artistic movements, how various painters conceived of it—whether as the mirror of the soul, the simple play of light, objective nature, or a metaphor of existence.

Never before had the conception of landscape been so grandiose, so filled with religious significance, as in German Romanticism. The next painter to demonstrate a view of nature as rich in meaning as Caspar David Friedrich's would be Cézanne, though to be sure he expressed himself more soberly.

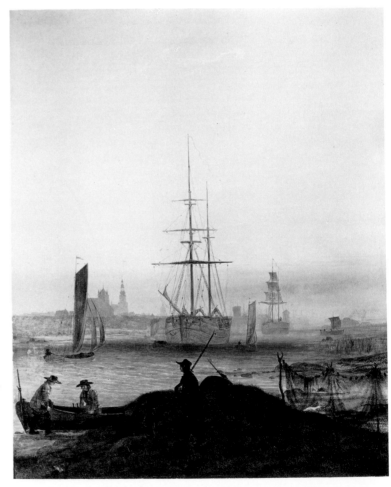

Fig. 27. Infra-red photograph (1974) of **Ships in Greifswald Harbor.** c. 1818–20. Oil on canvas, 35⅜ × 27½″ (90 × 70 cm). Staatliche Museen Preussischer Kulturbesitz, Nationalgalerie, Berlin (B-S 1). See plate 16.

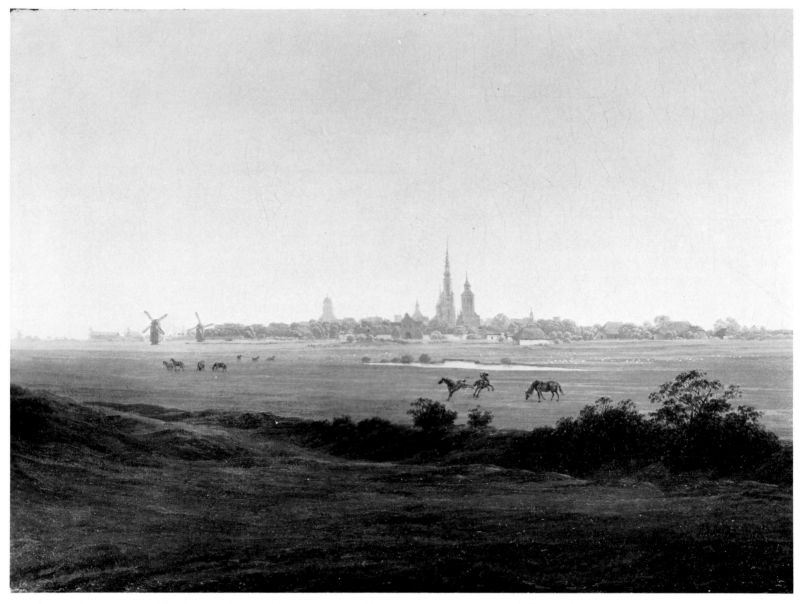

Fig. 28. **Meadows near Greifswald.** c. 1820–22. Oil on canvas, 13¾ × 19¼ ″ (35 × 48.9 cm). Kunsthalle, Hamburg (B-S 285)

perceive this landscape, and it seems to me you are correct. I don't wish to record trees and mountains, but rather my own disposition, my mood, what moves me at this hour. This is what I want to capture for myself and share with others like me."

Strictly speaking, this special relationship between the observing subject and nature as perceived by him has existed as long as we have had such a thing as a "concept" of landscape. It dates from the Age of Discovery, when landscape too became an object for artistic study and individual style was first acknowledged. Landscape—an arbitrary but organically coherent segment of the whole of nature—is inconceivable without an observing subject. As Schelling remarks in his *Philosophy of Art*, "Landscape becomes a reality only in the eye of the beholder." It came into being once man, at a specific moment in his intellectual history, attained full consciousness of himself and his own individuality. That moment is anticipated for us in Petrarch's terror at the vastness of the view from atop Mont

Ventoux in the year 1336, and we see its full effect in the creative autonomy of artists like Albrecht Dürer, Albrecht Altdorfer, or Adam Elsheimer.

While there had always been a special relationship of this kind between the observing subject and the perceived landscape, it was not until Romanticism that the relationship itself became an object of speculation and the actual subject of such painting. The Romantic artist, having outgrown the traditional range of subject matter, no longer looked at his landscape with the eyes of an innocent; he saw in it his inner self.

Here is where the utopian hope of Runge comes into play— the hope that landscape, in which the ego objectifies itself, lending specific contours to vague emotions, might offer a new means of artistic communication, a common stock of forms and symbols through which subjective experience might be projected onto the external world and be read back, in turn, from its objectified forms. One has to know something of

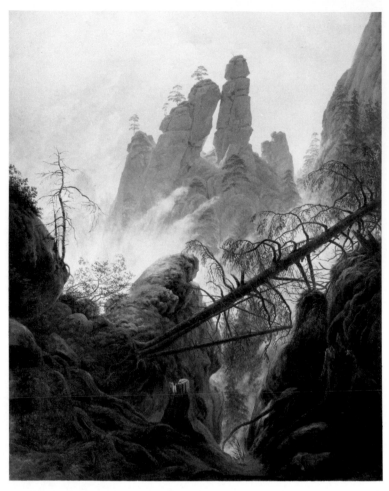

Fig. 29. **Rocky Gorge in the Elbsandsteingebirge.** 1822–23.
Oil on canvas, 35⅞ × 28⅜″ (91 × 72 cm). Kunsthistorisches Museum,
Vienna (B-S 301)

Romantic philosophy to appreciate what a grandiose role Runge had in mind for the art of landscape. To the Romantic philosopher the observer and the observed, subject and object, "I" and nature, were ultimately one and the same. "Selfhood is the basis of all knowledge," we read in Novalis. Our knowledge of nature is rooted in this self. Only like things can know each other. Walter Benjamin managed to reduce this complex relationship in the thinking of Novalis or Schlegel between "I" and nature, or knowledge and self-knowledge, to the pithy formula: "Knowledge is anchored in mirror images on every side." We are here at the core of Romantic speculation. Perception as intellectual contemplation of nature is a reciprocal illumination and inspiration: man sees nature because he is himself nature—and because nature mirrors his perception of it. "A thing radiates its original self-perception onto other beings to the extent that it expands by being reflected and includes other beings in its perception of itself.... Mirroring each other, the object and the perceiving being blend into one" (Benjamin, *The Concept of Art Criticism in German Romanticism*).

Their identical perception is the absolute root of all things, all beings. Through it everything is obscurely connected to everything else. Romantic thought found its correlative object in nature, Romantic painting its appropriate subject matter in landscape. In Friedrich that subject matter seems inexhaustible. The two poles of his art—meticulousness with regard to details and absolute freedom in overall design—are thus explained. Complementary aspects of the Romantic experience of the world, they bespeak a surrender to objects and a simultaneous autonomy of the soul. They signal nature's twofold triumph: its individuality and its universality. The foundation of all Romantic speculation is this, that the "I" liberated from all traditional bonds will ultimately discover its autonomy in a new and complete unity with the numinous.

Friedrich in Novalis's Terms

How is one supposed to look at Friedrich? How interpret him? Great as the current fascination with the painter is, attempts at interpreting him are widely contradictory. This is particularly apparent, to take only a single example, with regard to his characteristic motif of the figure seen from the back, with which he reverses the classical tradition of staffage. In that tradition it was the function of figures to blend in organically with the landscape, but Friedrich's reversed figures are juxtaposed against nature, seemingly isolated and estranged from it. The classical staffage figure was meant to establish a rapport with the viewer, to lure him into the picture, as it were, but Friedrich's figures give us only the choice of remaining outside or of putting ourselves in their shoes. They appear to be utterly passive—wanderers who have stopped for a time and are deep in meditation. Surrendering to contemplation, they absorb the landscape into themselves.

It is possible to interpret the complex relationship between these reversed figures and the landscape in all manner of ways. Some see it as an attempt to express alienation, to formulate the conflict between freedom and necessity or between the individual and society in images of estrangement, of man and nature unreconciled—and not in some arbitrary, timeless moment but in a specific historical context. The fact that Friedrich's figures wear the typical costumes of their time supports this view, which has been given plausibility most recently by a group of scholars gathered around Berthold Hinz.

Others see the reversed figures quite differently. Might it not be that the figures have taken up what Schlegel would call a "transcendental position," one that places them outside the physical context of nature "where all external realities [melt] into the ideal, all internal ones [assume] the highest vividness"? Werner Sumowski argues for this reading of Friedrich's landscape visions. With reference to Novalis, he writes:

Thus the reversed figure along with the landscape as projection of the absolute within represents a state in which the unity of nature and

spirit in God is attained. Such an occurrence is frequently documented as a primal experience in the literature of the time, in Tieck, for example, in Runge, in Theodor Schwarz, who feels himself becoming immaterial when gazing at the sea, or in Wilhelm von Kügelgen, who at one point describes his oneness with a nature become transparent.

What was Friedrich's intent? Was he picturing estrangement and alienation, or did he really mean to portray unity with nature? To put it another way, does the reversed figure suggest the tragedy of man set apart from the world, or is it meant to represent the possibility of communion with it? Werner Sumowski writes:

> *To maintain that the motif is essentially tragic, as H. Sedlmayr does with particular insistence, is unjustified. The feeling of painful isolation was doubtless familiar to Romanticism. Yet Friedrich may well have been one of those, like Novalis, Ritter, or Schleiermacher, who believed that the dichotomy between man and the All might be overcome, thanks to their faith in the conciliating power of the universe.*

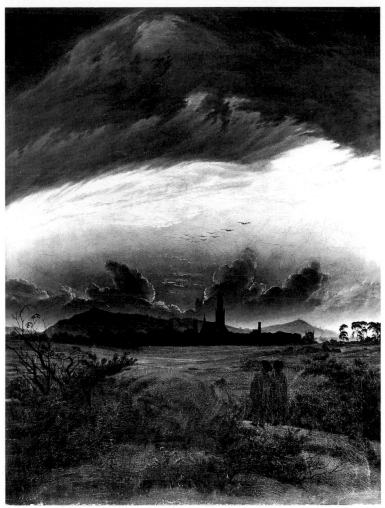

Fig. 31. **Neubrandenburg.** c. 1817. Oil on canvas, 35⅞ × 28⅜″ (91 × 72 cm). Stiftung Pommern, Kiel (B-S 225)

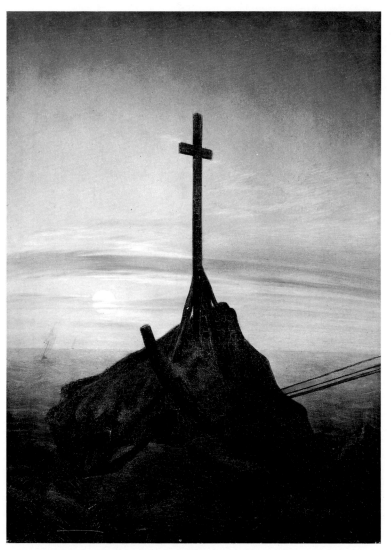

Fig. 30. **Cross by the Baltic.** 1815. Oil on canvas, 17¾ × 13⅛″ (45 × 33.5 cm). Schloss Charlottenburg, Berlin (B-S 215)

An artist of our own day, Oskar Kokoschka, saw something else entirely in Friedrich's pictures. When confronted with the paintings of the Dresden years, Kokoschka felt himself moved by a despair similar to his own: "Caspar David Friedrich, a loner, suddenly sees with horror and with his eyes wide open how terrifying nature is, how lost the individual is in the world—in contrast to the academic, classicist idea of a falsely romanticized nature in the bucolic sense." This may be merely a projection of the Expressionist's own worldview, but there is indeed a suggestion of such feeling in Friedrich's works.

It is my contention that we must first of all see Friedrich from the point of view of his own time, within the context of Romantic thought. To this end it is necessary to review Romantic literature, philosophy, and natural history at some length. It would be impossible here to link every aspect of his work with a specific idea, even within the period of early Romanticism, when Friedrich had his start. Armed with such an intellectual survey of the epoch, we will be able to note a number of closer internal connections. Some phenomena will seem only peripheral, and much will even strike us as contradictory. But inconsistency is also a part of the picture, for inconsistency is

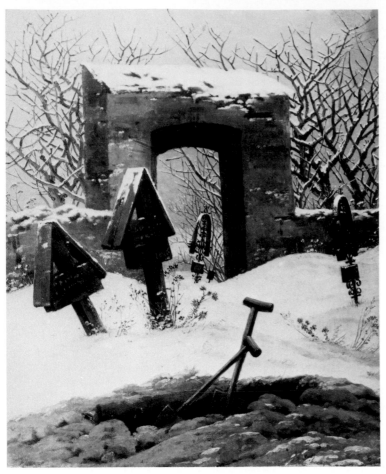

Fig. 32. **Graveyard in the Snow.** 1826–27. Oil on canvas, 11¾×10¼″ (30×26 cm). Museum der Bildenden Künste, Leipzig (B-S 353)

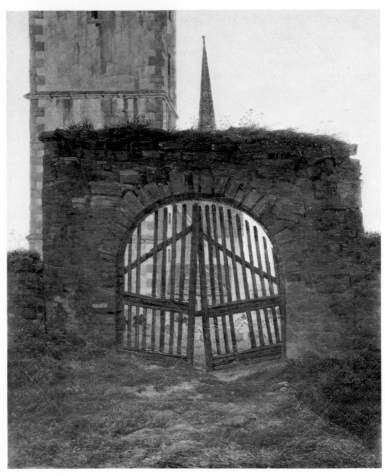

Fig. 33. **The Churchyard.** c. 1826–28. Oil on canvas, 12½×9⅞″ (31×25.2 cm). Kunsthalle, Bremen (B-S 357)

apparent in Friedrich himself. One only has to look at some of his observations from the period 1829–33, fragments of thoughts arising from various moods, noted in front of various pictures, formulated in response to a variety of criticisms. They frequently do not jibe at all. Without doing them violence, it is impossible to construct from them anything resembling a consistent point of view. Some points he stubbornly returns to again and again, and regarding others he appears to change his mind—depending on how he approaches the question. On one occasion he finds traditions essentially worth preserving, yet on another he mocks those who do not dare to break them. He calls for an art that comes from the heart and is sustained by feeling, but is greatly annoyed when such art is not thought through or is poorly crafted. He rails against "patching and mending" and complains when disparate motifs are combined in a picture. Yet he righteously defends his own practice of juxtaposing the most remote motifs and most varied moods of nature in a single work. He rejects cold erudition but reveals himself to be quite well read—referring to specific poems and alluding to Hegel—despite the judgment of his contemporaries that he stood aloof from his time.

It is necessary to see Friedrich against the background of his

time, but pinning down specific influences should not be one's primary goal. Nor is it so important, though such details might be worth knowing, to ask first of all whether Friedrich was as familiar with the literature of early Romanticism as was Runge, for example, or to try to prove precisely what he read and when he read it, what he absorbed from friends, and what he discussed with them. It is characteristic of a period movement that kindred spirits from the most varied fields tend to support it, that identical ideas are stated in similar ways by various people, quite independently of each other, at the same time. The subtlest suggestion is enough to trigger wide reverberations in contemporaries, a whole range of responses. Such general receptivity to specific ideas and feelings constitutes the unifying mark of any epoch. All the more so in the case of Romanticism, a movement that dreamed of a universal poesy to serve as "communal world soul for all the arts," and that put such a premium on the ideal of friendship.

We do know how much the university town of Greifswald meant to Friedrich in his formative years. It was there, by way of his teacher Quistorp, that he became familiar with Kosegarten's sermons and poems—and thus not only with the cult of Ossian but also with Hamann and Herder. And after

26

1798, again perhaps through Quistorp, he there came into contact with the aesthetics and philosophy of Thomas Thorild, and through him with the ideas of Spinoza, Leibniz, and Shaftesbury. We know of his encounters with Runge, Klinkowström, and Tieck around 1802. He doubtless knew Tieck's *Franz Sternbald's Wanderings*, Schleiermacher's *On Religion*, Wackenroder's *Outpourings from the Heart of an Art-loving Friar*, however distasteful that monk's enthusiasms might have seemed to him. He probably read each new issue of the *Athenäum*, and was familiar with Novalis's *Heinrich von Ofterdingen*. Tieck must surely have spoken to him of the latter, for he was just then in the process of publishing the novel posthumously from the author's papers.

Novalis is at the heart of Romanticism, and it is instructive to view Friedrich through the poet's eyes. The intellectual parallels speak for themselves, but we are further justified in doing so by the testimony of Tieck, who in his 1815 essay on the life of the poet quotes from conversations he had had with Novalis on the subject of art: "I recall a quarrel about landscape painting. I could not understand what he meant, but later it was demonstrated in large part independently, out of his own rich imagination, by the superb Dresden landscape painter Friedrich." In his "A Summer Journey," which takes place in 1803, Tieck

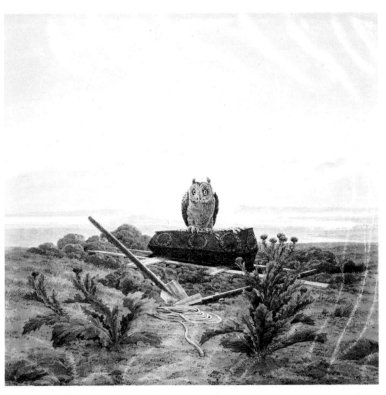

Fig. 35. **Landscape with Grave, Coffin, and Owl.** c. 1836–37. Pencil and sepia, 15⅛ × 15⅛" (38.5 × 38.5 cm). Kunsthalle, Hamburg (B-S 460)

speaks of Friedrich at greater length: "This truly marvelous spirit has made a strong impression on me, even though there is much about him that I don't understand." Did Friedrich remind him of Novalis? Another section in "A Summer Journey" seems to imply as much: "One sees again and again … how a single spirit proclaims itself in this age in diverse places and temperaments. Even people who neither know Novalis nor understand him are thus related to him."

Novalis's description of the teacher in the first chapter of his *Apprentices at Sais* can be read as an interior biography of Friedrich. Here, expressed in incomparable fashion, is early Romanticism's religious understanding of nature, its passionate yearning to decipher nature's handwriting and thus discover the innermost workings of the world. Here is everything that attracted Friedrich to landscape from the very start, leading him to devote himself to its study as a means to self-discovery. Novalis describes the teacher's childhood as follows:

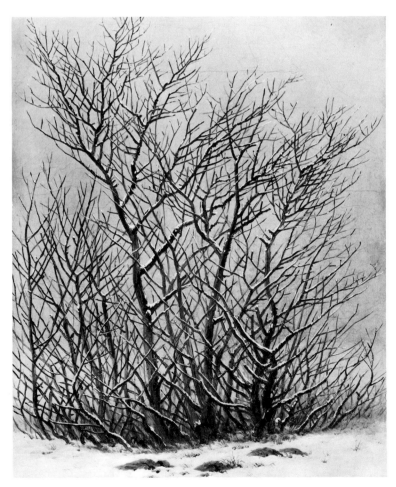

Fig. 34. **Trees and Bushes in the Snow.** c. 1828. Oil on canvas, 12¼ × 10" (31 × 25.5 cm). Staatliche Kunstsammlungen, Gemäldegalerie, Dresden (B-S 359)

He often told us how as a child the urge to develop his senses, to engage and satisfy them, left him no peace. He would gaze at the stars and trace their courses and positions in the sand. He would incessantly study the sea of air, and never grew tired of observing its clarity, its movements, its clouds, its lights. He would sit on the seashore, searching for shells. He listened carefully to his own soul and his thoughts. He had no idea where this was leading him. Once he grew older he became a vagabond, had a look at other countries, other oceans, different skies, strange stars, unfamiliar plants, animals, and peoples. He would explore caves to see how the earth was structured in seams and brightly

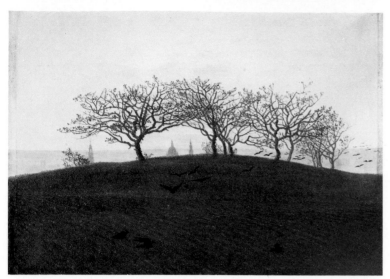

Fig. 36. **Hill and Plowed Field near Dresden.** c. 1824. Oil on canvas, 8¾×12″ (22.2×30.5 cm). Kunsthalle, Hamburg (B-S 321)

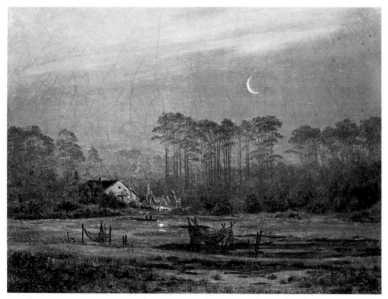

Fig. 37. **Isolated House next to a Pine Forest (Evening on the River).** c. 1825. Oil on canvas, 7½×10″ (19×25.5 cm). Wallraf-Richartz-Museum, Cologne (B-S 329)

colored layers.... Everywhere he found things that were familiar, but in new combinations, unexpected pairings, and accordingly the most curious things often fell easily into place inside him. He soon began noticing the connections in all things, similarities, coincidences. And soon he saw nothing anymore in isolation. The perceptions of his senses would come together in large, colorful pictures: he would hear, see, taste, and think all at the same time. He enjoyed bringing strangers together.... What has become of him since he did not say. He told us that under his guidance and that of our own inclinations we would discover ourselves what had happened to him. Several of us drew away from him.

Here, in fictional form, we read how the world of appearances must have impressed itself on the soul of Caspar David Friedrich, how by learning to understand its separate elements, to read its coded language, he managed to forge out of the most disparate fragments his own private world of images. Here we find the intuition that everywhere lights upon the symbolic correspondences hinted at by nature, and that is capable of making sense out of myriad separate impressions. Here we discover how the painter managed to absorb nature into himself—to the point that he could then reconstruct it in his pictures with freedom and self-assurance, simply by following his instincts.

Friedrich could paint the external world only to the extent that he carried it in himself, had rediscovered and reexperienced it within. Only when the outward image matched his inner one—and this is the case in his best pictures—do the individual ciphers take on meaning, does nature assume symbolic significance. One of the chief characteristics of his specific approach is his need to limit himself. In order to interpret objects simply and profoundly, he had to be extremely selective, to reduce to a minimum the multitude of natural forms. His relentlessness in this regard has never been equaled. He would focus on certain things that he loved, such as trees, boulders, or boats, attempt to capture their unique character, then abandon them again. He would reduce a landscape until it verged on absolute emptiness, until nothing was left but a line of mountains, the sea, or the sky. For this reason his image of nature strikes us as being more laden with meaning, freer of arbitrary details, than that of any other painter of his time.

Of all of Novalis's observations on nature, some of the most profound are those found in his *Apprentices at Sais,* and a further quotation from that novel seems appropriate: "Being a prophet of nature is a beautiful and holy office," says the teacher. He then explains what a person "really requires to be such a spokesman," and what things are immaterial, among them "the richly inventive skill of arranging natural phenomena in easily comprehended and strikingly illuminated paintings ... or of thrilling the intellect with a profound sentiment." Being a prophet of nature entails much more:

To anyone whose interest lies somewhere other than in nature this is enough, perhaps, but anyone who feels an inner longing for nature, anyone who looks to it for everything and is attuned to its esoteric workings, will recognize as ... the intimate of nature only the person who speaks of it with reverence and faith, whose utterances have that wonderful, inimitable urgency and wholeness with which ... true inspirations announce themselves. If one is born with the proper disposition, one has to nourish it and cultivate it with great effort from childhood on, with solitude and silence ... with a childlike passivity and untiring patience.

One of the apprentices seated on the steps in front of the teacher then responds:

To understand nature you have to let nature rise up inside yourself in all its complexity.... But the art of passive observation, of creative contemplation of the world, is by no means easy. It requires constant, intense

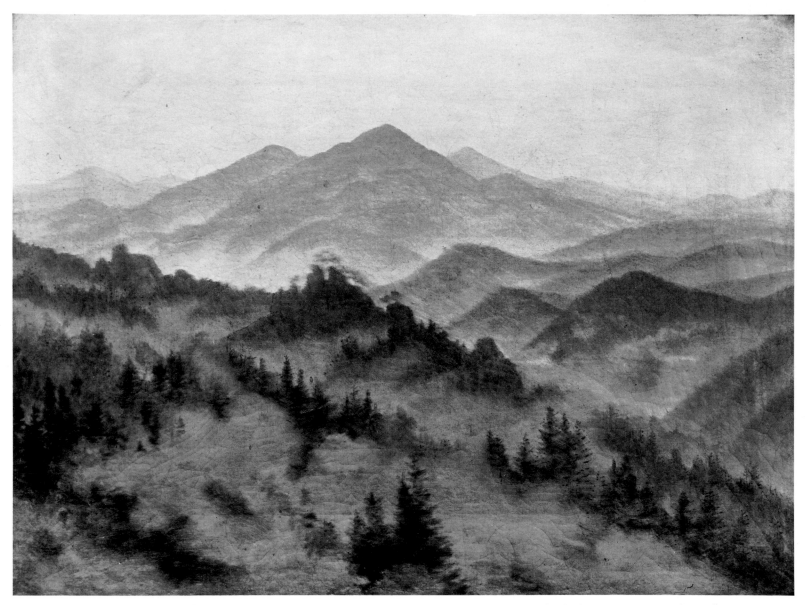

Fig. 38. **Mountain Landscape with Rising Mist (Misty Morning in the Riesengebirge).** c. 1835 (unfinished). Oil on canvas, 13¾×19″ (34.9×48.5 cm). Städelsches Kunstinstitut, Frankfurt am Main (B-S 420)

concentration and absolute sobriety, and one's reward is not the grati- tude of one's indolent contemporaries but only a delight in knowledge and awareness, a more intimate contact with the universe.

The work of Caspar David Friedrich was created in such a spir- it and with just such self-awareness, and we should understand his paintings as participating in the inspired vision of nature of early Romanticism, no matter how much else we manage to infer from them about his person, his time, his historical role. His contemporaries certainly saw him in this light, as we know from the testimony of the admiring philosopher Gotthilf Hein- rich von Schubert. He speaks of Friedrich as a man "whose soul appears to be deeply familiar with the innermost meaning of nature."

Among the many interpretive approaches undertaken in recent years, I am therefore least sympathetic to the one that

would attach to every element in a Friedrich picture a specific Christian allegorical significance. Those who champion such an approach ignore the intensity of vision in a picture and its many-layered meanings in favor of the most hackneyed formu- las. To them, there is no question but that the moon stands for Christ, for example, the fir tree for his stalwart follower, the boulder for faith, the anchor for hope, and mist for human ignorance. This forces on the viewer the "neat little crutches" that Friedrich dismisses with such scorn in his aphorisms, sug- gesting that only "wretchedness limps along" on them. In one of Friedrich's winter scenes a veteran has flung his crutches into the snow, far out of reach.

Allegorical equations such as these were already antiquated by the end of the Baroque period, and to my mind they should be consigned to the dustbin of history. To apply them to Friedrich is to diminish him. Those who do so imply that his

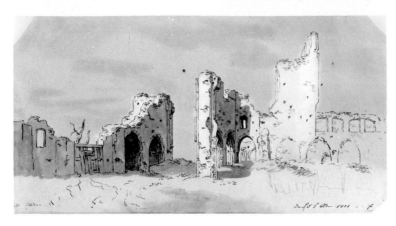

Fig. 39. **Ruins of Eldena Abbey.** 1801. Ink and watercolor wash over pencil, 7 × 13⅛″ (17.6 × 33.4 cm). Graphische Sammlung, Staatsgalerie, Stuttgart (Not in B-S)

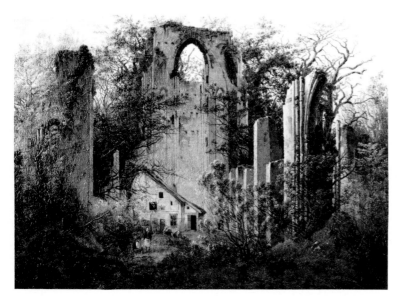

Fig. 40. **Eldena Ruins.** c. 1825. Oil on canvas, 13¾ × 19¼″ (35 × 49 cm). Staatliche Museen Preussischer Kulturbesitz, Nationalgalerie, Berlin (B-S 328)

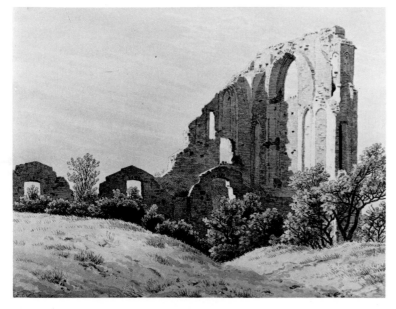

Fig. 41. **Eldena Ruins.** c. 1825–28. Pencil, ink, and watercolor, 7 × 9″ (17.8 × 22.9 cm). Collection Dr. Georg Schäfer, Obbach, near Schweinfurt (B-S 376)

spirituality was far more primitive than that of his contemporaries, Schleiermacher for example; that in his concept of nature he was less advanced than Kosegarten or Theodor Schwarz, two Rügen pastors with whom Friedrich was in contact and whose worldview betrays unmistakable pantheistic features.

Interpretation based on such rigid formulas tends to contradict all that we find in Runge on the subject of hieroglyphs. It denies the possibility that a given sign might have a different meaning and importance within the syntax of two different pictures. Finally, it ignores the emphatic hints about his own sense of religion that Friedrich provided in a number of pictures through the symbolism of ruins. His ancient church structures are derelict: only a few walls still stand; the roofs have collapsed. They have not lost in the process, however, but rather gained. They have become more open, more spacious. They have let nature enter in, accepted it; the whole sky now serves as a roof. They are still places of worship for the solitary spirit; one could still hold services in them. Old incrustations have given way, dividing walls have fallen; formal religion and landscape are reconciled. Surely we are meant to read this as an indication that traditional symbols must now be opened up and expanded, that all of nature can be the setting for divine revelation.

The similarity between Novalis and Friedrich is most apparent in two specific aspects of their thinking: that is to say, their conception of nature and their respect for mathematics. For Novalis mathematics had symbolic significance and played an important role in the realm of the arts. In his 1798 "Monologue" we read:

If only one could make clear to people that a language is just like a mathematical formula. They constitute a world of their own; they have to do only with themselves, express nothing but their own wondrous nature, and that is precisely why they are so expressive—that is why the curious play of relationships in things is mirrored in them. It is only their autonomy that makes them components of nature, and only in their free motion does the world-soul express itself, rendering them a sensitive measure and outline of things.

Friedrich left us no comparable observations about the importance of mathematics in his work. Yet close examination of his pictures reveals what a crucial role mathematics plays in them, and he must have discussed his fascination with others. Theodor Schwarz, writing under the pseudonym Theodor Melas, provides a good indication of Friedrich's thinking in his novel *Erwin von Steinbach oder Geist der deutschen Baukunst,* published in 1834. One of his two main figures, who hikes through Sweden with the novel's hero, is a painter named Kaspar and is obviously based on Friedrich. As Kosegarten's successor in Rügen, Pastor Schwarz was well acquainted with the painter,

and it is probable that in the 1820s Friedrich was his guest in the parsonage on several occasions. We may therefore credit the observations of the fictional Kaspar with a certain authenticity, and in fact many of Kaspar's comments do seem to be borrowed from Friedrich's aphorisms. Kaspar explains his method in creating a picture as follows:

When making a picture everything compels me first to collect my thoughts in a specific geometric figure, and to proceed to construct it quite abstractly, like a mathematician. I cannot rest until I have found some rhythmic form of that sort, one that often enough remains quite hidden, and is only visible to an artistic sensibility. Be it a rhombus or a polygon, I have to work it out quite coolly and clearly before I can think of embellishing it. If a picture lacks such a form as a foundation, it has no art. For all its other virtues it remains only a draft, an impressive collection of natural observations without coherence and truth. Yet always the most difficult part is to disguise this figure once again by means of painterly contrasts and diverse tints, so that it strikes the eye as something accidental and is not simply boring.

Friedrich's contemporaries held his love of geometry to be but a part of his "architectonic imagination," and even his friends tended to criticize rather than admire him for it, as we see from certain comments by Carl Gustav Carus, for example. Thus it is easy to see why Friedrich should have wished to prevent the casual viewer from seeing how he constructed his pictures. Not only did he avoid letting anyone look over his shoulder while he was working on them, but he also makes no mention of his method in his writings. All of his nature studies reveal, moreover, that he was a somewhat timid draftsman. Whenever he incorporated into a painting one of his careful studies from nature—on which he frequently made precise notations of the relative dimensions of a landscape—he was forced to copy it very precisely and systematically. Given his need to calculate things so precisely, he could hardly have functioned without the help of using geometric figures. They lent his forms a degree of weight, proportion, symmetry, and consistency that compensated for the absence of an expressive, flowing line. Friedrich may have suffered from a lack of spontaneity, but he certainly did his best to disguise it.

In many of Friedrich's pictures we discover a hidden geometry, an underlying scheme that assigns a place to every object. It governs everything from the deliberate contrast between verticals and horizontals to the tension produced by curves of varying tautness; from the most obvious symmetries and alignments to the most complex intersections and linkages; from parallel lines, displaced lines, crosses, and triangles to hyperbolas, parabolas, ellipses, and circles. When we come to the descriptions of specific pictures, in the plate section, we will have occasion to discuss this in greater detail. For the moment, it is enough to say that these geometries are designed to underscore the picture's meaning in the subtlest of ways. What is more, the geometric figure serves to enhance the significance of each of the objects depicted. Every element in the picture has its proper place, as though established in the successful solution of a mathematical equation. The more complex a picture's intended meaning, the more complex the geometric figure employed to support it. It has often been noted how Friedrich appeals to the mind's eye, and perhaps this is because he challenges us to see the secret correspondences in things, to appreciate the larger form in a given landscape, to perceive behind the things themselves the strict laws on which their existence is based.

Without mathematics we would have no hope of comprehending nature, the play of relationships between things. We would be left with only vague surmises. Mathematics is itself an alternate nature, a harmony parallel to nature. Numbers and shapes are also keys to landscape. An artist can wholly grasp a landscape, give form to it, reconstruct it in his studio, only by reference to the laws of geometric forms. Because Friedrich relied so heavily on calculation in his work, he tended to emphasize its opposite, the warmth of invention with which it must go hand in hand. He placed as great a value on the "inner sense of symmetry" as on the "law of feeling." Mathematics and nature—a work of art based on either one without the other is less than half of what can be achieved when they are used in combination.

Friedrich's Concept of Mortality

One can grasp the full import of the art of Caspar David Friedrich only if one understands his special attitude toward death, the role he assigned to it in his view of the world, and the significance he reserved for it in his work. A number of things suggest that Friedrich had a definite affinity for death from an early age. There are the biographical facts, notably the loss of his beloved siblings and his own attempted suicide. There are the descriptions of him by his contemporaries, which invariably stress his tendency toward melancholy. There are also his own confessions. And above all there are his pictures themselves. Even the earliest works of his that we have include depictions of ruins, crosses, groups of mourners, funeral processions, churchyards, and tombstones. At thirty he sketched his own burial, and in his later years he was forever imagining churchyards and monastery ruins or conjuring up visions of a grave, a coffin, and an owl (see fig. 35) as though he found strength, or at least comfort, in the contemplation of such images.

He identified death early on, not only in its obvious guises but everywhere in nature: in crumbling masonry and dying trees, in the butterfly and the rising moon, falling rocks and ships returning to port, mountainous regions and the polar sea of ice. Death reveals itself in the fleeting lives of plants and in

the ocean's vastness; the progress of the day and succession of the seasons only bring death closer.

Whether in physics or philosophy, the Romantics sought to discover the mysterious correspondences between the inner world and external nature, and the business of deciphering nature's signs was one of their most compelling obsessions. Once they learned to read nature's hints, they found death all around them. No aspect of our existence was subjected to such passionate scrutiny as was death—perhaps most movingly by Novalis, most unusually by J. W. Ritter, most comfortably by Gotthilf Heinrich von Schubert, most comprehensively by Jean Paul. Friedrich's fascination with death must be seen in this context, for it is only against the backdrop of Romantic thinking on death that one can begin to appreciate the richness and variety he managed to give to its individual symbols in his work. Death alone gives meaning to life and assigns us our place in it. Setting a limit to our lives and thus giving them proportion, death brings order to our destinies. In Novalis's *Hymns to the Night* we read: "It was death that revealed to us eternal life. You are death and only you make us whole." One of Friedrich's own poems includes the line: "If one is to live forever, one must succumb to death often."

Death links both realms, both worlds, the here and the hereafter. It is the gate through which we step from one existence into another. We can pass through this gate in only one direction—and often just such a gate appears in Friedrich's pictures on the verge between foreground and background (see figs. 21, 25, 32, 33). It stands open (or at least ajar) not only to permit our passage, our crossing over, but also to let the numinous enter into the here and now. We see what space there is on the other side, what light. Through death's gate we can glimpse in our mortality a reflection of eternal life, and that reflection colors the physical prospect spread before us. Out of his knowledge of death's inevitability the artist is licensed not only to reveal to us the vanity of our existence but to create life anew, to design new worlds more logical, permanent, and real than the world of appearances. Having in his paintings passed through the gate so frequently himself, whether the high portal beneath the broken vaulting of an abbey or the narrow opening in an ancient garden wall, Friedrich was free to rearrange appearances as he chose, and in his best compositions he did so masterfully. He was also free to anticipate the passage of time and its possible effects. Therefore he can envision the Cathedral of St. Nikolai in his hometown of Greifswald as a ruin, Neubrandenburg's Marienkirche in flames and smoke, or the cathedral at Meissen in decay and filled with rubbish.

Friedrich thinks in temporal sequences; he is an artist of cycles. In groups of pictures he traces the passage of the day, the turning of the year, the seasons of life, the flowing of rivers, the courses of boats setting sail and returning home, the progress from fallow field to harvest time. As an antidote to his decaying Gothic ruins he presents us with visions of an otherworldly, indestructible architecture, glimpses of a city just over the horizon, a faint promise across the water or the meadows, delicate gray contours against the sky, the high towers and pointed gables of distant Greifswald—home. The wanderer stops and

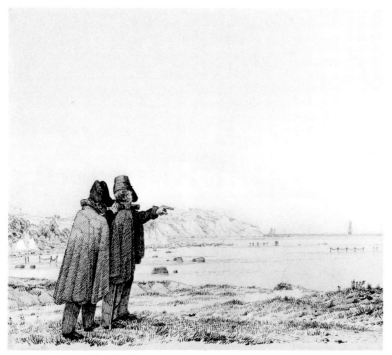

Fig. 42. **Two Men on Mönchgut.** c. 1826. Ink, 6¾ × 7⅜″ (17.1 × 18.6 cm). Kupferstichkabinett, Dresden (B-S 348)

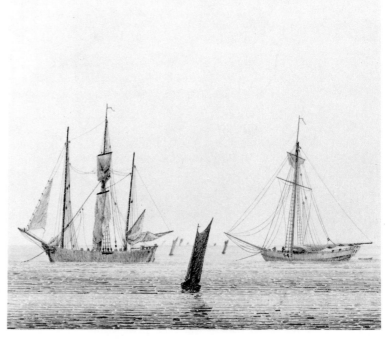

Fig. 43. **Sea with Sailing Ships.** c. 1826. Ink and wash, 6⅝ × 7¼″ (16.8 × 18.5 cm). Kupferstichkabinett, Dresden (B-S 347A)

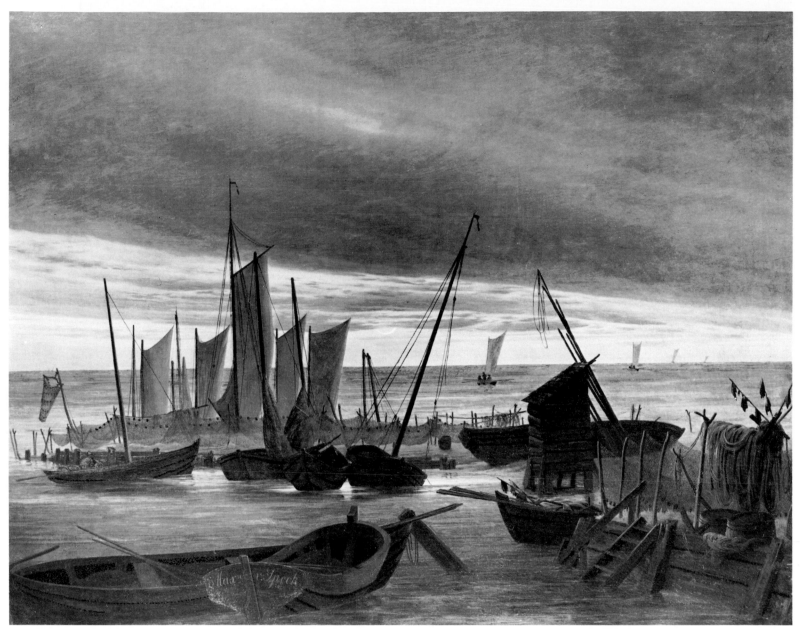

Fig. 44. **Ships in Harbor in the Evening.** c. 1828. Oil on canvas, 29¾×34⅝″ (75.5×88 cm). Staatliche Kunstsammlungen, Gemäldegalerie, Dresden (B-S 358)

rests, sinking into contemplation of nature and pondering its meaning. The things he sees before him are not vapid allegories but rather the ambiguous ciphers of reality, the things we know by the names city, moon, tree, boulder, sea, mountain range, rainbow. Friedrich's friend Schubert introduces his *Symbolism of Nature* with the observation: "People have often suspected a spiritual significance in the nature that surrounds us, a so-called natural language."

In Friedrich's pictures the world of experience is arranged in concentric cycles that reflect and reinforce each other. Death is transcendent; it is the all-encompassing circle that sustains each cycle, the one to which all life and all evolution return. In one of his cycles of paintings, that in Hamburg presenting the seasons and the stages of life, the artist makes this perfectly clear by adding to the traditional four images three supplementary

ones. One depicts the morning of Creation above an empty sea of waves with foaming crests—a first birth, but also a symbol of all that is passing. Another shows a pair of skeletons lying in a cave, suffused with the cold light of the moon (fig. 60). The third portrays the soul's resurrection with figures of angels above a sea of clouds (fig. 61). These three works transcend the earthly round, yet they too constitute a cycle: water first appears as the sea, then frozen into icicles, and finally as vapor, rising upward in clouds—only to fall to earth again as rain.

Friedrich's fondness for cyclical form culminates in his *Stages of Life* (plate 40), in Leipzig. At the close of his life the painter has here combined his cycles and summed them up in a single picture. Man's destiny is reflected in the metaphor of departing and returning ships and in the colors of the water and the clouds, ranging from the green of the shoreline to the violet of

Fig. 45. **Nordic Sea in Moonlight.** c. 1823. Oil on canvas, 8⅝ × 12″ (22 × 30.5 cm). National Gallery, Prague (B-S 312)

the horizon. Friedrich himself, the old man wearing a shawl and carrying a cane, has turned away from us. It is evening. He is moving toward the sea, about to embark on a new voyage. The signs of death are unmistakable: the old man is frail; the ship in the center is already drawing in its sails; the overturned boat on the shore has the outlines of a coffin.

In Friedrich's oeuvre, even pictures that at first glance appear to have no relationship to each other frequently belong together as two points in a cyclical movement. Such is the case with *Monk by the Sea* and *Abbey in the Oak Forest* or with *The Solitary Tree* and *Moonrise by the Sea*. Here the ciphers appear to be laden with even greater meaning, the sequence of separate states more tightly compressed. This has nothing to do with Nietzsche's later doctrine of eternal recurrence, nor is it merely the tragedy of the individual that can never be reproduced. The opposites seem reconciled on a higher plane; the life image seems shadowed by death, while the death image stirs with renewed life. *The Solitary Tree* (plate 29) appears in the light of morning—yet the topmost branches that extend so far toward heaven are already dying, though autumn is still a long time away. The tree stump on the right and the ruin in the middle distance speak of life gone by. In *Moonrise by the Sea* (plate 30), by contrast, the reappearance of the heavenly body lights the night and the sea, and a new cycle begins. In place of the impossibly remote mountain range behind the lone tree, we now find large stone shapes in the foreground, shielding viewers from the play of the waves.

Monk by the Sea (plate 7) is a night piece, but above the wintry *Abbey in the Oak Forest* (plate 8) it still appears to be day. The monk facing the vastness of the sea and sky can only be contemplating the awesomeness of death, while the procession of monks carrying one of their own to his last rest beneath a crucifix in the abbey can only symbolize their faith in resurrection.

Which of these contrasting pictures belongs more to the realm of life and which to death? It is difficult to decide. The oak trees can be read either way, as can the sea or the moon. The monk is waiting for morning; the three city dwellers in *Moonrise by the Sea* are watching for approaching ships at the onset of night. In each phase nature is unmistakably involved with death, and yet isolated signs of hope have been planted for the knowing eye; everything is full of expectation. In Friedrich death never appears in the harmless guise favored by late Romantics; one does not find him playing the bell ringer's friend, as in Alfred Rethel. Friedrich knew him better. For him death was the very gateway to existence.

Friedrich's Modernity

Friedrich created his landscapes in his studio. At one point his friend Carus provided a description of his working method, but his observations may not be reliable. Friedrich clearly did not want anyone to know how he produced his works. It was not for nothing that he isolated himself, wishing to be alone, and "would often brood over his creations for hours at a time," as Carus relates. His wife reported that "on days when he painted the sky no one was permitted to speak to him."

Friedrich worked very slowly, apparently painfully so at times. It was essential that his ideas and emotions be perfectly attuned to each other. Everything was meant to seem free and spontaneous; no one was supposed to notice how much effort it cost him to create such calculated and meticulously executed

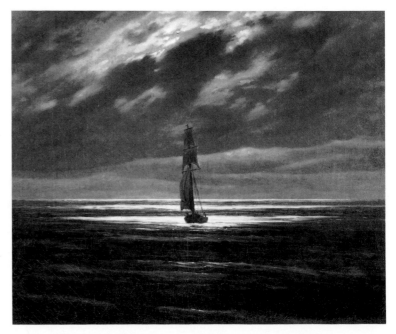

Fig. 46. **Moonlight on the Sea (Seascape by Moonlight).** c. 1830–35. Oil on canvas, 9⅞ × 12¼″ (25 × 31 cm). Museum der Bildenden Künste, Leipzig (B-S 393)

paintings. Their most diverse elements needed to blend into a harmonious, organic unity. The finished picture, generated out of the enthusiasm of the artist's heart and refined by his critical judgment, had once more to speak directly to the heart.

Space in Friedrich's paintings is no longer the familiar space employed by landscape painters of the eighteenth century. The traditional method for leading one's gaze step-by-step into the depth of a picture through classical perspective no longer applies. That earlier space has been distorted, exploded, demolished, and a new spatial sense has taken its place. Space has become foreign to us, often threatening and disturbingly unfamiliar as in *Monk by the Sea* or soothingly expansive as in the Bohemian landscapes painted a short time later. Friedrich sought to articulate the sense of space in his pictures by breaking it down into separate planes and stacking them one behind the other. To understand what this means, imagine looking through two, three, or even more vertical panes of glass placed before you at intervals. On the first pane the forms of the foreground are presented, on the last the line of the horizon. Often there is no middle pane, and once the eye leaves the familiar foreground it is suddenly confronted with a depth of seemingly limitless vastness. Even when there are intermediate pictorial planes between the foreground and the horizon, one is forced to lurch from one to the next. Each spatial layer stands alone, unrelated to any other. There are no diagonals leading from one to the next; no narrowing pathway serves to connect them. The spatial continuum is shattered. As a rule Friedrich's pictures are also open to the side: the limitless landscape extends to the right and left as well. One's gaze has nothing to hold on to. Often enough the things such as trees and boulders that served to frame his earlier pictures are now the actual subject matter, and are placed in the center.

There is also another factor, one that serves both to expand the visible space and confuse the viewer. The vantage points of the various picture planes are generally at different heights. In pictures of the Riesengebirge the horizon plane and the one placed immediately before it appear to be seen from above; we can see further than would be possible in reality. Even a picture at first glance so charming and serene as *Chalk Cliffs on Rügen* (plate 17) contains just such a distortion of point of view with an elevated horizon. The sea appears to rise up higher between the cliffs than would be expected given the viewer's position— if indeed there were such a vantage point. Friedrich thus creates a vertiginous space that presses our gaze downward into the depth of the crevasse—and reinforces this effect by providing a figure who seems almost to be falling into the abyss.

The incongruity of the individual picture planes with their uncertain perspectives robs the viewer of a fixed point of view. This is apparent even in works consisting of a single plane. Just where are we supposed to be standing while viewing the *Tetschen Altarpiece,* for example (plate 5), or *Morning Mist in*

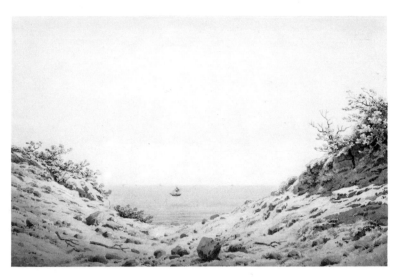

Fig. 47. **Dunes (View of the Sea through a Hollow in the Shore).** 1824–25. Pencil and watercolor, 9¾×14⅜″ (24.7×36.5 cm). Kupferstichkabinett und Sammlung der Zeichnungen, Staatliche Museen, Berlin (B-S 324)

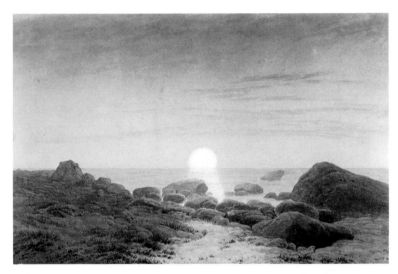

Fig. 48. **Seashore with Rising Moon.** c. 1835–37. Pencil and sepia, 9⅛×14″ (23.2×35.7 cm). Kupferstichkabinett, Dresden (B-S 484)

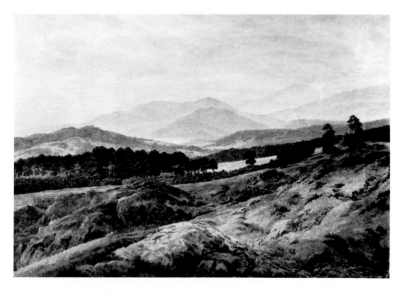

Fig. 49. **Landscape in the Riesengebirge (Mountain Landscape from Bohemia).** c. 1835 (unfinished). Oil on canvas, 28½×40½″ (72.5×103 cm). Nasjonalgalleriet, Oslo (B-S 419) Nasjonalgalleriet, Oslo (B-S 419)

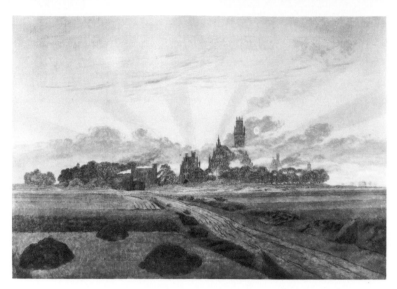

Fig. 50. **Sunrise near Neubrandenburg (Neubrandenburg Burning).**
c. 1835 (unfinished). Oil on canvas, 28½×40½″ (72.2×101.3 cm).
Kunsthalle, Hamburg (B-S 427)

the Mountains (plate 6)? Are we somehow hovering in space?
Friedrich has still another way of avoiding a fixed vantage point.
His foregrounds are often so dark and undifferentiated that it is
possible only very rarely to sense one is standing on firm
ground and to feel, as in earlier painting, in familiar surround-
ings. Forms in the foreground, outlined with reed pen and ink,
frequently blend in completely with the brownish underpaint-
ing, over which he has laid only a few thin layers of wash. Thus
even nearby objects seem obscure, and the security of a firm
point of view is denied us. This is especially apparent in the
misty foreground of *Abbey in the Oak Forest* (plate 8), in the stony
strip of shore in *Two Men by the Sea at Moonrise,* and on the rocky

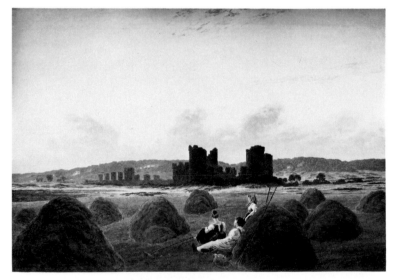

Fig. 51. **Hayers at Rest.** 1834–35 (unfinished). Oil on canvas,
28½×40⅛″ (72.5×102 cm). Whereabouts unknown since 1945.
Formerly Gemäldegalerie, Dresden (B-S 426)

path in *Two Men Contemplating the Moon* (plate 19). The gloom of
the foreground forces our gaze into the center of the picture yet
remains as a barrier.

Objects are isolated just as are the various spatial planes.
Friedrich produced hundreds of sketches of specific elements in
nature that caught his eye, studying them for hours, absorbing
them into his consciousness, attentively and humbly noting
their every detail: an anchor, rigging, a cottage roof, shrubbery
and fences, an oak tree, a church ruin, fragments of landscape,
one line of hills with another behind it, the course of a brook, a
small bridge, a path. Some he rendered only in outline; others
have shading indicating the precise disposition of light on build-
ings, the slope of a hill, a sailboat, the shape of a boulder. Much
is only fragmentary, but every particular is registered with an
appreciation of its individuality, its unique character. Almost
always he notes the date, sometimes even the time elapsed.

Back in his studio, certain of these isolated forms from his
studies would coalesce into a picture, arrange themselves in
separate planes, calling for other forms or eliminating them
again. In this way motifs recorded in different years and the
most remote locations can come together in a single painting.
The ruins of Eldena Abbey are transported to the Riesen-
gebirge; a Baltic fisherman finds himself on a pond in the morn-
ing fog in the Harz Mountains; trees observed in the vicinity of
Neubrandenburg end up growing in a Bohemian landscape.
Although Friedrich drew on his supply of motifs with utter
sovereignty and freedom, combining them according to their
inner resonances or his own intuition, he would transfer them
from his sketches with absolute, painstaking fidelity. It is
extremely rare to find him, owing to the demands of a compo-
sition, omitting a sail from the original sketch or lengthening a
tree branch.

Yet in addition to his fidelity to detail he also abstracts from
it: if we look more closely at his foregrounds, generally held
together by a uniformly dark tonality, it is often impossible to
determine what objects are actually depicted in them, or
whether there are in fact any objects at all. The various forms
blend into each other. Those close to us are as indistinct as the
ones on the horizon. Even in his details Friedrich is more likely
to leave us in uncertainty than to provide clear definition.

The same outlines that fixed given objects in his sketches
serve to describe them in his paintings, placing them in specif-
ic planes and giving those planes a form that distinguishes them
from other, more remote ones and contrasts with them. Johan
Christian Clausen Dahl, the painter who unlike the dilettante
Carus lived close to Friedrich for many years and knew his work
very well, described those outlines as "silhouettes like those on
Grecian urns." In Friedrich's paintings all objects become flat
and two-dimensional. They are characterized by a remote,
impalpable, and incomprehensible reality like the one recorded
in our own day by Alberto Giacometti.

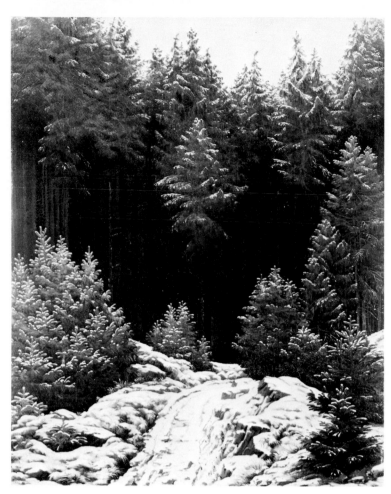

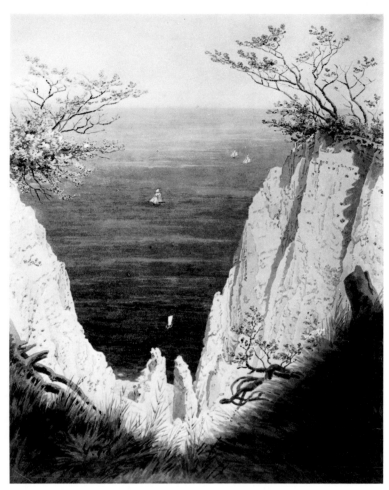

Fig. 52. **Early Snow (Fir Forest in Winter).** c. 1828. Oil on canvas, 17¼ × 13½" (43.8 × 34.5 cm). Kunsthalle, Hamburg (B-S 363)

Fig. 53. **Chalk Cliffs on Rügen.** c. 1837. Pencil and watercolor, 12½ × 9⅞" (31.7 × 25.2 cm). Museum der Bildenden Künste, Leipzig (B-S 490)

Line isolates objects and stresses contrasts. When these become too extreme and threaten to destroy the picture's cohesiveness, Friedrich softens them by means of color, relating them to each other with uniform tonal values. Line separates; color binds, reconciles, creates transitions. But color does not lift objects out of their separate planes, nor does it make them any more three-dimensional. In place of plasticity, Friedrich relies on formal similarities, symmetries, complex correspondences. For the classic spatial continuum he substitutes a compositional pattern. In an extended analysis of Friedrich's concept of form, Börsch-Supan has described this as follows:

His refusal to reproduce the landscape as an organic whole and his desire to depict individual objects in isolation threaten the integrity of the picture. Friedrich met that threat by employing distinct compositional figures that serve to tie isolated objects together after all, and help to define his open spaces. Doubly effective, these figures establish a relationship between objects and empty space, and thereby assume the mediating function of continuous relief features and a three-dimensional atmosphere. An abstract form thus replaces something concrete. The cohesion of the work of art is created by a pattern that is not present in reality, one that serves a more important function than it did in earlier prospect painting, where cohesion is already provided by the landscape motif and composition is simply a matter of selecting a point of view and rearranging, adding, or omitting details.

Because of its synthetic character, Friedrich's landscape composition is more closely linked to that of idealized landscape painting. What distinguishes it from that genre is the formal value of the composition itself. Idealized landscapes from the seventeenth and eighteenth centuries are also made up of separate motifs, to be sure, or "composed," but those elements are interrelated in such a way that the world depicted appears to be a self-contained whole. Individual motifs are incorporated organically into the overall composition. The composition appears to be established by the things themselves and can therefore manifest itself in them, which means that the world portrayed strikes us as harmonious. By contrast, in Friedrich's landscapes the compositional figure is presented undisguised as an invented structure imposed on the selected objects. Accordingly, the arrangement of the picture does not reflect an arrangement visible in nature; it is only the artist's invention, and therefore behind Friedrich's pictorial forms there lurks a certain doubt about the harmony of nature as it really is.

This is precisely what constitutes Friedrich's modernity. In Friedrich we encounter the autonomous individual of the early

Fig. 54. **Evening (Clouds).** 1824. Oil on pasteboard, 7⅞ × 10⅞" (20 × 27.5 cm). Kunsthalle, Mannheim (B-S 319)

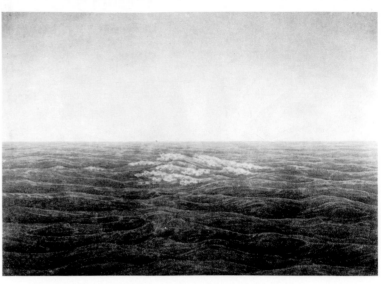

Fig. 55. **Sea with Rising Sun (The Morning of Creation).** 1826. Sepia and pencil, 7⅜ × 10½" (18.7 × 26.5 cm). Kunsthalle, Hamburg (B-S 338)

nineteenth century, answerable solely to himself and his own feeling, his own law, one who has outgrown earlier relationships and must redefine those that remain to him if he is not to succumb.

The old spatial continuum that permitted man to experience nature as a cosmos was no longer valid. That space—pieced together by Piero della Francesca or Hubert van Eyck, exalted in the ideal landscapes of Claude Lorrain or Nicolas Poussin, fashioned by the Netherlandish painters as a familiar world one might readily step into or possess—had begun to develop flaws. One could no longer rely on it. Soon it would be comprehensible only as a sense impression. In Turner and the Impressionists pictorial space simply dissolved into atmosphere; Cézanne, wishing to reassemble it more solidly than before, succeeded above all in disclosing its constituent elements, revealing the way it was constructed.

Friedrich also tried to construct, to create a new space. In so doing he began with objects, feeling that he could trust them, rely on them. To him separate objects, studied in long contemplation, painstakingly copied from nature, continued to be something absolute, unquestionable. Friedrich placed such objects in a void—then waited for them to create a surrounding space. In isolation, his objects took on added significance, became symbols. Space, however, continued to be only a matter of surfaces, as though objects were projected onto a transparent plane: it is as if each object brought with it its own space, and the rock in the foreground occupied a different layer of space from that of the tree behind it or of the line of mountains on the horizon. Friedrich's space was a spiritual, "inner" space, not the space of our sensual experience, but one of meditation. The strict regularity that Runge spoke of in connection with the mystics is what gave it form. The world of the visible,

grown suspect, was no longer the only conceivable world. It invited thinkers to propose other, more permanent worlds. A century before, Johann Jakob Bodmer had outlined the mission of the autonomous artist in his *Kritische Abhandlung von dem Wunderbaren in der Poesie* (1740): The "free imagination is not limited to the visible world … it can create its own possible worlds; thus it has both the actual world and possible ones at its disposal." Friedrich also was a creator of possible worlds, landscapes that he assembled according to an inner logic, in which he was able to articulate the experiences and anxieties of his age.

Friedrich found imitators but no successors. He quarreled with K. W. Lieber, a pupil Goethe had recommended to him, because he copied badly. In the works of Carus, Friedrich's motifs become merely sentimental, even banal. The paintings of Ernst Ferdinand Oehme from the 1820s, including one of a gloomy procession of monks through wisps of fog, reveal that the artist had not understood Friedrich at all; everything has been reduced to mere cliché. August Heinrich, who died young, was more independent and leaned more toward a sensitive realism incorporating features of painting of Friedrich's friend Dahl. One finds reminiscences of Friedrich's motifs in Julius von Leypold but no spiritual kinship.

Friedrich had created an altogether revolutionary pictorial form. It combined a multiperspective sense of space and a limited vocabulary of isolated objects arrayed in accordance with complex geometric figures, along with a metaphorical ambiguity conveyed in highly traditional, precisely rendered details. That combination was too personal, too idiosyncratic, too religious in its motivation to attract disciples who might have developed it further.

For all of these reasons, Friedrich's work had little influence and was long forgotten. Only in the twentieth century did it

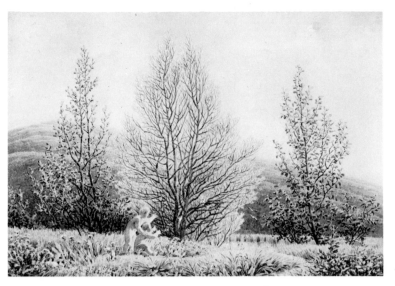

Fig. 56. **Spring.** 1826. Sepia and pencil, 7½×10¾″ (19.1×27.3 cm). Kunsthalle, Hamburg (B-S 339)

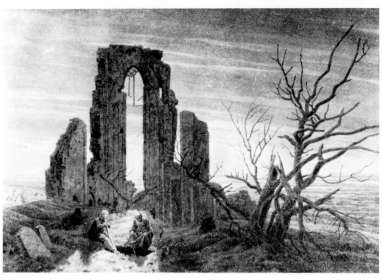

Fig. 59. **Winter (Churchyard by the Sea).** 1834. Sepia and pencil, 7½×10⅞″ (19.2×27.5 cm). Kunsthalle, Hamburg (B-S 432)

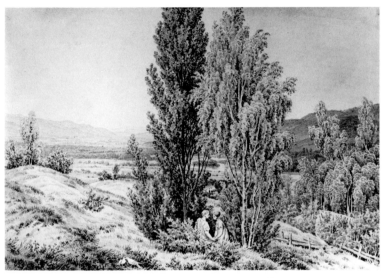

Fig. 57. **Summer.** 1826. Sepia and pencil, 7½×10⅝″ (19×27.1 cm). Kunsthalle, Hamburg (B-S 340)

Fig. 60. **Skeletons in Dripstone Cave (Death).** 1834. Sepia and pencil, 7⅜×10⅞″ (18.8×27.5 cm). Kunsthalle, Hamburg (B-S 433)

Fig. 58. **Autumn (Mountain Landscape).** 1834. Sepia and pencil, 7½×10¾″ (19.1×27.5 cm). Kunsthalle, Hamburg (B-S 431)

Fig. 61. **Worshipping Angels (Resurrection).** 1834. Sepia and pencil, 7½×10½″ (18.5×26.7 cm). Kunsthalle, Hamburg (B-S 434)

Fig. 62. **View of the Riesengebirge across Meadows.** c. 1837–40. Pencil and watercolor, 5½×8″ (13.8×20.5 cm). Museum der Bildenden Künste, Leipzig (B-S 503)

Fig. 63. **Landscape with Crumbling Wall (Gate in the Garden Wall).** c. 1837–38. Ink and watercolor, 4¾×7¼″ (12.2×18.5 cm). Kunsthalle, Hamburg (B-S 496)

become apparent that Friedrich had anticipated much of our modern experience of the world, and belatedly he was accepted—often mistakenly—as a precursor of various modern movements. Scholars have claimed him variously for naturalism, Symbolism, Impressionism, Expressionism, and the Neue Sachlichkeit. They have noted his faithfulness to detail, based solely on observation of nature, not artistic precedent. Many have pointed out the similarity between his paintings and the symbolic seascapes of Edvard Munch. Because of the (presumed) importance of atmosphere in his landscapes, he seemed for a time related to the Impressionists, yet his use of isolated figures in a limitless expanse evoked the sensibility of the Expressionists as well. His synthetic approach to composition made him attractive to the Magic Realists. Some have found in him precedent for the intimacy of Paul Klee, for the sailboat constructions and Central German churches of Lyonel

Feininger, or for the landscapes of Emil Nolde dominated by an overwhelming sky. However, parallels such as these have rarely shed any light on the essentials of Friedrich's art; they have to do only with its more or less peripheral features. To my mind there are more fundamental connections between Friedrich and two of the central currents of our century's art, namely abstraction and Surrealism.

We have already spoken of Goethe's enraged response to some of Friedrich's pictures that he felt might just as well be viewed upside down. Carus tells of visitors who actually did see some of them that way, mistaking the clouds for waves and the sea for sky. From contemporary reports we know that viewers often found it difficult to recognize nature in Friedrich's pictures and decipher it. Time and again they claimed to see nothing but emptiness, and not only in paintings like *Monk by the Sea* (plate 7) or *Riesengebirge Landscape* (plate 31). Karl Schnaase wrote in 1834 that in Friedrich's landscapes "nature was actually destroyed." Around 1880, when he was only vaguely remembered, it was said that he had lost his way "in abstract, formless ideas." Klaus Lankheit, in his 1950 essay "Early Romanticism and the Foundations of Non-Objective Painting," worked out a number of ways in which Wackenroder, Tieck, Novalis, Runge, and Friedrich contributed to the notion of an abstract art. He had in mind primarily the spontaneous abstraction, derived from the experience of landscape and inspired by music, that Kandinsky developed in a series of magnificent compositions and improvisations between 1910 and 1914. But with respect to Friedrich's compositional figures and the hidden geometry of his pictures, it is possible to find links to the constructivist side of abstract art, to the Kandinsky of the Bauhaus years as well as to de Stijl or to El Lissitzky. Finally, Robert Rosenblum found something of the numinous quality of Friedrich's empty landscapes in certain of the large abstract panels by painters of the New York School from the 1940s and 1950s, especially those of Mark Rothko.

Less often discussed, but just as important, are the connections between Friedrich and Surrealism. Max Ernst quoted Friedrich repeatedly. His concept of collage as the clash of two or more separate realities whose juxtaposition gives rise to the "spark of poetry" is reminiscent precisely of Friedrich's method, his startling confrontations of seemingly heterogeneous motifs. For that matter it evokes the fundamental principle of Romanticism in general, which according to a definition by Novalis sought "to give a higher meaning to the commonplace, to give to the quotidian the appearance of mystery, to the familiar the aura of the exotic, and to the finite the dimensions of the infinite." Max Ernst and Friedrich are also alike in their love of the forest, though they both painted it only seldom. Friedrich tended to paint individual trees or groups of trees, the forest appearing only as a distant backdrop in *Mountain Landscape with Rainbow* (plate 9), clothed in haze in *Morning Mist*

Fig. 64. **Cirques in the Riesengebirge (The Kynast).** c. 1837. Ink and watercolor wash, 10½ × 14⅛″ (26.6 × 35.9 cm). Wallraf-Richartz-Museum, Cologne (B-S 492)

in the Mountains (plate 6), as an impenetrable barrier in *Bohemian Landscape* (plate 11)—or as a "forest" of ships' masts in *Sisters on the Harbor Promenade* (plate 21) or of stalks in *Swans in the Reeds* (plate 20). Only very rarely does the forest actually surround the erring wanderer, as in *Chasseur in the Forest* (plate 14).

Yves Tanguy, whose studio was as utterly spare as was Friedrich's, reversed Friedrich's compositional principle. Rather than projecting actual objects into a void, he placed invented shapes in a landscape with wide horizons and high skies, in a space exhibiting rational and irrational features at the same time.

Most astonishing, however, are the parallels between Friedrich's work and the thinking of René Magritte. It is as though the Belgian had based his work directly on paintings like the twilight *Sisters on the Harbor Promenade* (plate 21) or *Hiker above the Sea of Mist* (fig. 22). His figures seen from the back,

generally a man wearing a homburg, served a similar function to the figures seen from the back in Friedrich. Like Friedrich, Magritte manipulated individual motifs as though they were interchangeable parts: they were the grammatical elements that gave rise to the syntax of the painting. What Max Ernst referred to as the "spark of poetry" was for Magritte the "inspired idea," that unique and inexplicable attraction that can develop between very different objects and turn their encounter into an altogether extraordinary event. Like Friedrich, Magritte did not paint moods or even create while in a specific mood, yet like him he understood how to engender precisely calculated moods with his pictures. In Magritte's pictures gravity appears to be suspended, proportions are confused, causality is rescinded, perspectives are distorted, solid objects deformed, windows made to seem opaque, and under a radiant blue midday sky it can be darkest night. Friedrich loved incongruities too,

and often combined an evening sky with the short shadows cast by the sun at midday, or transposed a ruin from the valley and placed it on a mountain peak. He justified his method as a personal idiosyncracy and preference, born out of his feeling for the picture. Beneath the harmony resulting from his intuitive juxtaposition there was still much that was disturbing. In *The Watzmann* (plate 33), for example, each of the few objects is rendered in a different and contradictory scale, so that we lose all sense of distance. Though the sky is blue and cloudless, the foreground appears in deep shadow while the rest of the landscape lies in full sunlight. In *Mountain Landscape with Rainbow* (plate 9) a wanderer stands transfixed in full daylight beneath a cloudy night sky. Viewing *Chalk Cliffs on Rügen* (plate 17), one is required to assume various different points of view and accommodate different perspectives. In many of the landscapes inspired by the Riesengebirge, as in *Chalk Cliffs on Rügen,* we are confronted with the phenomenon of a raised horizon. In the painting *Greifswald in Moonlight* (plate 15) what is near becomes distant, what is distant near: understood as relatively close by, the city silhouette is a vision; in the distance it is a reality.

Let these few examples suffice. From our vantage point it appears that many of the stylistic tricks employed by the Surrealists were anticipated in Friedrich. They were second nature for him, even though he used them sparingly and was far removed from the more radical claims of Surrealism. It is as though all the various trump cards that Magritte played so knowingly, delighting in his ability to shatter our complacency, were already hidden up Friedrich's sleeve. Only occasionally, just when we begin to think we know where we stand with him, does he permit us a fleeting glimpse of them.

Postscript

One further comment is necessary. In our attempt to interpret Friedrich's art in its contemporaneous context of Romanticism and indicate something of its connection to modern art, we have so far treated it as a whole, with no mention of his various periods. This is certainly justified, for in its fundamentals Friedrich's art remained constant for more than three decades—which makes it difficult to date some of his works. Yet one cannot deny that there are distinct developmental phases in his work. In his dissertation, Helmut Börsch-Supan identified these as follows:

Pre-1801: Early style; dominance of tradition.
1801–6: Preparation for a style of distinct contrasts; transition from the sentimental view to the composed landscape.
1806–16: Style of distinct contrasts; emphatic separation of foreground and background with no transition.
1816–20: Crisis in style; danger of becoming predictable. New emphasis on individual objects.
1820–30: Assimilative style; the picture space becomes more unified, with a greater wealth of individual motifs. The foreground leads toward a limitless depth.
Post-1830: Late style; expansion of the background.

Fig. 65. **The Nets.** c. 1830–35. Oil on canvas, 8½ × 11¼″ (21.5 × 30 cm).
The State Hermitage Museum, St. Petersburg (B-S 199)

BIOGRAPHICAL SKETCH

Caspar David Friedrich was born in Greifswald, in what was then called New Hither Pomerania, on September 5, 1774. From 1648 to 1815 (that is, from the Peace of Westphalia to the Congress of Vienna) New Hither Pomerania was ruled by Sweden, though Sweden imposed no particular burdens on the region. In 1815 it became Prussian, as had Old Hither Pomerania a century before.

Both of Friedrich's parents, Adolph Gottlieb Friedrich (1730–1809) and Sophie Dorothea née Bechly (1747–1781), came from Neubrandenburg (Mecklenburg-Strelitz). They married in Greifswald in 1765, where Adolph Gottlieb Friedrich had settled two years earlier as a candlemaker and soapmaker. The year he was married he acquired the house at Lange Strasse 18, near the Cathedral of St. Nikolai. The painter's ancestors on his mother's side were also craftsmen.

Caspar David was the sixth of ten children. Two of his siblings died in childhood, and a sister died of typhus at the age of twenty. His brother Johann Christoffer, a year younger than he, drowned before his eyes at the age of twelve. It was in December, and tradition has it that the two boys had set out in a small boat, which tipped over. Johann Christoffer died, as the church register at St. Nikolai attests, "trying to save his brother, who had fallen in the water."

Friedrich lived in Greifswald until he was twenty. At sixteen he became the pupil of Johann Gottfried Quistorp, an architect and teacher of drawing at the university, whose influence was decisive. Quistorp owned an impressive collection of paintings, drawings, engravings, and books, and he permitted the young Friedrich to study them and copy from them at will. He also introduced his pupil to the local landscape and its antiquities. They often walked out to Eldena, to Gützkow, or along the Ryk. Finally, it was Quistorp who first introduced him to the thinking and poetry of Gotthard Ludwig Kosegarten, a close friend. Kosegarten, a theologian and writer, had been since 1785 rector in nearby Wolgast and was from 1792 to his death in 1818 provost in Altenkirchen on Rügen. He was also a major influence on Philipp Otto Runge, who was born in Wolgast in 1777.

Quistorp encouraged Friedrich in his desire to become an artist. It was probably on his advice that Friedrich entered the Royal Academy of Art in Copenhagen in 1794, at the time the most liberal and advanced school of its kind and one in which tuition was free. Runge, Georg Friedrich Kersting, and Johan Christian Clausen Dahl would all attend the Copenhagen Academy, somewhat later. The standard course of study included drawing from plaster casts and from the nude. The two teachers who meant most to him were Nicolai Abraham Abildgaard and Jens Juel. Abildgaard, who had been introduced to Norse poetry and mythology by Johann Heinrich Füssli in Rome, was considered one of the founders of Danish classicism. He may have impressed Friedrich as the painter of *Ossian* and *Fingal,* for the younger artist had become acquainted with Ossianic lore through Kosegarten; however, his eclectic, pathos-laden mannerism left only slight traces in Friedrich's development. Friedrich would prove to be much more indebted to the landscape painter Jens Juel. Juel was capable of combining the charm of poetic, atmospheric moods with a studied and ordered, often symmetrical pictorial design; he was also fascinated by details of landscape, often using a single tree as the focus of a composition. Painting at the Copenhagen Academy was influenced by English landscape gardening at the time, and Friedrich's own visits to the many parks laid out in the English manner in the environs of the Danish residence supplied the motifs for his earliest landscape sketches, whose sentimental, elegiac tone was doubtless inspired by the mood of that landscaping style.

In the spring of 1798 Friedrich completed his studies in Copenhagen and returned to Greifswald. In October he went by way of Berlin to Dresden, there to settle, as Ernst Sigismund puts it, "in the proximity of superb art treasures and in lovely natural surroundings." In 1798 Dresden happened to be a center of early Romanticism, thanks to the presence of Novalis, Friedrich Schelling, Johann Gottlieb Fichte, the Schlegel brothers, and Henrik Steffens, but Friedrich had no contact with them. He frequently visited Dresden's painting galleries, finding much to inspire him, for example Jacob van Ruisdael's *Jewish Cemetery.* And he explored the surrounding countryside and studied its features, sketching mainly trees, leaves, boulders, and clouds. He hoped to earn a living painting views and panoramas and making pen-and-ink drawings and sepia sketches, adopting the idea of landscape as promoted at the Dresden Academy by Johann Christian Klengel and Adrian Zingg. For income he also produced a series of small engravings between 1800 and 1803. Friedrich was quite withdrawn; virtually his only connection to the Academy was his participation in its life drawing classes. He was first represented at its annual exhibition in 1799. In 1801 and 1802 Friedrich was back in Greifswald, where he was sought out by Runge. In 1802, in Dresden, he became acquainted with Ludwig Tieck, to whom Runge had recommended him. He regularly visited the island of Rügen, and under the influence of its gentle but grandiose landscape he produced drawings bearing his unique mark. Specific features recur with increasing frequency: the horizon line at Jasmunder Bodden, the foothills of Cape Arkona, the Stubbenkammer cliffs. In these months of constant drawing in his homeland he appears to have achieved a new self-assurance. He was now possessed of the elements from which he would develop his own idiom. In July 1802 he returned to Dresden.

His first notable success was his participation in the exhibition of the Weimar Kunstfreunde in 1805. Goethe awarded him half of the prize, amounting to 60 ducats, for his sepia drawings *Pilgrimage at Sunset* and *Autumn Evening,* even though they had nothing to do with the announced theme of the competition, "The Life of Hercules." He also saw to it that Friedrich's works were praised in the *Jenaische Allgemeine Literatur-Zeitung.* Goethe's relationship with Friedrich would be an ambivalent one. On a number of occasions he recognized the painter's achievements and recommended him as a model—"Perfection is so rare that one must value it even in its most unusual guises and take delight in it"—but as the years passed he increasingly distanced himself from Friedrich and criticized his work, until in 1815, in an outburst described by Sulpiz Boisserée, he threatened to smash the painter's pictures against the corner of his table, shouting, "That sort of thing should not be allowed."

Friedrich first became more widely known and controversial at Christmastime in 1808, when he held a public showing in his studio of his painting *The Crucifix in the Mountains (Tetschen Altarpiece)* (plate 5). Councillor Basilius von Ramdohr recognized quite clearly that the work represented a new direction in landscape painting. In his essay "Landscape Painting, Allegory, and Mysticism," published in January 1809, he forcefully condemned the work, while Friedrich's friends—Ferdinand Hartmann, Gerhard von Kügelgen, Christian August Semler, and Johann Rühle von Lilienstern—vigorously defended it. At a stroke Friedrich had attained notoriety. He was then in close touch with the Phoebus circle headed by Heinrich von Kleist and Adam Müller; however, the story that Kleist first read from his manuscript of *Die Hermannsschlacht* in Friedrich's studio is pure legend.

Several trips of importance for his later work fall into this period. In 1806, 1809, and again in 1815 Friedrich was in Greifswald. In the summer of 1806 he stayed for some time on Rügen, and on the way there and back he stayed with relatives in Neubrandenburg. In 1807 and 1808 he hiked through northern Bohemia, in July 1810 he explored the Riesengebirge with Kersting, and in June 1811, accompanied by the sculptor Gottlieb Christian Kühn, he made a hiking tour of the Harz Mountains. On his way home he paid a call on Goethe in Jena, responding to an invitation extended when the poet visited him in Dresden in September 1810.

It was not until about 1807, after he had perfected his sepia technique, that Friedrich first painted in oils. The *Tetschen Altarpiece* is one of his first works in the new medium. His *Monk by the Sea* (plate 7) and *Abbey in the Oak Forest* (plate 8), his largest paintings up to that time, were exhibited at the Berlin Academy in 1810, where they created an equal, or even greater, stir. At the urging of the crown prince the two works were purchased by the king of Prussia, and Friedrich was elected—with the narrowest possible majority vote of five to four—to membership in the Academy of Art. A short time later Kleist published his essay "Sensations on Viewing Friedrich's Seascape."

Friedrich enjoyed a similar success in the spring of 1814 at the exhibition celebrating the liberation of Dresden, where his pictures were the talk of the show. The paintings in question were his *Rocky Gorge (Grave of Arminius)* (fig. 15) and probably his *Chasseur in the Forest* (plate 14). In 1816, following the death of the landscape painter Zingg, Friedrich was appointed to the Dresden Academy with an annual salary of 150 thalers. It was not a teaching position, however. In 1824 he was named a part-time professor, and his salary was increased to 200 thalers. Yet when Klengel died in that same year, making room for a full professor and director of the landscape class, the authorities left the post vacant rather than give it to Friedrich. Ultimately Klengel's position was filled by Ludwig Richter. The official explanation was that though Friedrich had unquestionably reached a higher level of achievement, he owed his success more to intrinsic genius than to a thorough study of art; therefore he could hardly be expected to prescribe a strictly ordered course of study for potential pupils. Clearly Friedrich's politics had something to do with the decision as well. He had never made a secret of his sympathy for the liberal reformers, had stood up for men like Ernst Moritz Arndt, Joseph van Görres, and Baron von Stein, and had spoken out against censorship and the persecution of the so-called "demagogues" following the Karlsbad Decrees of 1819. In these years of restoration Friedrich was a man to avoid.

On January 21, 1818, Friedrich had married Caroline Bommer, a young woman from the neighborhood. The couple had three children: a daughter, Emma, was born in 1819, a second daughter, Agnes Adelheid, in 1823, and a son, Gustav Adolf, in 1824. In 1820 the family moved to a larger apartment a few houses away at An der Elbe 33. The Norwegian painter Johan Christian Clausen Dahl had arrived in Dresden in 1818, and in 1823 he moved into the same building. Like Dahl, Friedrich had a number of private pupils, among them August Heinrich and Christoph Wilhelm Bommer, his brother-in-law. It is not certain, but it appears that Ernst Ferdinand Oehme, Julius von Leypold, Georg Heinrich Crola, Albert Emil Kirchner, and Gustav Friedrich Papperitz actually studied with both men. Dahl became a lifelong friend of Friedrich's, as had the physician and painter Carl Gustav Carus, whom he met in 1817 and who can also be considered his pupil, though Carus later distanced himself from Friedrich at Goethe's urging. One can read about the break in Carus's *Letters on Landscape Painting,* which provides a good description of the impression Friedrich made on contemporaries:

He was then in his forties and at his most rigorous, physically and intellectually. Born on the Baltic coast, he was a typical North German, with blond hair and sideburns, craggy features, and a gaunt, bony frame. His pale face wore an uncommonly melancholy expression, his blue eyes hidden so far back beneath the prominent ridge of his brow and his bushy, blond eyebrows that they appeared to be constantly gauging light effects with the concentrated gaze of a painter.... His life was of a piece with his art, characterized by a strict integrity, rectitude, and reclusiveness.... One almost never met him in society ... he could almost always be found brooding over his work in his deeply shadowed room.

Carus relates that Friedrich's pictures were highly sought after at that time, and that he was frequently visited by both distinguished and less imposing lovers of art, whose ignorance he sometimes found annoying in the extreme. Among his visitors in this period were the heir to the Russian throne, later Tsar Nicholas I, the Russian poet Vasily Shukowski, Friedrich de la Motte-Fouqué, and even the Nazarene painter Peter Cornelius. A certain shift in the public response to him could also be seen in these years; tastes were changing, at first leaning more toward the concept of landscape promoted by Joseph Anton Koch in Rome and then to that of the increasingly popular Düsseldorf school.

In 1826 Friedrich suffered a major illness, necessitating a period of convalescence on Rügen. This was his final journey to his homeland, which he had last visited with his wife in 1818. In 1828 he traveled to Teplitz, probably to take the cure. Friedrich grew increasingly resigned and bitter. His "Observations on Viewing a Collection of Paintings," written about 1830, reveals this quite clearly. The Saxon Art Society, founded by the collector Johann Gottlieb von Quandt in 1828, bought a number of paintings from Friedrich in the 1830s—often at the urging of Carus, and Shukowski did what he could to promote him at the Russian court, but even so the painter increasingly found himself short of money. In 1835 he suffered a stroke, and a stay of six weeks at Teplitz brought only temporary recovery. Friedrich painted almost no oils after 1835; however he continued showing sepias, drawings, and watercolors in the annual art exhibition in Dresden until 1838.

"I visited our old Caspar David Friedrich," we read in a letter from Wilhelm von Kügelgen of March 1836. "I found him very ill; he has had a stroke and looks as though he could hardly survive another six months." Carus saw him as late as December 1839: "As for Friedrich, his life seems tolerable enough, though he is paralysed from his stroke and cannot work." Shukowski made a similar report after a visit in March 1840: "Went to see Friedrich. A sad ruin. He cries like a baby."

Friedrich died on May 7, 1840, in Dresden. He was buried on May 10 in Dresden's Trinity Cemetery.

FRIEDRICH ON ART AND ARTISTS

On Art and the Artistic Spirit: Comments by Caspar David Friedrich Recorded by Johan Christian Clausen Dahl

Beware of cold erudition, of sacrilegious hairsplitting, for it kills the heart, and no art can dwell where a man's heart and soul are dead.

Preserve a pure, childlike sensibility, and follow without question your own inner voice, for it is the divine in us, and does not lead us astray.

Think of each pure stirring of your soul as holy; consider holy every devout presentiment, for it is art in us! In an inspired moment it will take on a visible form, and that form is your picture.

No one should speculate in foreign currency and bury his own coin! You should trade only in what you recognize to be true and beautiful, noble and good in your soul.

Look with your own eyes, and re-create things faithfully, just as they appear to you; reproduce everything in your picture precisely as it affects you yourself!

Many are modestly blessed, a few richly. The spirit of nature manifests itself to each of us in a different way, and for that reason no one should impose his own theories and rules on anyone else as infallible laws. No one is the standard for all; everyone is a standard only unto himself and those souls more or less like him.

One's absolute standard is thus not another person; his object is the divine, the infinite. One must follow art, not the artist! Art is infinite, the skill and knowledge of all artists but finite.

To achieve beauty you must strive for the highest and most glorious.

You teachers of art, you who think so highly of yourselves with all of your skill and knowledge, must therefore take great care not to impose your theories and rules on everyone in tyrannical fashion; if you do, you could easily crush the most delicate flowers, destroy the temple of individuality, without which man can accomplish nothing great. You cannot construct anything better; no matter how much you think of yourselves, the individual in man reveals itself in its own fashion, to each in a different way according to his inner nature.

Art may be play, but it is serious play.

Observations on Viewing a Collection of Paintings, for the Most Part by Artists Still Living or Only Recently Deceased (1830)

The artist's feeling is his law. Pure sensation can never be contrary to nature, but only in accord with it. The feelings of someone else must never be imposed on us as law. Spiritual affinity may produce similar works, but such affinity is anything but simple mimicry.

Who seeks to know what is uniquely beautiful, and who can teach it? And who seeks to set limits and make rules for what is of a spiritual nature? O ye tedious, leathery prigs, forever thinking up rules! The mob will praise you for the crutches you provide, but anyone conscious of his own strength will scorn you.

Is the person gifted with a rich imagination fortunate or unfortunate? He is fortunate, for while the mob passes by indifferent and unfeeling, he is so filled with reverence and worship for the eternal that he could sink to his knees. Yet he is also unfortunate, for where others pass calmly by without suspecting a thing he feels shattered and depressed. He is receptive to all that is beautiful and good, but also tortured by everything ugly, disgusting, and vulgar, and thus he is in balance with other human beings.

Man stands equally close to God and to the Devil, and equally far from them. He is the highest and lowliest of creatures, the noblest and the most abject, the quintessence of all that is good and beautiful and of all that is abominable and accursed. He is the most sublime of all creatures, but also Creation's disgrace.

Art serves as a mediator between nature and man. The primal image is too great and too sublime for the mob to comprehend. Its likeness, being the work of man, is more readily accommodated by the weak, which probably explains the often-heard opinion that the copy is more pleasing than nature (reality) itself. Take the expression "It is as beautiful as a painting"; no one says of a painting that it is as beautiful as nature.

Or the tendency of so many people to force everything belonging to the realm of the spiritual, the infinite, whether in science or in art, into constricting forms. The philistines would prefer to curb every spontaneous upward leap of the soul, so that all might proceed along familiar and well-trodden paths. O ye wise ones, if only you would allow each aspiration to go its own way undisturbed, for even mistakes ultimately lead to something good. Every age has its good spirit and its bad; if only you could recognize the better one in the present and not, as many would prefer to do, hold up the past as an absolute standard for today. At most one might warn, but one must not thwart.

How great the number of those who call themselves artists without the slightest suspicion that this might entail something altogether different than mere manual dexterity. To many it is incomprehensible that art has to emerge from a person's inner being, that it has to do with one's morality, one's religion. For just as only a pure, unclouded mirror can reflect a true image, so a genuine work of art can emerge only from a pure soul.

What appeals to us in old pictures is primarily their devout naïveté. Yet it is not for us to become naive, as many have, and mimic their mistakes, but rather to become devout, and imitate their virtues.

The noble man (or painter) perceives God in everything; the common man (or painter) sees but the form, not the spirit.

Like many others, he only has eyes to see mistakes, not to recognize what is beautiful. This is a trait of most connoisseurs, and many of these gentlemen do not even see the beauties they extol or the mistakes they criticize.

Art might be compared to a child, science to a grown man.

The single true source of art is the heart, the speech of a pure and childlike spirit. Any work that has not issued from this source can only be artifice. Every true work of art is conceived in a sacred hour and born in an auspicious one, often unknown to the artist, out of the inner urging of his heart.

The majority do things the way their grandfathers and grandmothers did before them, not the way nature constantly admonishes us to and the way a modicum of healthy human reason would require after a little reflection. Foreground dark, background light! Whether that can be, whether it is possible, is not our affair. That is the way it is in old paintings, and that's the end of it.

Close your physical eye so that you see your picture with your mind's eye. Then bring to light what you have seen in the dark, so that it can affect others.

One often finds pictures undertaken and completed by the hand, with no picture in the mind. Then, and only then, are the rules of art of any use, and they do wonders, for with great effort they manage to create from nothing—nothing.

Painters practice invention, composition as they call it. Isn't that only another way of saying that they practice patching and mending? A picture must not be invented, but felt.

Observe form precisely, the tiniest as well as the largest, and make no separation between the small and the large—but do of course keep anything trivial from the whole.

From looking at pictures, art critics have drawn up rules that the artists themselves doubtless didn't even think of, and they are convinced that one can create pictures from such froth. The fools!

If the painter knows only how to imitate dead nature, or more precisely, can produce only a dead imitation of nature, then he is little more than a trained ape, or let us say a milliner; the milliner adorns the countess, the painter the rooms of the count, that is the only difference.

Art is not a matter of solving difficult problems; that is simply cleverness.

A desire to express themselves in contradictions is common among painters; they call it contrast. Crooked as opposed to straight, cold as opposed to warm, light against dark, such are the neat little crutches on which wretchedness limps along.

If you wish to know what beauty is, ask the aestheticians. It will be useful to you over the tea table, but not in front of your easel; there you have to feel what beauty is.

Is it really a service to art when our academicians of the fine arts take pains to force wretchedness up to the level of mediocrity? I don't think so.

There are people who paint beautifully just as there are people who write beautifully. One judges the latter according to their well-formed letters, regardless of what they mean. But the value of the former is very slight if nothing more than painting beautifully is involved.

Some things cannot be taught, cannot be learned and mastered by sheer dull practice, for what one might call the truly spiritual dimension of art lies beyond the narrow boundaries of craft.

Certainly it is an honor to have a large public. But it is surely a much greater honor to have a small but discerning public.

In this picture things are expressed through color and form that language cannot capture.

What we think of as a virtue in the hands of a genius is more often a vice in the hands of a clod.

Why is this picture so large when the subject is so trivial, or rather the idea of it so trivial?

If you can, then make machines that have human intelligence and demonstrate it, but do not make men that resemble machines, with no will of their own and no drive.

This picture is large, but there is no grandeur in it.

Every picture is more or less a character study of the person who painted it; for that matter a person's inner spiritual and moral self is expressed in virtually everything he does. But the more clearly and decisively and harmoniously all that one does and creates is of a piece, the more genuine, the more decisive one is, whether good or bad.

I have seen many pictures today. Most smell of the factory, many of the academy, and only a very few, at best, could be called the creations of individuals.

It seems to me that the painter has interpreted this subject incorrectly; instead of portraying Joseph's chastity he concentrates on the lasciviousness of Potiphar.

To my thinking the great expenditure of color in so many of these pictures is a reflection of our time. Everyone wants to be recognized at all costs, to outdo everyone else.

Here is another picture like so many one sees here and everywhere, neither thought out nor felt nor experienced: everything neatly done according to the rules, which may be the best thing for dullards. Such people want laws for all and everything, in art as well as in science, so as to be relieved of any independent thought, feeling, and experience.

But how in the world is it possible that X should accept the criticism and scorn that is now accorded to his achievements with such seeming equanimity, with no response? Those who knew him before are aware how he used to accept the praise so liberally heaped upon him in various public journals with the same indifference as he now does the criticism, and yet doubtless knows himself that his current achievements are worth more than his earlier works. Is it any wonder then, or does one need any further explanation of his behavior?

X was considered an artist when he wasn't yet one at all. Now that he is one, he is no longer counted. At one time he meant something to others, now he means something to himself. Many would prefer his earlier position, few his present one.

The painter should not merely paint what he sees before him, but also what he sees inside himself. If he sees nothing inside, he should refrain from painting what he sees in front of him. Otherwise his pictures will have no life. This Mr. X hasn't seen a thing that anyone who isn't totally blind can't see as well, yet one requires of an artist that he should see more.

This painter knows what he is doing and that one feels what he is doing; if only one could combine them!

Anyone who foolishly maintains that anything in nature is unworthy of the fine arts doubtless deserves no notice, and yet our art critics have continued to do so only recently. Indeed anything in nature can become the subject of art if properly and worthily and sensibly perceived. And though it may not have been so perceived by any painter heretofore, that does not mean that it will not be in the future.

FRIEDRICH IN THE EYES OF HIS CONTEMPORARIES

Philipp Otto Runge:

The young Friedrich from Greifswald is here, a landscape painter who has exhibited a couple of views of Stubbenkammer, drawn in sepia and in a considerable format, very beautifully lighted, composed, and executed; everyone admires them, and they deserve it. I thought of buying them from him as an experiment and sending them to you, but it seems that he has sold one of them to Herr von Racknitz and promised the other to someone else; but he has now finished a view of the Rugard toward Jasmund, the Prora, and a great stretch of sea that is far richer and more beautiful. For thirty thalers apiece I have bought that one and another from there toward Putbus, all of Mönchgut, in the background the Pomeranian coast (also the towers of Greifswald and Wolgast), which he has yet to do, the first rendered as Morning, the second as Evening. I will bring them to Leipzig with me, they will give you a great deal of enjoyment.

April 6, 1803

Ludwig Tieck:

This truly marvelous spirit has made a strong impression on me, even though there is much about him that I don't understand. In sensitive landscapes he tries to express the religious impulse that oddly enough again appears to be enlivening our German world of late, evoking a solemn melancholy. His efforts are attracting many friends and admirers and, what is even more to be expected, many opponents. Historical paintings have often wholly disintegrated into symbolism or allegory, many religious paintings even more, and landscape seems better suited to evoke a contemplative musing, a sense of well-being or delight in the reality depicted, which is automatically associated with a pleasant longing and reverie. Friedrich, however, attempts to evoke a specific feeling, a real insight, with definite ideas and concepts that are absorbed in that melancholy and solemnity and become one with it. Thus he attempts to introduce through light and shade life and death into nature, snow, and water, likewise allegory and symbolism in the staffage, indeed to some extent to elevate landscape, which has always struck us as such a vague reproach, as dream and caprice, above history and legend by means of the specific clarity of his concepts and the deliberate intent of his vision. This attempt is new, and it is amazing how much he has achieved with the simplest of means on more than one occasion.

June 19, 1803 (*A Summer Journey,* 1834)

Johann Jakob Rühle von Lilienstern:

Friedrich, the landscape painter, an altogether Nordic-Ossianic spirit, grew up in its icy air and on the Baltic coast with its looming chalk cliffs washed by an inky surf; everything that he is, is his own doing, and the result of attentive study of his beloved homeland; hence with firm conviction and faith in his own powers, aloof from all artificiality and academic prejudice, he has set about blazing a new, original trail for himself.

1809

Johann Wolfgang von Goethe:

Shortly after Runge, another artist, named Friedrich, also a native of Pomerania and living in Dresden, made an honored name for himself with remarkably fine watercolor landscapes in which he sought to suggest mystical-religious concepts, in part through the landscape itself, in part by the figures he placed in it. As in the work of Runge, much that is abnormal, even ugly, is presented for the sake of meaning. Accordingly, Friedrich too experienced a great deal of opposition from people who either failed to grasp his intended allegories or disapproved of them. Yet everyone had to concede that he was capable of portraying the character of many objects, for example various types of trees, decaying buildings and such, with the most conscientious diligence and accuracy.

This Friedrich is still the only one who has attempted to inject mystical-religious meaning into landscape paintings and drawings. He also differs from those who attempt something similar with figures in that he is concerned with copying nature directly, not the old masters. All of his compositions have the admirable merit of being thought out; however, since gloomy religious allegories are generally of little appeal, no matter how charmingly and beautifully portrayed, and since moreover he either does not understand the art of lighting or disdains it, using colors with no thought of softening them and harmonizing them, his clean bister drawings are more pleasing to the eye than his paintings, and because he neglects the rules of art Friedrich finds himself handicapped in the same way as everyone else with similar tastes, whatever their specialty.

Goethe (recorded by Heinrich Meyer), 1817
(*Über Kunst und Altertum*)

Vasily Andreyevich Shukowski:

Anyone who knows Friedrich's misty paintings and supposes on the basis of those pictures portraying nature only from its gloomy side that he is a pensive melancholic with a pallid face, with a look of poetic abandon in his eyes, is mistaken. No one meeting Friedrich in a crowd would find his face remarkable. He is a raw-boned man of medium height, blond, with blond brows hanging over his eyes; what is most striking in his face is his sincerity; not to mention his character; one is aware of his sincerity in everything he says. His speech is artless but spirited, and full of genuine feeling, especially when one touches on nature, his favorite subject, with which he stands on intimate terms; yet he speaks of nature in the same way that he portrays it, without rapture, but with originality; in his pictures as well there is nothing fanatical; on the contrary, what makes them appealing is their truth, for each of them awakens in the soul the memory of something familiar. If one discovers in them more than meets the eye it is because the painter does not see nature like an artist who is merely searching for something to paint, but rather like a man of sensitivity and imagination who finds in it, wherever he looks, a symbol of human existence. Friedrich troubles little enough with the rules of art; he paints his pictures not for connoisseurs of painting but for lovers of nature; the critics may find him wanting, but the best critic, one's unprejudiced instinct, is always on his side. He judges the paintings of others by the same standards; I have visited galleries with him on various occasions. When viewing many paintings he was unable to tell me the name of the artist, and he knows little of what is contained in textbooks on painting. Nonetheless, he could find in many pictures particular triumphs or defects that would be noticed only by a person versed in the textbook of nature.

June 23, 1821

Ludwig Richter:

By way of the spiritual concept of nature our conversation turned to Friedrich; it seems to me that Friedrich's way of looking at things leads to an error that could become quite epidemic in these times; most of his pictures exude a kind of unhealthy melancholy, a feverish charm that mightily affects every sensitive viewer but always elicits a feeling of desolation. That is not nature's importance, nor its character, nor its spirit and meaning; that is something forced upon it. Friedrich ties us to an abstract idea, only using natural forms allegorically, as signs and hieroglyphs intended to signify this or that. In nature, however, everything expresses nothing but itself, its spirit and its message are contained in every shape and color. A lovely natural scene evokes only a feeling, to be sure, not ideas, but it is a feeling so all-encompassing, so strong, so potent, so immense, that in its presence allegory withers and dies.... It is an unfortunate error of our time and an indication of its overextension, weakness, and infirmity that it has a predilection for gloomy, feverish images. (Byron, and in a more positive sense Friedrich.) They unsettle us, then suddenly break the thread and abandon us to our roused emotion.

Diary entry, Rome, January 30, 1825

Carl Töpfer:

In a painter like Friedrich even the errors are interesting—he can never drown in the mire of the ordinary, he can only keep climbing into regions that cause us to grow numb, though in the warmth of his enthusiasm he has remained untouched by the surrounding frost.... How significant, how utterly indispensable does a dead tree appear in the composition of a painting of death like the one we find in Friedrich's painting in Berlin [*Abbey in the Oak Forest*, plate 8]. Here it means something, it is a letter, one that in combination with its neighboring letters—snow, sunken tombstones, ruins, the procession of monks carrying a coffin—forms the terrifying word death; here the dead tree is a pillar supporting the entire structure, and one cannot imagine doing without it.

1826

David d'Angers:

This evening we called on the painter Friedrich. He opened the door himself. He is tall and gaunt. His eyes, beneath the shadow of thick eyebrows, are deeply circled. He led us into his studio: a small table, a bed that seems more like a bier, an empty easel—that is all. The walls of the room, painted a greenish tint, are utterly bare and plain; one looks in vain for a picture or a drawing. Only after long pleading did Friedrich pull out a few works, among them a picture of a solitary tree. It hasn't a single leaf; an owl is perched on one of its branches, and the diffuse light of the moon illuminates the background. No plot of earth in which the tree might be rooted. An almost dreamlike effect. We were eventually shown a considerable number of his pictures. They are never enlivened with figures. The painter is solely interested in the choice of landscape, the play of light, the overall effect. Friedrich's gift lies in the simplicity of his feeling and his line; his brush has something of the laconic pithiness of a great orator.

One often notes in Friedrich's features the kind of meditative expression that one associates with people occupied with great thoughts. His face wears a look of melancholy, benevolence, and shyness. It is clear that he controls his passions, which must have been violent, by means of will power. He is quite suggestible: when I asked him to put his name at the bottom of a drawing he had given me, one showing a grave at the edge of which the gravedigger has left his spade, on which sits an owl, with the moon illuminating the whole, he spilled a little ink on it. I could see that his first impulse was to tear the drawing in two; but he did nothing of the kind, for I assured him that one could think of the spot as a bird. He smiled with a childlike expression that one finds only in Germany's eminent men.

November 7, 1834

Gotthilf Heinrich von Schubert:

The still wilderness of the chalk uplands and oak forests of his native island of Rügen was his invariable, favorite retreat in summer, but even more in the stormy time of autumn and in the early spring, when the ice would break up on the sea along the coast. He stayed most often in Stubbenkammer, where at the time there was still no comfortable inn. Fishermen often watched with alarm as he would climb up and among the pinnacles of the rock face and its cliffs projecting out into the sea like someone determined to fling himself to a watery grave. When the wind was strongest and the foaming waves were at their height, he would stand there, soaked through by the flying spray or a sudden cloudburst, gaping like someone who cannot get his fill of such delectable visions. Whenever a storm swept across the sea with lightning and thunder, he would race toward it along the edge of the cliffs like one sworn to those forces, or follow it into the oak forest, where lightning would split the tallest tree, muttering softly to himself "how tremendous, how powerful, how glorious."

From his autobiography (1855)

Johan Christian Clausen Dahl:

Friedrich was not properly understood by his time, or at most by a very few. Most saw in him only a forced, unnatural mysticism. But that is not what he was about. Though his way of speaking was often somewhat abrupt, it was informed by a profound allegiance to nature and careful observation, conveyed in concepts that often bordered on the punctilious or vacuous. And not infrequently Friedrich appears to have overstepped the boundary between painting and poetry....

C. D. Friedrich was by no means fortune's child, and he fared much as the most profound natures often do; they are properly understood by a few and misunderstood by most. His time saw in his pictures forced ideas that were not true to nature. For that reason many people bought his pictures only as curiosities, or because, especially during the period of the wars of liberation, they sought—and found—in them a special, prophetic political meaning, so to speak: hints of an all-powerful, invisible hand that intervenes in the muddled destinies of men and would effect the liberation of Germany from the weight of the foreign yoke. Artists and connoisseurs saw in Friedrich only a kind of mystic; because they themselves were only looking for the mystical ... they failed to recognize Friedrich's sincere and conscientious study of nature in all that he portrayed. For Friedrich knew and felt very well that a person does not, and cannot, paint nature itself, but only his own impressions—which must however be genuine. Friedrich saw it in a tragic way that was certainly not forced, but exaggerated only with respect to what can be depicted in painting.

After 1840

Carl Gustav Carus:

His pictures were highly sought after at that time, and he received many visits by art lovers of more and less exalted station, during which there was no shortage of singular confrontations inasmuch as many of his works could not be understood at all by less imaginative souls. For example, the world-famous scholar Councillor Böttiger, with whom I frequently came in contact as well at the time, and about whose constant desire to please and "ubiquitous nature"—to use Goethe's expression—countless stories were circulated, once brought some aristocratic ladies to see him at the very moment when a new picture stood on his easel, an expansive, misty mountain landscape with a single eagle soaring in the sky. With a wink, the archeologist quickly placed himself before it, half turning away, and in eloquent phrases began explaining to the astonished viewers the beauty and deep significance of this *seascape,* until Friedrich, annoyed, finally pointed to the mountains and took the picture away. Other connoisseurs were occasionally guilty of placing one or another of Friedrich's sea paintings—often enough admittedly somewhat obscure, but in which the painter always had in mind some profoundly felt lighting effect typical of the Baltic—upside down on the easel, perceiving the dark clouds as waves and the sky as the sea, and so forth!

Recollections and Memoirs (1865–66)

Wilhelm von Kügelgen:

Pictures of that kind never existed before, and will hardly appear again, for Friedrich, like all true geniuses, was sui generis. It is a pity that one cannot describe works of art; one can only suggest something of their subject matter, and it was odd stuff that Friedrich painted.

If my father had not regularly referred to Friedrich the strangers who visited his studio and touted him wherever he could, the most important landscape painter of his time would have starved.

Friedrich's studio...was so utterly empty that Jean Paul might have compared it to the gutted corpse of a dead prince. There was nothing in it but his easel, a chair, and a table, over which hung, as the sole wall ornament, a lonely T-square, though no one could imagine why it was so honored. Even his paintbox, of all things, not to mention his bottles of oil and paint rags, was relegated to the adjoining room, for Friedrich was convinced that all external objects tended to disturb the essential serenity of the world in the picture....

My father, a brown-haired, clean-shaven man, was always dressed very properly, while the light blond Friedrich, with his beard like a Cossack's, was content to work in a long gray overcoat, which made one wonder whether he wore anything else underneath it; and those who knew him were aware that he didn't.

An Old Man's Recollections of His Youth (1870)

COLORPLATES

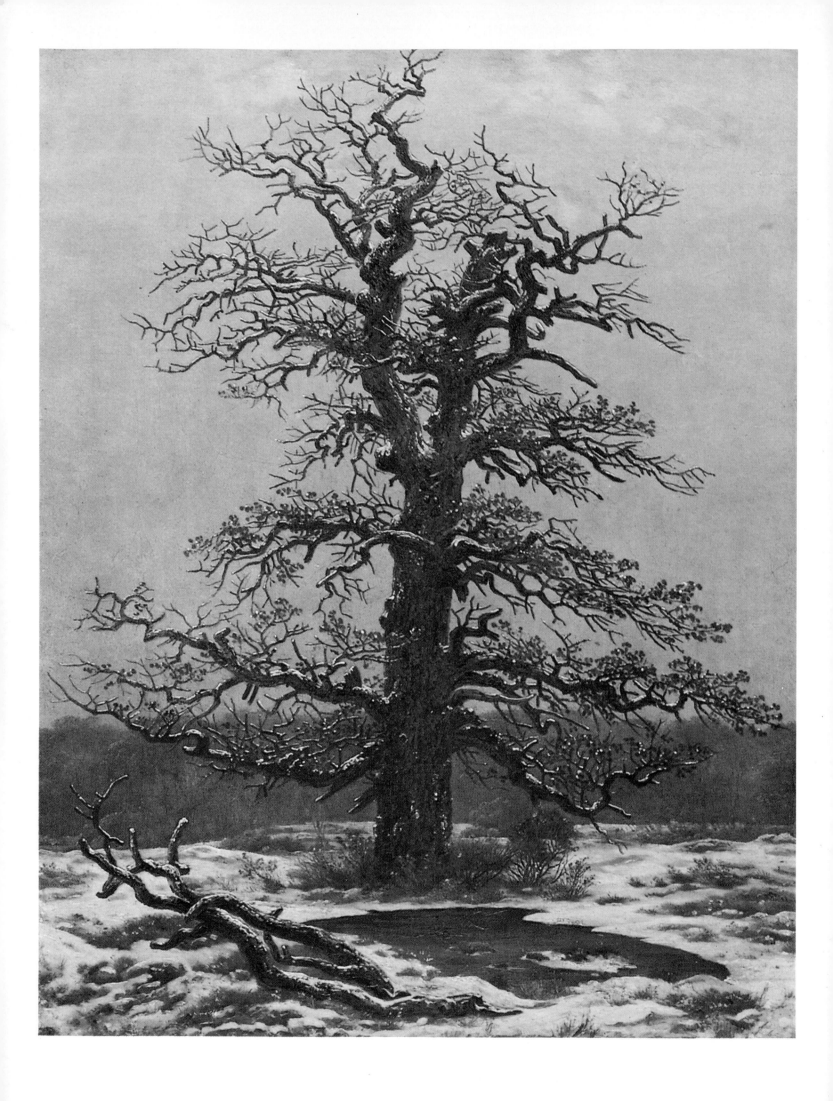

1. OAK IN THE SNOW

c. 1828. Oil on canvas, 17⅜ × 13⅜" (44 × 34.5 cm)
Wallraf-Richartz-Museum, Cologne (B-S 364)

In the years 1828–29 Caspar David Friedrich took up once again a motif that had long interested him, that of *The Solitary Tree* (1822, plate 29). His *Oak in the Snow,* now in Cologne, dates from about 1828, while *Oak Tree in the Snow* in the Nationalgalerie, Berlin, was painted somewhat later, about 1829. Both paintings present a single oak towering over the surrounding landscape. Both trees, like the one in *The Solitary Tree,* stand next to a pond and are dying at the top. Unlike the summer landscape of *The Solitary Tree,* however, the two pictures from 1828 and 1829 portray a wintry setting, shown in the dusk of late afternoon or early evening, rather than the clear light of morning.

One can encounter both of these oak trees repeatedly in Friedrich's work. Whenever the artist wished to include oak trees in his paintings and give them a characteristic form, he would refer back to the same nature drawings, executed primarily in 1806 and 1809 on hiking tours in Mecklenburg and Brandenburg. The tree in the Berlin *Oak Tree in the Snow,* for example, can be seen in one instance functioning as a watchman, standing guard, as it were, in *Cairn in the Snow* (plate 4). In the painting *Winter* (1808), it serves as a counterbalance to the ruins of a church. Finally, it appears as a framing architectural element next to the ruins of a Gothic cathedral in *Monastery Graveyard in the Snow* (fig. 21). The Cologne *Oak in the Snow,* reproduced here, is unquestionably the more imposing of the two trees, with longer and more richly articulated branches. It dominates the early sepia drawing *Cairn by the Sea* (1806–7). In the 1828 and 1829 paintings, the two oak trees have been freed from association with cairns, church ruins, and the graveyard and become the primary focus. They command our full attention.

The Cologne *Oak in the Snow* was rediscovered only in 1942, in a castle in Mecklenburg. There are no documents telling us how the work was received by the public of its day. We do have such records for the Berlin *Oak Tree in the Snow,* which was exhibited in Dresden in 1829 and in Berlin in 1832. The critics, all of them favorably disposed toward Friedrich, alternated between praise for his characteristically poetic atmosphere and sensitive painting and consternation at the severity with which the oak tree is presented against the winter sky, some wondering about the significance of its isolation in the midst of nature. The charge of excessive severity, raised by the Friedrich collector Carl Schildener concerning *Cairn in the Snow* as well, had been refuted long before by Johann Gottfried Quistorp, Friedrich's drawing teacher in Greifswald. Schildener quoted him in 1828:

Great oak trees like that are severe and rugged-looking by their very nature, especially without their leaves. So too is winter, with its mantle composed mainly of the most glaring and gloomiest of contrasting colors, black and white.... Anyone wishing to portray winter with real fidelity cannot render it softly, least of all in the foreground, where atmospheric perspective provides no haze.

The pond in front of the oak collects the runoff from the melting snow, which is dotted with tufts of brown grass. The water mirrors the dark sky and lowering clouds. Börsch-Supan asserts that with this "reflection of the heavens in the earthly sphere" and with the snow melting around an ancient oak, Friedrich meant to celebrate the triumph of Christianity over paganism, which may or may not be the case. If Friedrich did have some such message in mind, he certainly took care not to say so. Nothing was more remote from his method than reducing the impressive reality of an oak in the snow to a mere illustration for a catechism lesson.

Friedrich may have wished to simplify the motif in this composition, but by no means did he intend to reduce its meaning. In his pure landscapes especially, he was careful to preclude any rash allegorical interpretation, and to let the depiction speak for itself, leaving open as many readings as possible. In a picture like this, portraying a force as powerful as winter at its extreme—a turning point in the cycle of the seasons, and therefore having associations with the cycle of human existence—he would have recognized the need to be particularly cautious. It is often pointed out how economical Friedrich was as an artist; coupled with that frugality was his reticence in alluding to hidden levels of meaning in his portrayals of nature. Friedrich painted for like-minded souls, for initiates. As Max Beckmann said of his own pictures, they are meant "to speak only to people who consciously or unconsciously carry in themselves the same metaphysical code." ◈

2. GEORG FRIEDRICH KERSTING (1785–1847): CASPAR DAVID FRIEDRICH IN HIS STUDIO

1812. Oil on canvas, 20 × 15¾" (51 × 40 cm)
Staatliche Museen Preussischer Kulturbesitz, Nationalgalerie, Berlin

Georg Friedrich Kersting was one of Friedrich's Dresden friends. A full decade younger than Friedrich, he had studied under the same teachers at the Copenhagen Academy from 1805 to 1808, immediately before settling in Dresden. A native of Güstrow, in Mecklenburg, and therefore a countryman of Friedrich's, he soon got to know the older artist more intimately. In the summer of 1810 he accompanied Friedrich on his hiking tour of the Riesengebirge; he is thought to be the figure seen from the back in Friedrich's drawings and watercolors from that journey, always a few steps ahead of his friend, leaning on a fence or resting on a boulder. In 1818 Kersting was appointed director of the painting division of the porcelain factory in Meissen, yet his relationship with Friedrich, albeit less intense than before, continued for several years longer.

Some ten painted portraits of Friedrich are known. Along with the two by Caroline Bardua from 1811 and 1839, which document the triumph and decline of his extraordinary face, the three by Kersting are the most impressive. All three of the Kersting portraits show Friedrich in his studio. In the painting in the Kunsthalle, Hamburg, of 1811 he is seated in front of his easel, his arm resting on his maulstick, painting a mountain landscape with a waterfall—perhaps the companion picture, now lost, to *Morning in the Riesengebirge* (plate 12), which Friedrich exhibited together with the latter work in Weimar in late 1811. In the Berlin portrait of 1812, reproduced here, the painter stands in contemplation before his canvas, which has been turned away from us. The Mannheim portrait from 1819 is a copy of the one in Hamburg.

None of Kersting's other pictures are as restrained, as concentrated, or as spare as the ones in which he portrays his distinguished friend. It is as though in these works—which reproduce the monastic cell that was the painter's studio with absolute accuracy, just as it was described by a number of contemporaries—Friedrich's spirit had taken hold of the portraitist. The only anecdotal concession Kersting allowed himself is the cuspidor on the floor. It is present in all of the variants of the picture.

In 1811 Kersting submitted the first version, now in Hamburg, to the exhibition of the Dresden Academy, together with another study of a painter in his studio, his portrait of Gerhard von Kügelgen. Both works were very well received, and he was encouraged to make copies of them. The two artists' studios could not be more different. Kügelgen's "chaotic workroom," as his son Wilhelm describes it in his *An Old Man's Recollections of His Youth,* is filled with thousands of objects in a creative disarray, a collection of theatrical props that would find their way into his paintings. Friedrich's studio, in contrast, is "utterly empty."

Of Kersting's Friedrich portraits the one reproduced here is the most emphatic, the most uncompromising in its concentration and its realism. In the Hamburg portrait the viewer has just entered Friedrich's studio, while in the present one he is already standing in the middle of the room, so that his view is more restricted, the artist at his easel that much closer. At least the artist *seems* closer; in fact he remains quite unapproachable as he leans contemplatively on the back of the chair that stands between him and the easel—not to mention between him and the viewer—and carefully scrutinizes his painting. He appears to have withdrawn, and not only from his work in progress. In the Hamburg picture Friedrich is seated and painting. There is something intimate, even private about its glimpse of the artist in housecoat and slippers. Here, his stance and a chair leg prevent us from seeing just what he wears on his feet. The door that was visible in the Hamburg picture has disappeared, so that the room seems even more closed off, confining, almost impossible to enter. The most important change, however, is the position of the easel. Due to a slight twist, we can no longer see what picture it holds. We cannot see what Friedrich is working on, which picture he is pondering. The mystery tantalizes, for although there are no overt clues, the painting is turned toward the window, the clouds, the sky—and appears to reflect them toward the artist.

Friedrich worked in the studio shown here, on the edge of the suburb leading toward Pirna, until 1820. From two sepia drawings of 1805–6 (see fig. 1) we know that its windows, here partly shuttered, looked out on the Elbe. He installed the shutters, with which he could screen the whole window or at least its lower third, after 1806. When he moved a few houses away in the summer of 1820, from An der Elbe 26 to An der Elbe 33—he had meanwhile married, his first daughter had been born, and the old apartment had become too small—he took these wooden fittings with him and adapted them to the windows of his new studio, as we shall see in the picture *Woman at the Window* (1822, plate 28).

Kersting's picture shows us the painter Friedrich as he was and as he wished to be seen. The artist who created landscapes like abstractions does not look outside. His windows are closed. The only light in the room comes from the sky. The painter looks within; it is there that he sees his picture. Everything that might distract him has been removed. Only what he most requires for his work is permitted. The emptiness is suggestive of asceticism, meditation, vision. Kügelgen's recollection that "Even his paintbox, of all things, not to mention his bottles of oil and paint rags, was relegated to the adjoining room, for Friedrich was convinced that all external objects tended to disturb the essential serenity of the world in the picture" comes close to the real Friedrich.

In Kersting's portrait, the picture on the artist's easel has doubtless progressed to the point that he can lay his drawings aside and critically evaluate the whole. Kügelgen wondered why a drafting instrument hung as the "sole wall ornament" in the studio. "No one could imagine," he tells us, "why it was so honored." Kersting, ever the precise chronicler, included the ruler and triangle on the wall with good reason: they are part of the no-nonsense atmosphere of this studio and have to do with Friedrich's complicated way of working, for they were essential in the laying out of his compositions. What his contemporaries all too often thought of as mere mysticism was in large part mathematics. ◼

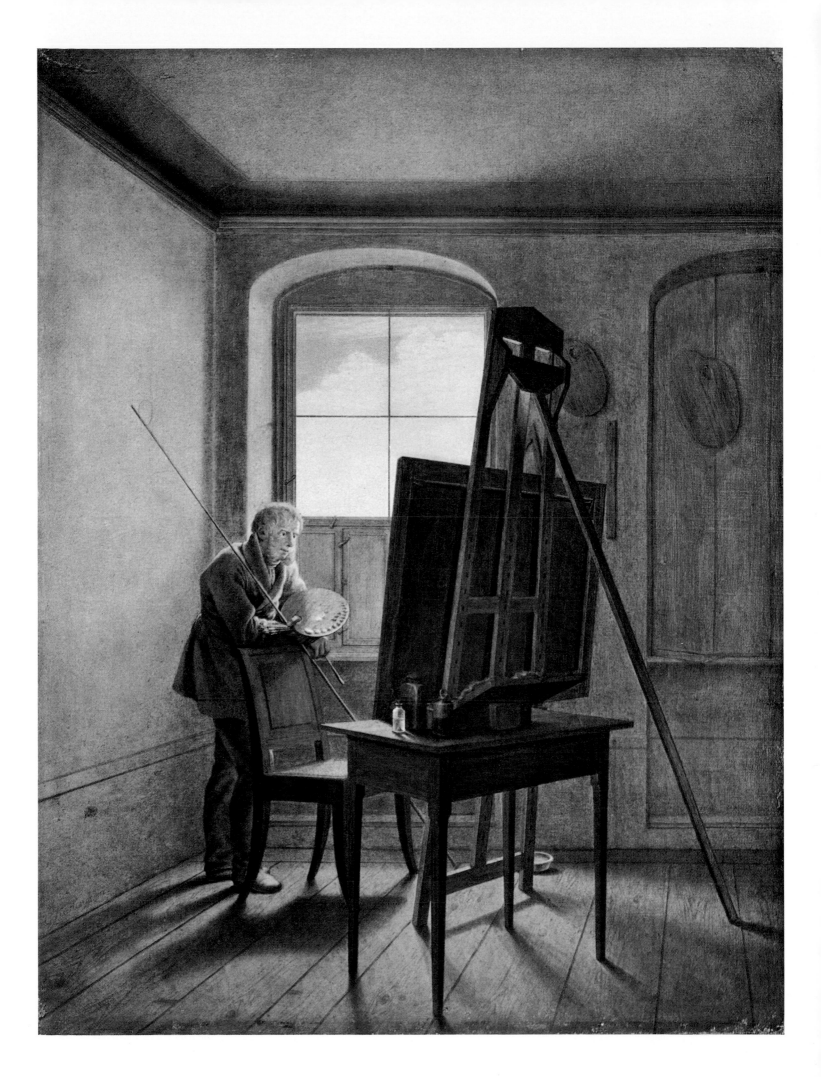

3. VIEW OF THE ELBE VALLEY

c. 1807. Oil on canvas, 21¼×31½" (61.5×80 cm)
Staatliche Kunstsammlungen, Gemäldegalerie, Dresden (B-S 163)

This is one of Friedrich's earliest oil paintings. In its composition, with a hill and grouping of trees in the foreground, a stream and mountains in the background, it is related to his *Summer* in the Neue Pinakothek in Munich, while in motif—the fir trees growing around and out of an outcropping of rock—it is similar to the *Tetschen Altarpiece* (plate 5), both of which paintings are known to have been produced in 1807–8. In its coloring it seems closer to the Munich painting, but in the manner in which the color is applied it is more like that of the *Tetschen Altarpiece*. Yet it is probably a mistake to interpret this view into the upper valley of the Elbe in summer merely as a preliminary stage of the *Tetschen Altarpiece*, for it was most likely intended as a counterpart to *Cairn in the Snow* (plate 4), which is identical in format. In contrasting firs and oaks he may have wished to suggest the difference between the Christian view of the world and the pagan one. Whatever his precise intentions with the work, there is no question but that in terms of technique, motif, composition, and coloring, *View of the Elbe Valley* belongs with Friedrich's early work.

Critics still disagree about the dating of the painting. As recently as 1970 Werner Sumowski assigned it to the period 1816–20, and the exhibition catalogue from the Kunsthalle, Hamburg, in 1974 dates it accordingly. To my mind, however, Helmut Börsch-Supan's argument for an early dating, put forward in his 1960 dissertation, seems altogether convincing: the clarity of the background, the river winding off into the distance, the imbalance between the two halves of the picture, the "precarious tilt of the firs on the left"—all of these features are more compatible with Friedrich's composition in his early style of 1807–8 than with the works of later years. Added to this is his tentative way of painting: a thin application of pigment, as in watercolor, and drawing traced with the tip of the brush. While Sumowski found this picture to be "eminently painterly," and therefore unrepresentative of Friedrich's style in 1807, Börsch-Supan sees in it a certain technical insecurity, which would indicate it was executed even before the Munich *Summer*. Also, if indeed it were a picture from the period 1816–20 one might expect to see the figures typical of that phase, a pair of wanderers or a figural grouping. Finally, all of the drawings used in the composition of this painting date from the years between 1799 and 1806–7, which certainly supports the earlier dating. Nonetheless, this is not decisive proof, for Friedrich would often rely on old sketches made years before.

A Berlin dentist bought the painting from a secondhand dealer in Leipzig in 1929 for 5 marks, as the work of an unknown master. Soon afterward it was acquired on the art market by the Gemäldegalerie, Dresden. It may be the painting sold at auction from the estate of the collector J. C. Lampe in Leipzig in 1819, described in the catalogue as follows: "On a hill, between two massive stones, a number of slender firs reach up toward the sky." But since the dimensions given (in inches) are not the same as those of the present painting, this identification is uncertain.

Karl Wilhelm Jähnig was the first to publish the picture as the work of Friedrich, in 1932, after it had come to Dresden. He found the landscape in the background reminiscent of a stretch of the Elbe in Bohemia, and it is true that Friedrich had trekked through northern Bohemia in the summers of 1807 and 1808. The studies for the rocks and the individual firs in the foreground were apparently made in the mountainous region known as Saxon Switzerland and in the environs of Dresden.

The outcropping and the firs are silhouetted by the panorama of the valley. They form an obstacle that the eye has to get past before it can look into the distance. Once it has, a definite leap is required, for the background opens immediately behind the barrier of the foreground, with no transition, no intervening objects, no middle zone. Nevertheless, the distant valley seems barred to us, accessible only to our gaze.

There is a route, however, that seems much more inviting, one leading not to the river below but into the underworld. The tumbled boulders form the entrance to a cave—they somehow suggest a tomb. Can it be that this is the way down into the paradisiacal valley? Is this the answer to the pagan *Cairn in the Snow*? Perhaps such an interpretation is too extreme. Yet the fact remains that in a picture of seemingly unencumbered summer serenity one cannot help but notice that Friedrich is reminded of death; he even pictures it in the small dying fir tree on the left above the precipice.

The boulders rise up in front of us like a monument, blocking our path, forcing us to stop. We have reached a boundary. Our gaze seeks a way past the stones, probes them, discovers the dark cave, recoils—only to be attracted by the group of ever taller fir trees and lifted upward, away from all that is close and familiar. The same theme would recur in much more radical form a short time later in the *Tetschen Altarpiece*. ▣

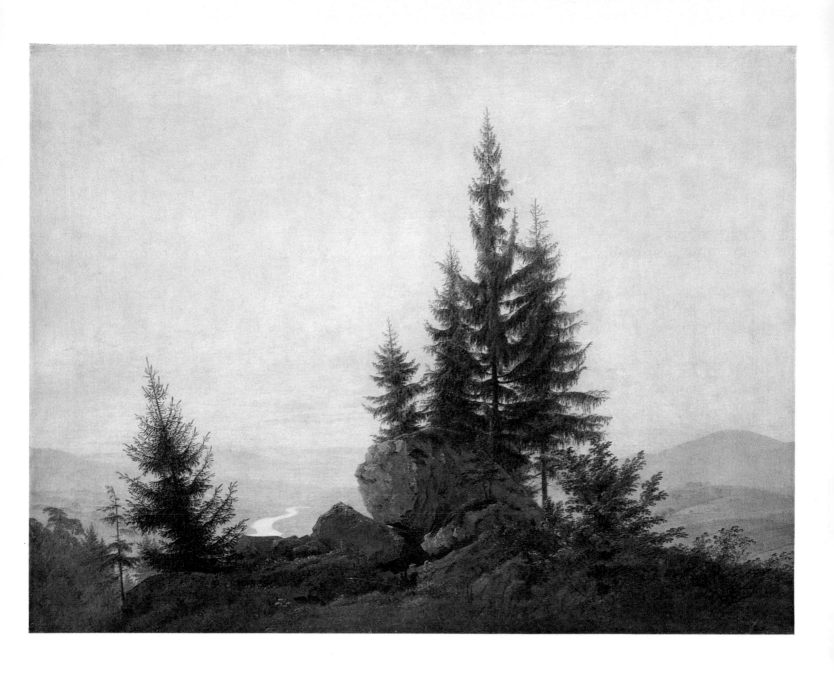

4. CAIRN IN THE SNOW

c. 1807. Oil on canvas, 21¼ × 31½" (61.5 × 80 cm)
Staatliche Kunstsammlungen, Gemäldegalerie, Dresden (B-S 162)

Like *View of the Elbe Valley* (plate 3), this work is one of Friedrich's earliest oils. A previous, less elaborate version of the composition is the sepia *Cairn by the Sea*.

Again and again in Friedrich one finds oak trees in conjunction with graves, as sentinels of the dead, guardians of a glorious past. The tree on the left in the present painting can be seen again in *Abbey in the Oak Forest* (plate 8), next to church ruins, while the one on the right towers over the ruined Eldena Abbey in the deathlike atmosphere of *Winter (Monk in the Snow)* (1808; destroyed in the fire at the Crystal Palace in Munich, 1931). The same tree appears again as the solitary *Oak Tree in the Snow* (1829; Nationalgalerie, Berlin), while the one standing to the right among the boulders in *Cairn by the Sea* was also portrayed around the same time with a pond in a variant of the Berlin picture, *Oak in the Snow* (plate 1). What is most surprising, however, is that we encounter the same two towering oak trees from *Cairn in the Snow* in a very different wintry burial scene, *Monastery Graveyard in the Snow* (1817–19, fig. 21). In the latter picture as well the trees play a dominant role in the composition, but their positions are there reversed; the left-hand tree is now on the right—and seen leaning to the right—while the right-hand one has been moved to the left, and it too, so vertical in the present picture, is made to lean, this time to the left, so as to complement the architectural forms of the ruins. The effect is remarkable. The sky in *Cairn in the Snow* is open (obstructed only by the center tree, curving away from the two foreground oaks). But once their positions are reversed, in *Monastery Graveyard in the Snow,* the branches of the same two trees form a protective roof over the masonry of the ruined choir.

We encounter the same oaks over and over in Friedrich's churchyards and next to his cairns, and in such pictures it is generally winter or late fall. The oaks have long histories: they have withstood wind and weather, been scarred by storms, and struck by lightning. They have a distinct character, and Friedrich always paints them with obvious respect for their individuality. By contrast, Friedrich's evergreens generally seem oddly timeless, untouched by storms and the changing of the seasons. Firs and spruces invoke silence, meditation. Perhaps Börsch-Supan is correct when he sees in *Cairn in the Snow* a counterpart to *View of the Elbe Valley,* which has the identical format and was painted at roughly the same time. Friedrich may have wished in a pair of pictures to confront oaks with firs, a cairn with an overgrown outcropping. And perhaps it is also true that with the oaks Friedrich intended to represent our pagan heritage and with the firs around the boulder an apotheosis of Christianity. If such was the case, it nonetheless seems to me that his sympathies were more strongly engaged—perhaps not consciously—by the pagan oaks.

In the present picture the motif of the oaks is combined with another motif of a distinctly "patriotic" character, the pagan cairn. In the years 1802–9, Friedrich repeatedly sketched such relics on his wanderings in his homeland, on the island of Rügen, and in the region to the south of Greifswald on the mainland, and he did so again as late as 1815. The alliance of the Saxon king with Napoléon in 1805 had been a great spiritual blow for Friedrich. His journey through his native Hither Pomerania in 1806 became for him a true "pilgrimage to the cairns," as Eva Reitharovà put it, or in the words of Tina Grütter, "a desperate search for symbols of a national identity." For nearly four weeks in Rügen, he drew its various prehistoric stone monuments. On some of his hikes he was accompanied by his friend and collector, Pastor Kosegarten, an Ossian enthusiast who was greatly drawn to the "heroes' mounds" of the cairns. As it happens, he selected an even earlier drawing as the basis for his picture *Cairn in the Snow,* which he painted in Dresden around 1807, after his trip to Rügen. It was a sketch made in 1802 of a cairn near Gützkow, southwest of Greifswald, one he had found with his old drawing teacher Quistorp. In that sketch Friedrich had included Quistorp as a tiny figure on top of the covering stone as an indication of the monument's vast size.

Cairn in the Snow is a picture of winter. Everything in it suggests death: the bare trees, the snow, the tomb, the ravens. Yet it is also possible to interpret these symbols in a different way—and to my mind that is the hidden meaning of the picture. The trees have not died; they will be green again and bear leaves. As we know from one of his own comments, snow was for Friedrich "the great white cloth, the symbol of highest purity, beneath which nature makes ready for a new life." I would even venture another suggestion, that the horizontal boulder balanced on the wall stones rising up out of the ground, which covers the grave but does not seal it, was meant to imply a possible resurrection. The notion is supported by a poem Kosegarten wrote about a cairn on Rügen in 1778:

> *Above the four moss-covered stones,*
> *Beneath the three whispering oaks, peace and calm!*
> *Sleep well, ye who slumber below,*
> *Ye who fell in the battle for freedom …*

The heroes only sleep, protected by the arrangement of stones, the mound of earth, and the covering of snow. They may reawaken and return. The ravens also support such a reading. In legend it is they who stand watch near the bodies of fallen warriors to announce to them the hour of their return. They fly about the Kyffhäuser, in which Emperor Friedrich Barbarossa sleeps, stroking the stone with the beating of their wings. Once the stone has been worn away the emperor will arise again. The raven above the cairn in Friedrich's picture nearly touches the boulder.

Friedrich's contemporaries understood *Cairn in the Snow* as an ancestral scene, as we know from an essay written by the owner of the work, the Greifswald collector Carl Schildener. Painted in 1807, after Napoléon's victory at Jena and Auerstedt, it is perfectly plausible that it was intended as a patriotic statement in the guise of a scene from nature. One cannot overlook this quality in the picture. Friedrich appears to be saying: Here is my homeland. The monument of boulders, erected untold ages ago, marks man's place in nature, and memorializes the dead amid the living. ◼

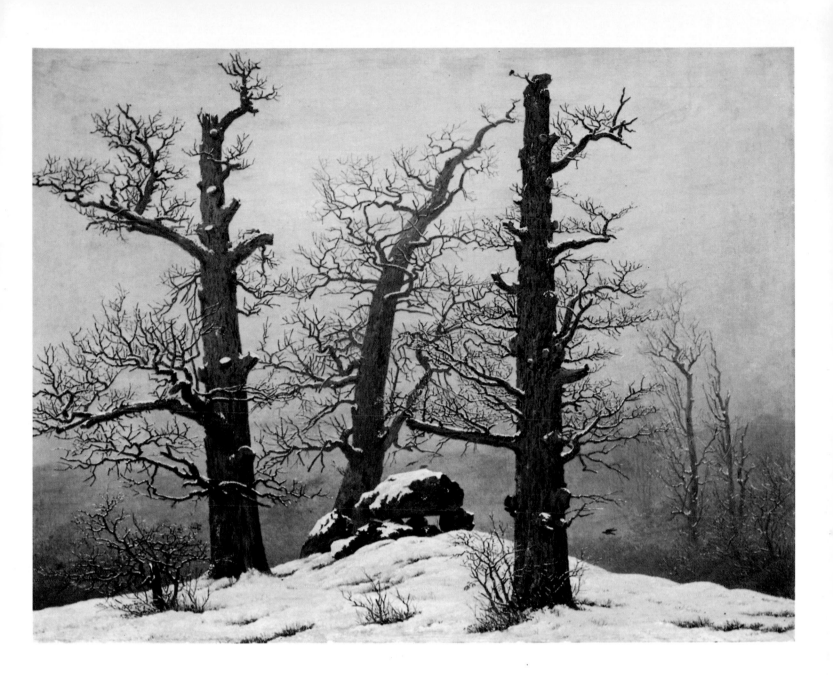

5. THE CRUCIFIX IN THE MOUNTAINS (TETSCHEN ALTARPIECE)

1807–8. Oil on canvas, 45¼×43½" (115×110.5 cm)
Staatliche Kunstsammlungen, Gemäldegalerie, Dresden (B-S 167)

The Crucifix in the Mountains is frequently spoken of in the Friedrich literature as the *Tetschen Altarpiece,* since some early documents suggest that it was commissioned by Count Franz Anton von Thun-Hohenstein for the private chapel of his castle at Tetschen in northern Bohemia. The name is misleading, however, for as Eva Reitharovà has recently shown, the work was neither a commission nor did it ever serve as an altarpiece. Tetschen Castle did not in fact have a private chapel; the picture hung in the count's bedroom. It may be that during her engagement, before her marriage to the count or her familiarity with Tetschen Castle, the young Countess von Brühl wished for such a chapel and that the painting, which she had seen at Friedrich's studio in Dresden (at least an earlier version in sepia), struck her as ideally suited to be its centerpiece. But it never played such a role, even though Friedrich accepted its designation as the *Tetschen Altarpiece* and accordingly ordered a special frame from his friend the sculptor Gottlieb Christian Kühn. The frame, with symbolic ears of wheat and grapevines and a choir of angels, alludes to the celebration of the eucharist.

The Crucifix in the Mountains, not originally meant to adorn an altar, was moreover—according to Gerhard Eimer—not even conceived as a religious picture. It was to be a tribute to the celebrated Swedish king Gustavus Adolphus, showing his emblem, the sun—the light from the north, the midnight sun—illuminating a crucifix and thereby seemingly taking a beleaguered Christianity in its protective embrace. Friedrich, still a Swedish subject, had thought to present it to Gustavus Adolphus's descendant, Gustav Adolph IV, whom he hoped would help defeat the hated Napoléon. In a letter only recently discovered, Countess von Brühl lamented: "Unfortunately, the lovely crucifix is not to be had! The good Northerner has reserved it for his king, and although he has no opportunity of sending it to him ... he still doesn't want to sell it."

If Friedrich subsequently gave in to the urging of the count and countess and let them have the work, after being told they intended to use it as an altarpiece, it is perhaps not so surprising as it might at first seem. Religious and patriotic sentiments could be combined as a matter of course at the time; pietism and love of the fatherland were all too often closely associated, and an essentially secular painting could certainly accommodate a metaphysical dimension. Friedrich kept his picture so uncomplicated, making do with a minimum of symbols, that its range of possible meanings is very wide. It does seem plausible, then, that without any changes it could serve either as a homage to the Swedish king or as a votive image for a new piety tinged with pantheism. Against a backdrop of limitless space we see the silhouette of a mountain summit topped by a crucifix. The cross is flanked by a jagged line of firs growing up out of the thin soil (the Swedish king is said to have requested birches, but Friedrich insisted on evergreens).

The picture was finished at Christmastime in 1808, and Friedrich decided to exhibit it to the public in his studio. A table was moved into the room and draped with a black cloth. On it stood the picture, complete with its gold frame. One of the windows was draped—or possibly closed off with the wooden shutters by then installed (see plate 2)—so as to suggest something of the atmosphere of a lamp-lit chapel. Friedrich himself went off on a trip while the picture was on display. Marie Helene von Kügelgen described her impression of the work as follows: "Yesterday I went on my first outing, and went straight across the Elbe to Friedrich's to see his new altarpiece. I found many acquaintances there ... when stepping into the room all had the feeling they were entering a temple."

Another person who had seen the picture in Friedrich's studio, Councillor Friedrich Wilhelm Basilius von Ramdohr, was moved to compose a long-winded, stinging diatribe. This was the piece that unleashed the famous "Ramdohr controversy," which with its charges and countercharges served to establish Friedrich's early reputation. Ramdohr's objections, for the most part condescending but often perceptively argued, go to the heart of Friedrich's vision. More clearly than the others he recognized what was novel about Friedrich's picture, insisting that "it introduces ... a new concept in landscape painting." He categorically rejected the new idea as a "horrifying preview of the rapidly approaching barbarism." As he repeatedly stressed, he was not concerned solely with Friedrich's painting in his polemic, but equally with settling accounts with the "system manifest in it." Ramdohr's complaint is thus two-edged: on the one hand he rails against the picture's composition, on the other against its intended function. The councillor finds no traces of what had formerly delighted him in landscape painting—an abundance and variety of objects, their arrangement and differentiation by means of perspective, and a wealth of modulated colors—and properly notes that the viewer would be obliged to assume an unnatural position in order to see what the picture presents. Even more emphatic is his rejection of the intent to use "landscape as the allegory of a specific religious idea": the object of art, he says, is to evoke not "a pathological feeling" but an "aesthetic" one, yet in his view the psychic effect of Friedrich's picture aims toward the former. Apparently what Ramdohr had in mind we would now call existential anguish. He writes:

In fact, it is pure and simple insolence for landscape painting to try to steal into our churches and onto their altars. [It is] the sort of mysticism that is now all-pervasive, and wafted to us from art as well as science, from philosophy as well as religion, like some narcotic haze! The sort of mysticism that passes off symbols and fantasies as artistic and poetic images ... the sort of mysticism that prefers the Middle Ages and its institutions to the age of the Medici, Louis, and Frederick.

In short, he shows himself to be a thoroughgoing and learned opponent of Romanticism in all of its aspects.

His essay, which appeared in installments beginning in January 1809 in *Zeitung für die elegante Welt,* elicited a violent response. Friedrich's friends, including the painters Ferdinand Hartmann and Gerhard von Kügelgen, testified with more enthusiasm than

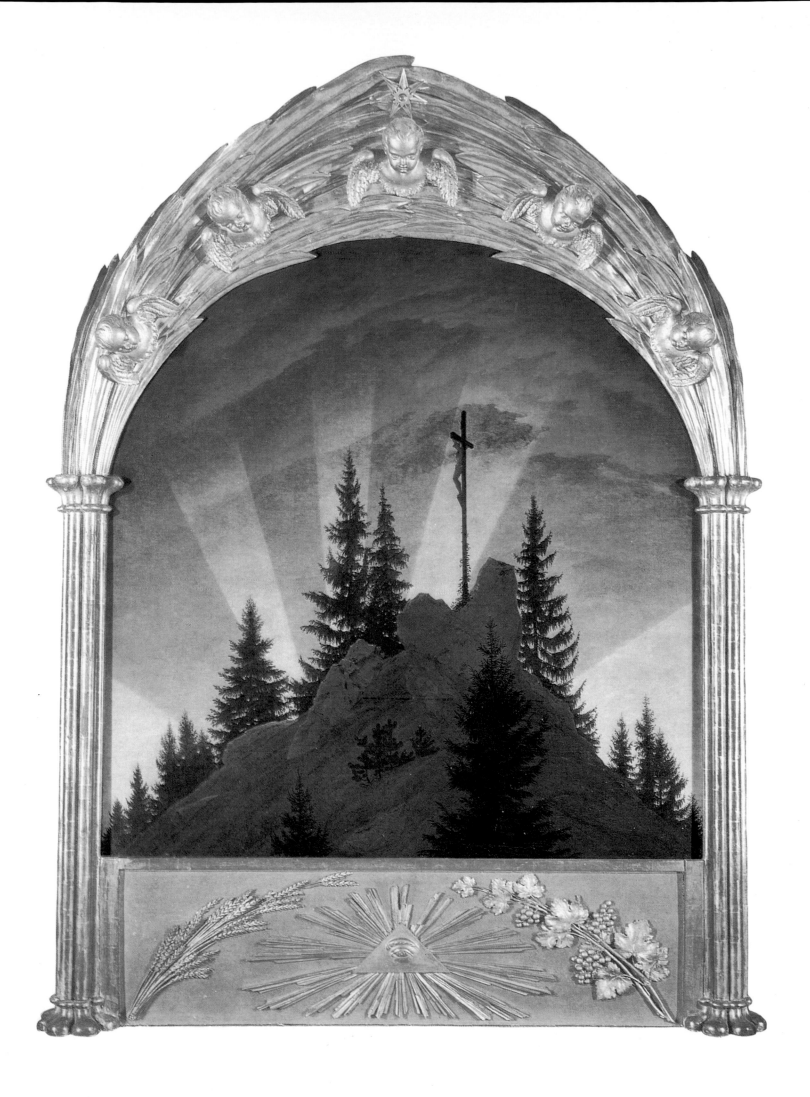

reasoned argument, though they did manage to formulate a few pertinent observations. Finally Ramdohr himself wrote a rejoinder, one in which he somewhat qualified his former position: "If Herr Friedrich manages to find his way to immortality by the path that he has chosen and that I have criticized, I will be convinced of his genius and his independence. My criticism will certainly not hold him back."

Gerhard Eimer has pointed out that there are two contradictory statements by Friedrich himself about his picture, one quoted by Ramdohr in his article and another contained in a letter to Professor Johannes Schulz of February 8, 1809, in immediate response to his reading of Ramdohr's accusations. In the first of them he speaks of the "imminent arrival of day," in the second of the "sinking sun," obviously in one instance characterizing his picture as representing dawn and in the other evening. Both statements are of questionable value. The first was reported only by Ramdohr. We may safely consider it sheer invention on the part of the councillor, or perhaps a misguided attempt to enter into Friedrich's way of thinking and experience it for himself. The second statement, brief and somewhat garbled, is authentic, to be sure, but so obviously an impromptu reaction to Ramdohr's attacks that it has to be taken with a grain of salt. Friedrich's remarks are, moreover, cast in the third person, so that they read like a set of notes for an essay he obviously hoped someone else would publish in his defense. His contemporaries considered Friedrich's comments to be only provisional. Probably the only part of them that should be taken literally is Friedrich's repudiation of statements Ramdohr had ascribed to him: "The C[ouncillor] is incapable of controlling the painter F[riedrich]'s tongue … F[riedrich] would certainly not have spoken as he quotes him."

Perhaps all that is important to us about Friedrich's response to Ramdohr is the note of pessimism sounded in certain passages of his commentary on the picture for Professor Schulz, for example when he says:

With the teachings of Jesus an old world died, a time when God the Father himself walked on earth.... This sun sank, and the earth was no longer able to capture its parting light. The Savior on the cross, formed of the purest, most precious substance, gleams … and so reflects a muted radiance on the earth.

Gerhard Eimer, much like Donat de Chapeaurouge, sees a radical skepticism at work in these lines and draws a parallel to Jean Paul's 1797 "announcement by the dead Christ from the cosmos that there is no God." Though it was more than half a century later that Nietzsche coined the phrase "God is dead," Eimer condenses Friedrich's message about Christ turning away from us, as confirmed in both *The Crucifix in the Mountains* and the artist's written statements, into the pithy formula: "God withdraws." ▩

6. MORNING MIST IN THE MOUNTAINS

1808. Oil on canvas, 28 × 70⅞" (71 × 104 cm)
Staatliches Museum Schloss Heidecksburg, Rudolstadt (B-S 166)

This picture presents essentially the same subject as the *Tetschen Altarpiece* (plate 5), a crucifix in the mountains. All that is different are the proportions. Was Friedrich attempting to correct them? Was *this* the way they were supposed to be? The crucifix at the top of the peak is barely visible. One has to look twice even to find it. Only the break in the clouds, with a trace of blue in the distance—hardly a nimbus—serves as a hint as our gaze slowly works its way up the slope. As in the other picture, firs are growing out of the boulders; firs and pines serve as escorts on the ascent to the summit, a journey that appears to be feasible only for the eye. Everything is veiled in dense mist, submerged in cloud. While the *Tetschen Altarpiece* depicted the light of evening, here it is morning. Mist to Friedrich suggested the dawn, the earliest light, when the various forms slowly begin to free themselves from the amorphous totality of things and take on individuality. He wrote in his *Confessions:* "When a scene wraps itself in mist it seems greater, more magnificent; it fires our imagination and heightens our expectations like a veiled girl."

In *Morning Mist in the Mountains,* mist and clouds blend together, forming a single, nearly impenetrable wall. The picture consists of almost nothing but this single plane of vapor. That was what was revolutionary about it, and it must have shocked Friedrich's contemporaries as much as his message in the *Tetschen Altarpiece,* completed the same year. The present work represented Friedrich's most radical break up to that date with the eighteenth-century concept of landscape, echoes of which persist in both his *Summer* and his *View of the Elbe Valley* (plate 3). They were still landscapes one might step into. A path led us into the foliage of *Summer,* and by means of perspective our gaze was invited to pass through a gently rolling space into the distance. In *View of the Elbe Valley* immediate access was blocked by the barrier of the outcropping, but behind it once again a view opened out; though the prospect might have been remote, its presence even in the distance seemed comforting. But this mountain looming up out of the morning mist and slowly divesting itself of clouds is forbidding, and behind it there is nothing. All of the objections put forth by Councillor von Ramdohr with regard to the *Tetschen Altarpiece* would apply equally to this picture. At the same time, it is much more temperate, more restrained, and quieter than a painting destined for a chapel. All pathos has been withdrawn, the message obscured.

After visiting Friedrich's studio, Johanna Schopenhauer wrote in 1810:

Friedrich's works differ noticeably from those of all other landscape painters, especially in the choice of subjects. The air, which he handles masterfully, takes up much more than half of the space in most of his paintings, and frequently a middle ground and background are altogether lacking, because he chooses subjects in which there are none to depict.

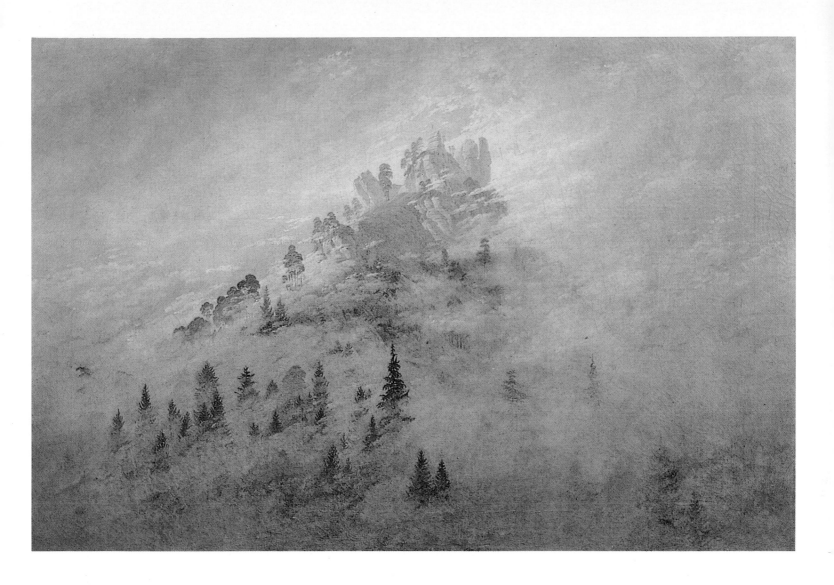

That is also true of this picture. Although it presents a mountain shaped like an equilateral triangle rising up well into the top third of the picture, it is above all a painting about air. Mist and clouds take up "much more than half of the space." The picture consists solely of a "middle ground," an intermediate pictorial plane; foreground and background are lacking. We have no idea what the viewer is standing on. We are told nothing about his position. It is as though we were seeing the picture from midair. All distances are veiled. The lone fir that stands out in the bottom third of the picture and points upward toward the peak seems to offer something concrete, but it too is for the most part veiled in mist. We have no idea how large any of these trees might be; we are given no indication of scale, either for the firs, the boulders, or the crucifix.

Everything is left open in this picture. The mountain looms up out of the shapeless wisps of passing fog as though out of a heavy sleep. It is as though we were experiencing the world in the moment of its creation. Proximity and distance have not yet been distinguished, solid rock has yet to be separated from the swirling fog. The immovable and the transitory appear to be at one with each other, the finite and the infinite interwoven, the physical subsumed in the insubstantial. A world is becoming visible, but we are uncertain whether it will last.

We can assume that *Morning Mist in the Mountains* was the picture referred to in *Prometheus* in 1808 as "a mountain veiled in mists and towering into the clouds, on the highest peak of which, in clear blue air, we spy a crucifix." Others have chosen to see in it the work that Wilhelm von Kügelgen frequently spoke of as a means of characterizing Friedrich: "The rocky summit looking up out of the mists toward the sun, that was his picture." But this identification is uncertain.

The mountain motif was probably compounded out of sketches made in Saxon Switzerland, none of which survive. It may be that the rocks to the right of the cross are the ones in the drawing from 1799 that Friedrich utilized for the foreground peak in *Morning in the Riesengebirge* (plate 12). Similar rock formations appear in *Hiker above the Sea of Mist* (c. 1818, fig. 22), and even more bizarre stone structures loom up against the sky in *Rocky Gorge in the Elbsandsteingebirge* (1822–23, fig. 29).

Karl-Ludwig Hoch has claimed that the rocky pyramid shown here is in fact the Tollenstein, in northern Bohemia, a volcanic formation encountered also in sepia drawings from 1804, earlier stages of the *Tetschen Altarpiece*. He may be right, yet it also appears that Tina Grütter is correct in maintaining that the actual details of the rocks on the summit conform to an undated sketch from the Elbsandsteingebirge called *Field Stones near Rathen*.

7. MONK BY THE SEA

1808–10. Oil on canvas, 43¼ × 67½" (110 × 171.5 cm)
Stiftung Preussischer Kulturbesitz, Schloss Charlottenburg, Berlin (B-S 168)

Monk by the Sea is the most radical picture Friedrich ever painted. In no other work did he break so violently with traditional notions of landscape painting. Classical perspective has been rescinded before this great wall of sky. This is no longer a world that is ours, that we can explore. A limitless space that is altogether foreign unfolds before us. That is how Heinrich von Kleist saw this picture. His famous commentary in the *Berliner Abendblätter* for October 13, 1810, has often been quoted:

It is glorious to gaze out at an infinite expanse of water under a lowering sky in complete solitude at the edge of the sea. Part of it, to be sure, is that one has chosen to go there, that one must go back, that one would like to cross over, but that one cannot, that one has nothing of what it takes to live on and nevertheless hears the voice of life in the rush of the tide, in the blowing of the wind, in the sweep of the clouds, in the lonely cries of the birds. Part of it is a claim that the heart makes and a rejection, if I may put it that way, on the part of nature. But this is impossible before the picture, and what I myself was to find in the picture I found only between myself and it, namely a claim that my heart makes on the picture and the picture's rejection of me; and so I became the Capuchin, the picture became the dune, but what I so yearned to gaze out onto, the sea, was altogether missing. Never is one more wretched and forlorn than when faced with the world in such a way: the only spark of life in the endless realm of death, the solitary center of an empty circle. The picture, with its two or three mysterious objects, lies before us like the Apocalypse, as though it were thinking Young's Night Thoughts, *and since in its uniformity and boundlessness it has nothing but the frame as foreground, one stares at it as if one had no eyelids. Even so, the painter has unquestionably blazed an entirely new trail in the field of his art; and I am convinced that with his spirit it would be possible to depict a square mile of march sand, with a barberry bush on which a solitary crow ruffles its feathers, and that such a picture would have a truly Ossianic or Kosegartenian effect.*

This essay, "Sensations on Viewing Friedrich's Seascape," was signed "CB," indicating that it was by Clemens Brentano. Kleist had originally asked Brentano and Achim von Arnim to write about Friedrich's picture. The two had submitted a text quoting from conversations between visitors to the exhibition standing in front of the painting. Kleist had cut out all of the conversations, some of them inspired, some merely silly—intended as a comment on the ignorance of the public—objecting that they did not capture the spirit of the picture. He kept only a few sentences from Brentano's preface. A quarrel ensued, and to smooth things over Kleist inserted a short note in the *Berliner Abendblätter* explaining that although the initials were another's, the spirit of the essay and the responsibility for it were his.

The essay in the *Berliner Abendblätter* is not the earliest surviving contemporary account of this picture. After a visit to Friedrich's studio in February 1809, Christian August Semler reported in the *Journal des Luxus und der Moden:*

One sees the sea, its waves flinging up greenish foam as they are swept by a moderate wind, and above it a gray sky heavy with mist. A strip of white sandy shore serves as foreground, with a few gulls hovering above it.... What especially delighted me about this picture was the significance the painter managed to give the scene by the addition of a single figure. A bald old man in a brown habit is standing on the shore, turned so that he nearly faces the sea, and to judge from his posture and especially the way his chin rests in his hand he appears to be sunk deep in thought. There can be no mistake that he is thinking about the vastness stretching off into the far, gloomy distance.

Marie Helene von Kügelgen, the wife of the painter Gerhard von Kügelgen, registered a less positive reaction, something more akin to shock, in a letter of June 22, 1809:

I also saw a large picture in oils that does not speak to my soul at all: a broad, infinite expanse of air. Below it is the restless sea and in the foreground a strip of light-colored sand on which a hermit in dark colors strolls to and fro. The sky is perfectly and apathetically calm, no wind, no sun, no moon, no storm—indeed, a storm would be a comfort and a relief, for then one could at least see life and movement somewhere. On the endless surface of the sea one sees no boat, no ship, not even a sea monster, and in the sand too there isn't a single blade of grass. There are only a few gulls wheeling about, making the solitude even more lonely and horrible.

The perplexity in these words reveals that the writer was quite deeply moved by the picture, however foreign it was to her in spirit.

It is possible to deduce something else from these two earliest documents. It appears that the picture progressed through several stages between its inception—toward the end of 1808, about the time the *Tetschen Altarpiece* was completed—and its submission to the exhibition at the Berlin Academy in September 1810, where at the urging of the young crown prince it was purchased along with *Abbey in the Oak Forest* (plate 8) by the Prussian king Friedrich Wilhelm III. The "apathetically calm sky" is traversed in the final version by an approaching wall of clouds. A visitor who saw the picture shortly before its completion described a nighttime scene, "lit by the moon in its last quarter and the faint glimmer of the morning star." The only traces of this today are the brightness of the sky in the center of the picture, the glowing edges of the clouds, and the reflection of the light on the waves. Infra-red photography has moreover revealed that Friedrich originally included two ships, fighting the waves, but he later obliterated them. There must have been a stormy sky to match. All of the changes he made while working on the picture served to simplify its subject and sharpen its impact.

Something of the character of a night piece has remained—enough to make us wonder whether the moonlight behind the bank of clouds is actually the dawn, and whether the monk is therefore awaiting the new day. It is this tiny figure, the only vertical element in the painting, that gives one the feeling of being at the mercy of space, of helplessness in the face of an incomprehensible nature. Clemens Brentano found the right words for him: "He is the temperament, the heart, the reflection of the whole pic-

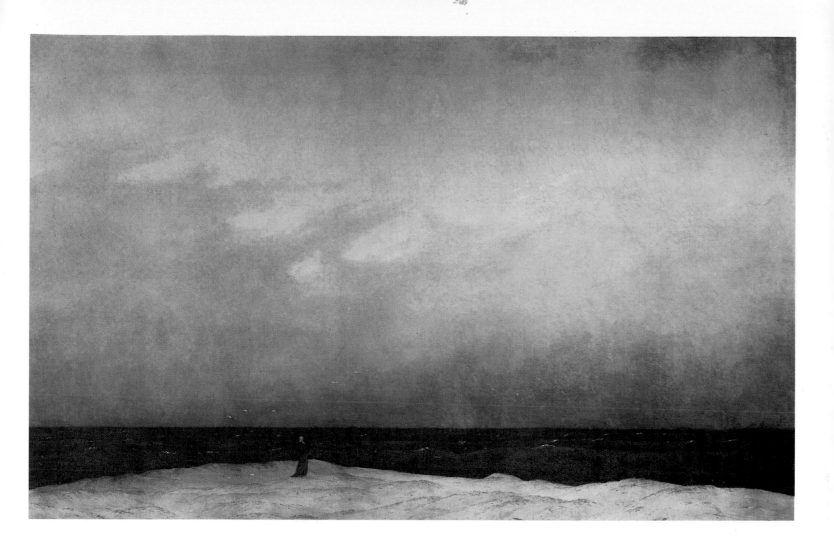

ture in himself." The monk forces us to identify with his situation. He draws us into the picture, requires that we imagine what he is experiencing. "I became the Capuchin," Kleist confessed. It is senseless to speculate—as has often been done—whether or not *Monk by the Sea* is actually a disguised self-portrait. The monk may be Caspar David Friedrich, but more important, he is each of us.

This picture provided the most pointed formulation possible of modern man's perception of space. It stands as a milestone in art history, the articulation of a new experience. Werner Hofmann aptly described the work as follows:

The unusual compositional device that gives the picture its solemnity is . . . monotony. Its horizontality is monotonous. Its space, divided into planes, has immense depth, but no yearning for the distant, originating in man and flowing back to him. The depth is withheld from man, he is not equal to it; it no longer soars above him like the space pictured heretofore, infinite yet controlled by perspective. This infinity is threatening to man; he is at its mercy but incapable of adapting to it. The narrow base on which he

stands shrinks to nothingness when compared to the all-encompassing magnitude of space.

This same experience of the world is expressed in the literature of the time. Friedrich Karl Kasimir von Creuz reflected on this sense of abandonment in his *Essay on the Soul* of 1753–54, over half a century before Friedrich painted *Monk by the Sea:*

In the moment when we become a part of the world totality we are like a drop that falls into the world sea and becomes a part of it. We turn about like a speck of dust in the whirl of infinities. Ignorant of what we are, and equally unfamiliar with our past and our future, we lose ourselves in the sea of time. Is it any wonder that we shudder when we consider the narrow strip on which we stand, looking down into the abysses on either side, between which an inscrutable fate has placed us?

His lines read like an advance commentary on *Monk by the Sea.* Nothing could better describe the monk's situation in the cosmos.

Just how did Friedrich convey such experience in his painting? If one attempts to analyze the means by which he expresses his experience of space, one is first struck by the uncommonly low horizon, its long line as though drawn with a ruler, the sharp contrast between the shore and the water—the scarcely accountable, almost blinding brightness of the sand next to the blackness of the water, of an extent beyond our comprehension. The eye finds nothing there to fix upon. With good reason Friedrich got rid of the ships he had originally planned. The sea and the dunes are seen from different perspectives: though we seem to be looking down onto the shoreline, the surface of the sea appears to be foreshortened, tipped away from us. The sky occupies still another dimension. Behind a thick bank of clouds lying just above the water a second, more distant wall is built up in bluish tones—as though there were two skies. Shore, sea, and sky are incompatible; each requires a different way of seeing, yet they form an inseparable unity. The presence of the monk in such a setting adds to its complexity and at the same time draws us closer.

Everything is calculated to hold us fast. The picture forces us to stand still. We cannot enter into its space: except for the narrow threshold of the shoreline, there is nowhere to walk. And this threshold does not lead anywhere; behind it there is nothing but an abyss, the sea. Since we have no sense of how far away the horizon might be, we cannot project ourselves into that distance. Nor can we withdraw, for this picture does not end with the frame. The shore, the sea, and the horizon line extend endlessly on either side, and even the wall of the sky, which takes up precisely four-fifths of the picture, continues upward and out of sight. We cannot escape this infinity. We have to look at it—as though, as Kleist put it, we had no eyelids. ▩

8. ABBEY IN THE OAK FOREST

1809–10. Oil on canvas, 43½ ×67¼" (110.4×171 cm)
Stiftung Preussischer Kulturbesitz, Schloss Charlottenburg, Berlin (B-S 169)

Carl Gustav Carus called this picture "perhaps the most profoundly poetic work in all of modern landscape painting." That was in 1865, in the second volume of his memoirs, as he recounted a visit made forty years before to the royal palace in Berlin, where *Abbey in the Oak Forest* hung at the time along with *Monk by the Sea* (plate 7) and *Morning in the Riesengebirge* (plate 12). In the decades after Friedrich's death, that is to say between 1840 and 1860, *Abbey in the Oak Forest* was repeatedly referred to as Friedrich's masterpiece. At the "Second Universal German and Historical Art Exhibition" in Cologne in 1861 it was the only Friedrich work shown. If Friedrich was remembered at all in the second half of the nineteenth century, it was largely for this picture. It was not until 1906, when the exhibition of German art from the period 1775–1875, held in Berlin, presented thirty-six of his paintings, that his work became more generally known.

Abbey in the Oak Forest was painted in 1809–10 and belatedly sent, together with *Monk by the Sea*, in September 1810 to the Berlin Academy exhibition, where the two paintings were hung one atop the other: *Monk* above, *Abbey* below. The first mention of the piece in the literature is by Goethe, who visited Friedrich in his studio on September 18, 1810, and noted in his journal: "Went to see Friedrich. His amazing landscapes, a misty churchyard, an open sea." Goethe must have later revised his spontaneous judgment—possibly under the influence of Heinrich Meyer. From a letter written by Johann Gottfried Schadow of uncertain date and to an unknown addressee, we learn something about Goethe's change of mind:

In the field of landscape, Friedrich in Dresden had already struck a night-watchman tone before, which still resonates in monastery graveyards covered with snow, where tiny cloaked figures slink about. Goethe said of this: beautiful work, but it was always my impression that art ought to make life more cheerful; here is coldness, impetuousness, dying, and despair—when the Netherlanders depict winter one sees sleds and skaters and a love of life, and this last, a love of life, is presented only sparingly in narrative painting in our day.

For a detailed description of the picture we are indebted to Johanna Schopenhauer, the mother of the philosopher, who must have been in Friedrich's studio at about this same time. Her report appeared in the *Journal des Luxus und der Moden:*

A winter evening, the setting presents the ruins of a church.... High in the cold, clear air hangs the new moon, beside it gleams the evening star, one can even see the dark side of the moon, as happens on very cold, clear winter nights.... Clouds of mist rising up from the ground, almost turned to frost already by the cold, obscure everything in the distance, and press quite close to us. What a picture of death this landscape is!... One shudders when looking at it.

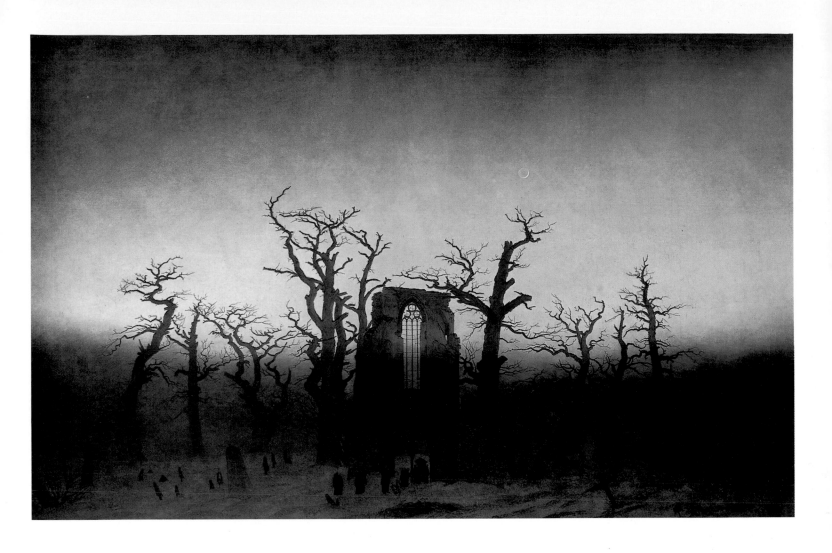

Friedrich started *Abbey in the Oak Forest* in 1809, after returning home from a stay in Greifswald. The large oak with the split trunk to the left of the ruin is based on a sketch he had made in May of that year in Neubrandenburg. His pattern for the ruin was the derelict Eldena Abbey, seen from the east. As Otto Schmitt has shown, the tracery Friedrich has placed in the west window, which was actually walled up, and the cross set into the portal were invented, while fragments of masonry adjacent to the west façade of the actual church have been omitted.

Abbey in the Oak Forest was conceived as a companion piece to *Monk by the Sea.* It is by no means uncommon to find in Friedrich pairs of paintings altogether different in their subject matter, composition, and coloring. Börsch-Supan considers these two so closely connected that he takes it to be the monk from the latter painting—Friedrich himself—who is here being carried to his grave in this picture: that the painter here portrays his own burial, as he had once before in a lost sepia drawing from 1804.

In gloomy solitude, before the infinite sea and an impossibly vast sky, at the very edge of dry land, the monk had meditated on life and its boundaries, about death and what follows. The doorway to death stood open in that other picture, and here, through the portal of the abbey, light shining above through the one remaining window, monks carry a coffin toward the cross. One could also imagine the sequence reversed: that the otherworldly scene of *Monk by the Sea,* the resurrection of the soul in a place that

must necessarily strike our physical eye as absolute emptiness, follows the one of the funeral in the oak forest, which is at least, for all its strangeness, an earthly setting.

A decade after painting *Abbey in the Oak Forest,* Friedrich presented the same subject again in a painting closely related in composition and format, *Monastery Graveyard in the Snow* (fig. 21). That work, formerly in the Nationalgalerie, Berlin, was destroyed by fire in 1945. The particular character and structure of *Abbey in the Oak Forest* can be identified by comparing it with *Monastery Graveyard in the Snow.* The symmetrical arrangement of the two pictures is the same, with a centered church ruin, which a procession of sorrowing monks enters from the left, flanked by bare oak trees. Around the ruin stand tilted tombstones and crosses, scarred by the passage of time. The church is destroyed, the graveyard abandoned, nature dead. Still the monks are celebrating the mass for their deceased brother on this spot, under the open sky. They pass by the freshly dug grave that lies in readiness in the foreground as though it were not their final destination. The coffin has just reached the portal; a light gleams from the cross.

To this extent the two pictures are perfectly identical, and yet how very different they are. The subtle theme of *Abbey in the Oak Forest* is quite blatant in *Monastery Graveyard in the Snow.* In the earlier work everything is obscured by a brownish veil—reminiscent of Friedrich's early preference for sepia, dealing solely with tonal values—and compressed into a uniformly somber zone before an

indistinct background, while the later one is rendered in a full range of colors in the clear light of day. Objects that crouched close to the ground in the one seem to soar upward in the other. That is true of the trees, of the church ruin; even the monks seem taller. This is perhaps most surprising in the case of the trees, for a number of them were painted from the same drawings: the one standing directly to the right of the ruin in both paintings, for example, or the one with three trunks standing to the left of the ruined abbey, which reappears on the far right of the monastery graveyard. For the choir of the monastery church Friedrich used a different pattern, a drawing he had made from inside the ruined Jacobi church in Greifswald, the proportions of which are here greatly exaggerated. The procession of monks in front of the earlier abbey seems to rise up out of the dark earth; they stand rooted in the ground like tombstones. In the later monastery graveyard the train of dark figures contrasts with the white path. A protective mantle of snow covers the earth.

In the picture of the abbey, the works of man have crumbled, reverting to nature. The leaning crosses and tombstones are sinking to the earth. The walls of the church have collapsed; the one relic that does loom up out of the ground seems indestructible, as though carved out of living rock. The bizarre branches of the trees, twisted and bent by the wind, add a dramatic accent to the picture.

The message of *Monastery Graveyard in the Snow* is very different. Night has by no means progressed as far as in the *Abbey*. Everything is lighter (in the sky as well as on the snow-covered earth), straighter, and taller. The portal has become narrower, space deeper. The trees stand stiff, solemn, and silent around the hushed ceremony. While in the earlier painting the abbey ruin appears to be a part of nature, in this one the relationship is reversed, and the oaks have become part of the architecture: they continue the structure of the monastery church, framing it and functioning as its roof. They fill the sky, reaching up to the upper edge of the picture as though to support the vault of heaven. With the two great trees on either side the structure is restored. Nature is reconciled with the works of man and completes his fragmentary endeavors.

The monolith of the abbey looms up out of nowhere, while the architecture of the monastery graveyard stands in a perspectival space of definite depth, its covering of snow reflecting the violet glow of the evening sky.

Carus, who admired *Abbey in the Oak Forest,* noted even before the later painting was finished that in it nature had taken on the quality of architecture, and he disapproved. He remarked that it looked quite imposing, on the whole, but "again somewhat baroque and architectonic. Altogether in Friedrich, I feel, a tendency toward architecture predominates, detracting too much from the freedom of the landscape painting." Carus's evaluation of the two pictures may also reflect a more general change in public opinion of Friedrich. By about 1810, with *Monk by the Sea* and *Abbey in the Oak Forest,* he had attained the height of his fame. A decade later his reputation was waning. ◉

9. MOUNTAIN LANDSCAPE WITH RAINBOW (LANDSCAPE WITH LUNAR RAINBOW)

1810. Oil on canvas, 27½×40⅛" (70×102 cm)
Museum Folkwang, Essen (B S 183)

Two Friedrich landscapes include rainbows. They were probably painted at about the same time, though given their different format, not intended as a pair. One is his *Landscape with Rainbow* (fig. 13; whereabouts unknown), the other the present *Mountain Landscape with Rainbow*. Both pictures were purchased by Duke Karl August von Weimar in 1810, presumably through the good offices of Goethe. The lost painting portrayed a shepherd gazing out on a Rügen landscape from a low hill. A remark made by Gustav Parthey in 1863 suggests that it was inspired by Goethe's poem "The Shepherd's Lament" (1802).

The other painting, reproduced here, depicts the Rosenberg in Saxon Switzerland. A hiker dressed in city clothes, perhaps Friedrich himself, leans against a boulder and gazes down into a deep ravine. In the first picture, above the plain of Rügen it was bright daylight, but here it is night. It would seem that the work was first conceived as a simple nocturnal landscape with the moon peeking through clouds above the mountain. The rainbow, often referred to as a "lunar" rainbow in the literature, appears to have been a later addition. That was the opinion of Duke Emil August von Sachsen-Gotha-Altenburg, who saw the picture in Weimar and referred to the rainbow as a "piece of frosting," calling Friedrich himself a "scenic confectioner." In his correspondence with the Dresden painter Therese aus dem Winckel, he alternated between praise and criticism, admiration and scorn. In a letter of October 9, 1810, for example, he wrote:

I have seen paintings by Friedrich that attracted me, captivated me, startled me, but did not wholly delight me, in contrast to his unfinished sepias, which are swiftly executed and profound—abbozzi of a totally different style and intent. These sepias have caused me to be highly interested in Friedrich, but the paintings, those garish, confused, polar monstrosities, those peep-show pictures that are supposed to be allegorical and mystical, and especially those rainbows that look like pieces of frosting, the foregrounds that look like mosaics, and the backgrounds like maps—no, all of that has forced me to make a singular confession. All those colorful muddles, though surely not altogether without merit, belong in the madhouse, in the cell of the poetaster, in the dungeons of the deranged.

The rainbow nevertheless occupied the duke for a long time. In a letter from Gotha of January 29, 1811, he spoke of it once again: "I cannot forget a marvelous rainbow that appears to hover over the picture quite stiff and opaque." He can only have been thinking of this "lunar" rainbow.

The natural phenomenon depicted in the picture is certainly puzzling. The mist-filled valley, the woods, the mountain peak, and the distant mountain ranges lie in darkness. A cloudy night sky

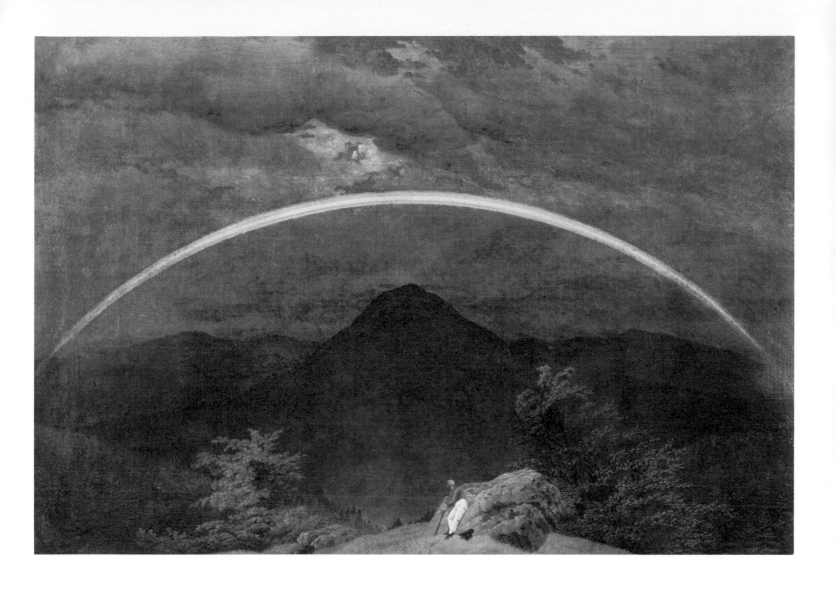

stretches above. Through a single break in the clouds we glimpse a silvery shimmer of moonlight. Yet the man on the hill in the foreground, resting against a boulder while leaning on his walking stick, is bathed in bright light. Is this moonlight? Sunlight? What is the source of the light falling on the leaves and branches of the nearby trees, illuminating the boulder and the patch of grass in front of it? It picks the wanderer out of the darkness and clings to him like a spotlight.

The presence of the rainbow is just as mysterious as the light falling on this figure. Börsch-Supan assumed that the light in the clouds can come only from the moon, and that what we are seeing is therefore a "lunar" or "nocturnal" rainbow:

But since a rainbow is seen only when the source of light is at the viewer's back, we must conclude that the sun is still up, as the illumination in the foreground suggests. The resulting contradiction is possibly explained if we assume that the picture was first planned as a night scene and only later enriched by adding the rainbow, painted in sharp, thick colors on top of the clouds, to clarify and modify its symbolic content.

Whenever the rainbow was added, it does not answer our questions about the lighting and the light source but only adds to them. Is this no "lunar" rainbow at all but an ordinary, solar rainbow stretched across a darkening sky? Is the sun still shining? Or is it actually nighttime in this picture, yet with certain portions still enjoying traces of daylight? For just what is the light source that we—like the wanderer—have at our backs, which causes the apparition of the rainbow against the dense clouds? Is it a flash of sheet lightning that illuminates the wanderer?

Mountain Landscape with Rainbow, painted a century before the appearance of the Surrealists, is a distinctly surreal picture. Altogether alone, utterly exposed, man stands in a nature that is foreign to him, mysterious, and gazes into an abyss whose depths he cannot fathom. 🔲

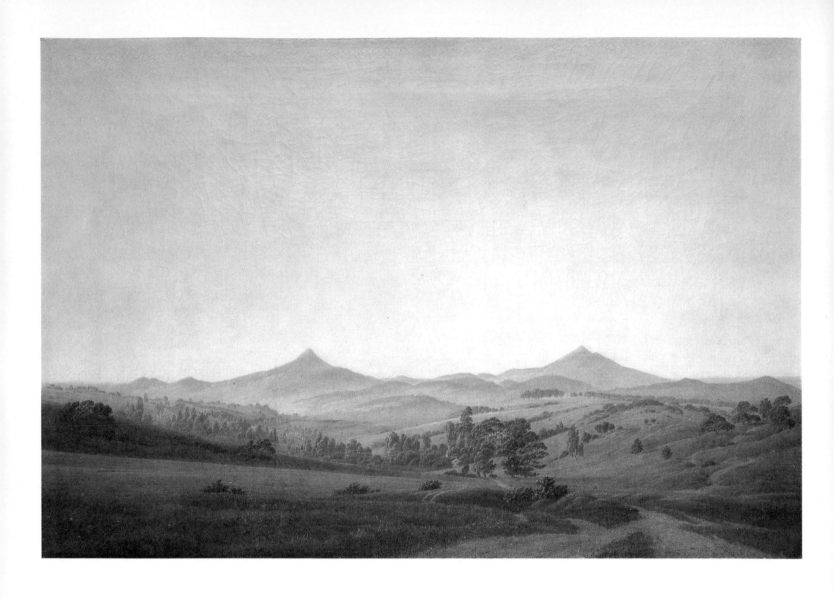

10. BOHEMIAN LANDSCAPE (WITH THE MILLESCHAUER)

c. 1810. Oil on canvas, 28 × 41" (71 × 104 cm)
Staatliche Kunstsammlungen, Gemäldegalerie, Dresden (B-S 188)

11. BOHEMIAN LANDSCAPE (MOUNTAIN LANDSCAPE)

c. 1810. Oil on canvas, 27½ × 40½" (70 × 103 cm)
Württembergische Staatsgalerie, Stuttgart (B-S 189)

In 1810 or possibly the following year Friedrich painted three Bohemian landscapes of quite similar character. All have the same format, and two of them can be considered companion pieces, one depicting morning and the other evening. These two, shown here, were bought by Count Franz Anton von Thun-Hohenstein, the owner of Tetschen Castle—a definite indication that they were intended as a pair. The third painting of a similar nature, *Landscape with Lake,* appears to have been painted independently; it was purchased about 1810 or later by Duke Karl August von Weimar, doubtless through the agency of Goethe.

These Bohemian landscapes appear to be true to nature, almost like photographs. They depict a peaceful, harmonious world. There is no trace of drama. It is as if Friedrich had to rest after the inner storm of *Monk by the Sea* (plate 7) and *Abbey in the Oak Forest* (plate 8), as though he needed to visit more benign locales once again after those inhospitable regions at the edges of human existence. Here the world has become welcoming again. A wide, well-traveled road leads into the center of the first picture (plate 10), where we discover a house with smoke rising from the chimney. People are at home here. We will see the same road again in another painting from two decades later, the picture in which the ruined Eldena Abbey has been transported to the Riesengebirge (plate 35). For Friedrich, even roads have their individual character. We will find them familiar if we take them again.

Inviting and broad, the road has two ruts with islands of grass down the middle. It disappears into a hollow, makes a turn, then reappears. It then forks and becomes two paths rather than a road, one leading off in a series of curves to the right and out of sight, the other continuing on toward a group of trees that forms a gateway. In the second picture (plate 11) we also encounter the motif of a gateway into nature, one that soars upward to dominate the center of the composition, but no longer is there a road leading

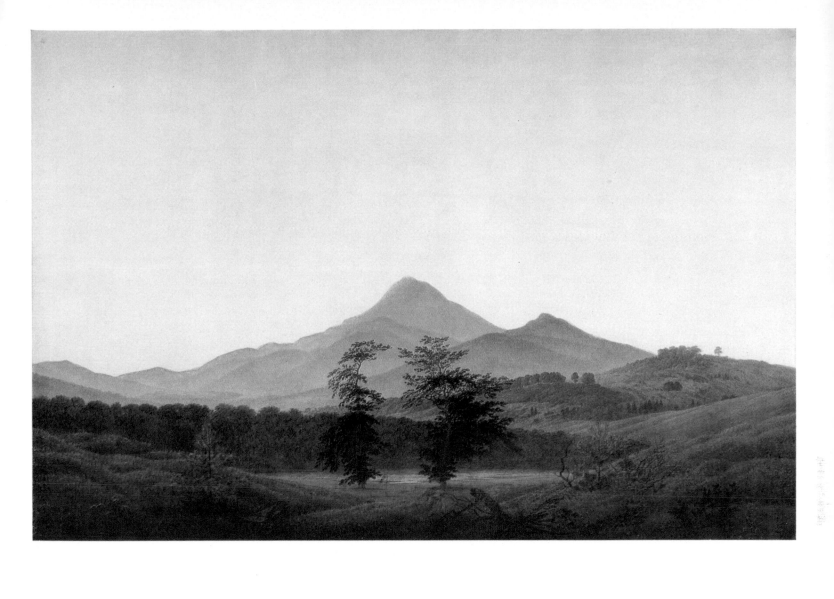

through it. In the first picture we lose sight of the path at this group of trees, and can only guess that it continues up to the house, following the draw, then again veers to the right. Perhaps its ultimate destination is the castle, indicated by two tiny towers, on one of the foothills between the two main peaks, or perhaps it leads beyond it. We cannot tell.

Bohemia was the first landscape Friedrich came to know after those of Greifswald, Rügen, and Neubrandenburg in Pomerania, which he had thoroughly explored during his youth and his student years in Copenhagen. He began to familiarize himself with it shortly after he moved to Dresden, striking out beyond the environs of the city. His sojourns in the Riesengebirge and the Harz Mountains came later. In 1807 and 1808 he went on long hiking trips in northern Bohemia and traversed the region once again on his way back from the Riesengebirge. It was also the last place he traveled to. In 1828 he stayed in the vicinity of Teplitz, and after a stroke in 1835 he took the cure there for six weeks, and began drawing again. From then on he could no longer travel.

His Bohemian scenes are among the most serene, most domesticated landscapes that Friedrich painted, yet there is not a soul to be seen in these pictures, not even on the roads. There are no shepherds, no hikers, not even as figures seen from the back. And

yet man is visibly evident in a nature that seems wholly intended for him, prepared to accommodate him.

Friedrich's Bohemian landscapes preserve a kind of recollection of paradise. They are full of nostalgia, steeped in homesickness, as though we had lost them once and for all. If one compares the two pictures, it becomes obvious how very different the morning is from the evening. In the second picture there is no longer a road leading into the landscape toward a house. Instead we are standing deep in a meadow. A gateway is formed by the two trees curving toward each other in the center, seemingly suggesting an approach to the mountain peak, yet it is meant for the eye alone. There is no trail leading upward, and a dark line of trees cuts into the picture like a barrier blocking our way. Only our gaze can pass beyond this obstacle, linger on the gentle foothills, and finally come to rest at the mountain's summit. In these two Bohemian landscapes morning and evening do indeed have very different qualities. If, however, we compare this mountain massif in the fading light of evening to a different and much more radical treatment of the same motif, in *The Watzmann* (plate 33), the two Bohemian landscapes are seen to be quite similar after all.

The first of these two paintings is usually called *Bohemian Landscape (with the Milleschauer),* although that mountain, near Teplitz,

is visible in both of them. For the background, Friedrich used a drawing of the Milleschauer that he had done perhaps as early as 1807, which presents something more like a village in the middle ground. In the painting the artist has added a large number of trees, and only the single house survives to remind us of the small farmsteads in the earlier work. Departing from his sketch, Friedrich solidified the symmetry of his composition by "sharpening" the right-hand peak, making the two mountains more similar in shape and extending the panorama to the right. The hill on the right side in the middle ground comes from a drawing from his Bohemian trip in 1807, and the road has been borrowed from a sketch made in Saxon Switzerland. Friedrich had drawn the group of trees in front of the house in the center in May 1806, in Neubrandenburg. It is likely that the bushy trees on the right-hand edge in the middle distance are—as Börsch-Supan suggests—based on a drawing, entitled *Treetop,* made in Saxony in April 1807. Here he has shortened their trunks, so that their leafy branches spread out closer to the ground. This is no place for towering, solitary trees. Everything hugs the gentle curves of the valleys, harmonizing with the lines of the hills.

The sources for the second painting are equally various. The two beeches whose tops curve toward each other like a gateway were drawn in different years and in different places, one in May 1807 in Saxony and the other in July 1809 in Neubrandenburg. Oddly enough the right-hand tree was originally an oak, but has here taken on something like the character of the beech with which it forms a pair. The bushes with the small pine on the right side and the twin pine on the left also come from the 1807 sketchbook. The line of woods thrusting into the center of the picture, behind the gateway of trees, Friedrich sketched in 1809 in Neubrandenburg, while the bare branch in the foreground and the thistle on the right go back to sketches from 1808–10 and 1799, respectively. For all their diverse origins, Friedrich has constructed out of these separate elements a painting as unified and consistent as one could imagine. Nothing seems out of place. It is true, of course, that all of these elements have one thing in common: they were discovered by the same piercing, affectionate gaze and drawn with the same care and precision.

One cannot look at these two pictures without taking special notice of the sky. Nowhere in Friedrich's work is the sky more serene, more still, than in these Bohemian landscapes. One recalls Caroline Friedrich's comment that "on days when he painted the sky no one was permitted to speak to him." No breath disturbs the serenity of these skies. The firmament stretched across the mountain in the evening light is just as peaceful as the morning one. A day has passed and nothing has been disturbed. ▓

12. MORNING IN THE RIESENGEBIRGE (CRUCIFIX ON THE MOUNTAINTOP)

1810–11. Oil on canvas, 42 × 66⅞" (108 × 170 cm)
Stiftung Preussischer Kulturbesitz, Schloss Charlottenburg, Berlin (B-S 190)

Friedrich probably composed his *Morning in the Riesengebirge* out of four separate sketches he had made while hiking in the region in 1810. Only two are extant. In one of them, *Sketch of a Boulder with Distant View,* dated July 11, 1810, it is possible to make out, despite some discrepancies, the silhouettes of the mountains in the left-hand part of the present picture. The study was made from the heights of the Riesengebirge—roughly from the Schneekoppe, which he climbed on that day. There is no surviving sketch of the ridge contours on the right side of the picture, and we cannot be certain that there was one. The drawings that Friedrich made on his wanderings in the Riesengebirge were all in a sketchbook that has been broken up. Some of its pages are scattered among various collections; others have disappeared. The second surviving drawing, made July 17, 1810, depicts the boulders next to the Kochelfall. Friedrich used it for the large boulders in the foreground, just below the mountain peak with the crucifix. There is no study of the peak itself. Günther Grundmann suspects that it is based on the Mannsteine, in the Riesengebirge, which does have the same vertical formation as this outcropping—though there was no cross on top of it. Werner Sumowski has nevertheless identified a detail of the rocks to the left of the cross in a study of boulders from 1799, a sketch made over a decade before Friedrich first set foot in the Riesengebirge.

Morning in the Riesengebirge is thus a panorama of an ideal landscape, one based on sketches made in earlier years though, as Grundmann insists, with the typical features of the Riesengebirge. He believes that Friedrich, with his unusual way of working, has "attained an ultimate idealized likeness," one that might be described as a "spiritual portrait."

It is true that the work is a "spiritualized" landscape in which the Riesengebirge have clearly taken on for Friedrich a numinous quality. To quote Grundmann again:

The mountains in the foreground lift their stony masses in sharp outlines out of a thick fog that grows thinner and lighter the further one's gaze penetrates into the distance. One therefore senses the contrast between the charming expanse of the valley, still shrouded in sleep, and the rigid and unchanging wakefulness of the height.

The painting was bought by Friedrich Wilhelm III of Prussia for 200 thalers at the Berlin Academy exhibition in 1812. It was not so much the otherworldly clarity of the work that captivated him as what to his mind was its realistic depiction of an experience of nature. According to the testimony of Johann Gottfried Schadow, the king announced while standing in front of the painting:

That's a nice picture; when I went to Teplitz I got up early and decided to have a look at the charming countryside; the hilltops were looming up out of the mist just like this, so that it looked like the ocean, and I couldn't

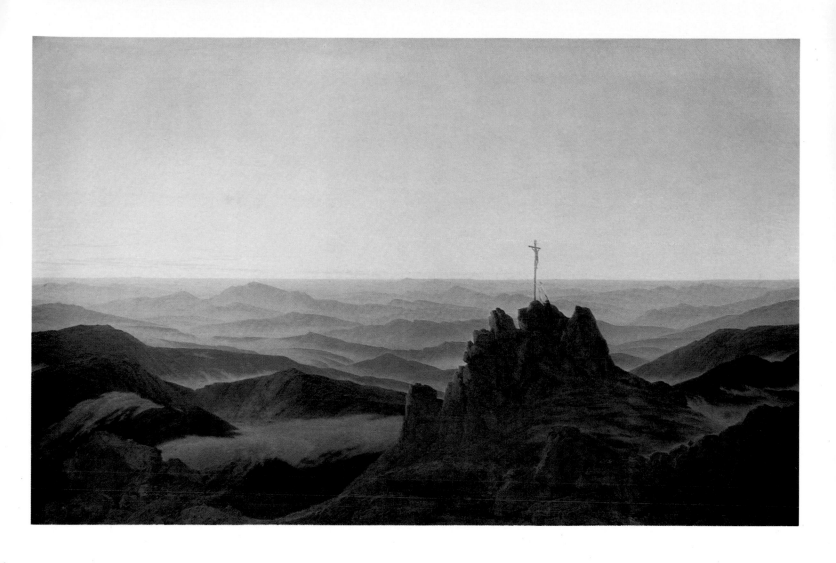

quite make out what I wanted to. If you haven't actually seen this you wouldn't believe it is true.

Schadow relates that the artists in the king's entourage were nonetheless "unanimous in their conviction that Friedrich had painted something he only imagined."

Although Friedrich started to work on the picture immediately after returning from his trip to the Riesengebirge, he did not complete it until March 1811, so that it was submitted somewhat late—as was almost always Friedrich's habit—for the annual exhibition at the Dresden Academy. The picture was enthusiastically received. Friedrich then stood at the height of his early fame. The *Zeitung für die elegante Welt* reported:

A few days before the close of this year's exhibition the original landscape painter Friedrich, only recently named a member of the Berlin Academy, submitted yet another large landscape in oils, to which all Dresden soon made pilgrimage, and the gifted and sensitive artist had the satisfaction of seeing the response that he intended to produce with this portrayal, which deeply affects everyone who sees it, in full measure achieved.

The cross that rises up above the horizon from the peak in the right foreground and balances the rising sun at the left of the picture towers over the land, which from this perspective resembles the sea. Like surging breakers, the mountain ridges roll out of the mist toward the craggy "shore." A woman—Goethe's "eternal feminine"?—is urging a man up toward the cross, which she herself has just reached. Lankheit linked this element of the painting to Friedrich Schleiermacher's idea that the beloved leads one to God. A number of contemporaries understood the painting in this way as well, as a passage from the reminiscences of Wilhelm von Kügelgen makes clear:

On a high crag rising up out of the darkest depths and towering into the bright morning sky stands a cross. A woman clasps it with one hand while holding out the other to help the man climbing up behind her. That was a touching chapter in the history of mankind, and especially my parents' history. My mother was the first to follow the path of faith. She was the first to reach the heights, where she found her heart's solace, and she then drew up after her the man she loved.

In addition to its religious content, we must not overlook the picture's patriotic dimension. The high mountains were frequently employed as a symbol of freedom by the early Romantics. The wanderer who reaches such heights has stripped off the constraints of the present, escaped all arbitrary political boundaries. The mountain landscape lies before him like the endless breadth of the sea, which no one can conquer. Here he confronts the awesome power of nature, in which—as the cross on the craggy summit reminds us—we can recognize the divine plan of the Creator. ▨

13. GARDEN TERRACE

1811–12. Oil on canvas, 21 × 27½" (53.5 × 70 cm)
Verwaltung der Staatlichen Schlösser und Gärten, Postdam-Sanssouci (B-S 199)

Friedrich tried for the most part to hide his love of geometry, but here it comes to light, serving as the actual subject of a painting. He presents a garden terrace, a setting meticulously shaped and ordered by man; everything suggests that the person who planned it and owns it lives in a nearby palace. The landscape visible beyond the park wall seems to have been tamed as well; we see a house on a hill, surrounded by meadows and orchards, and a castle on the mountain behind.

The painting is controlled by two systems of symmetry that support each other and vie with each other at the same time. The first and more obvious one is established by the two chestnut trees that frame the view. The circle of grass in the center is part of it, as is the stone figure on a square pedestal, slightly off center, above which the mountain in the background rises like the pediment of a temple.

This strict symmetry is opposed by a second system dominated by the two lions guarding the wrought-iron garden gate, which has a cross at its center. The basket with a red cloth at the bottom and the forested mountain topped by a castle in the background are aligned on this axis. The pediment shape recurs five times on this second axis: above, it is suggested by the foliage of the chestnut trees, which sinks down toward the statue in the center of the picture and also to the right of the trunk of the right-hand tree. The gentle curve of the castle mountain repeats it, though much less forcefully than the distant mountain peak. The pentagon of the garden gate forms a definite gable, and the recumbent lions to the right and left of it, the lines of their bodies lifting toward their heads, suggest a pediment form that would peak above the cross. The same shape is echoed a last time in the red cloth draped over the basket like a roof.

With its repeated pediment shapes on a single axis the second symmetry attempts to tip the first one out of balance. Its challenge is bolstered by the figure of the woman reading on the garden bench. She functions as a counterpart to the stone figure in the center of the first symmetry and threatens to draw the figure into the system of the second, for with the stone figure and the pair of lions she could define that second axis and firmly anchor it. And she succeeds; the statue already appears to have been pulled a little away from the central axis toward the right.

As a consequence the picture, seemingly so carefully balanced, has become heavy on the right side; the only counterweight on the left is the low hill bathed in full sunlight just above the garden wall, for the succession of mountain ridges belongs to more distant planes of space. This sunny hill would hardly be enough to prevent the picture from "tipping" to the right if the whole composition were not firmly stabilized by a number of strong horizontal elements in the foreground: the bands of paths and grass and wall constitute a solid base that can easily support the interplay of symmetries.

A preliminary drawing of the foreground, *Two Trees (View of a Park),* dated September 1811, shows how deliberately Friedrich constructed that base. There we find the two trunks of the chestnut trees and their luxuriant foliage, but the strip of lawn they stand in is interrupted by a path leading to a small, elliptical pool. When he painted *Garden Terrace,* Friedrich omitted this path, merged the two strips of grass, and thereby, with the continuous bands of path, lawn, and garden wall, created a foreground barrier, a device common to many of his compositions. Without it the picture would have fallen apart.

In addition to the drawing already mentioned, Friedrich probably used for this picture a landscape sketch he had made near Zittau on July 6, 1810, while touring the Riesengebirge. It presents a view of the Isergebirge. If this is the case, the lines of the mountains in the background represent the foothills of the Riesengebirge, which had a numinous significance for Friedrich.

Friedrich painted *Garden Terrace* between September 1811 and March 1812. As soon as it was finished he submitted it to the exhibition of the Dresden Academy and in the fall of the same year sent it to Berlin for the Academy exhibition there. The critic for the *Morgenblatt für die gebildeten Stände* was delighted to discover from what he saw as "a charming background" that "Friedrich can also have cheerful thoughts." The journal *Der Freimüthige* acknowledged the "diligence and cleanliness" of its execution, but found the concept of the landscape "too pedantic and forced." A review in the *Journal des Luxus und der Moden* was also less than complimentary; it praised the "expansive, hazy mountain distance" and the "gleaming, bright sky," but would have liked "rather more warmth," and criticized the composition as "somewhat forced."

Obviously Friedrich's fondness for geometry was not shared by his countrymen. It may be that such a charming depiction of a geometric park struck them as an impermissible homage to French rationalism. Nonetheless, it is possible to interpret the painting in an altogether different way. One could think of the foreground as the present, subjected to strict regimentation, and the sunlit landscape behind the closed gate as a vision of the freedom and joyous fulfillment of the future, a future that seems almost within reach. Read this way the picture takes on a "patriotic" meaning after all. ▨

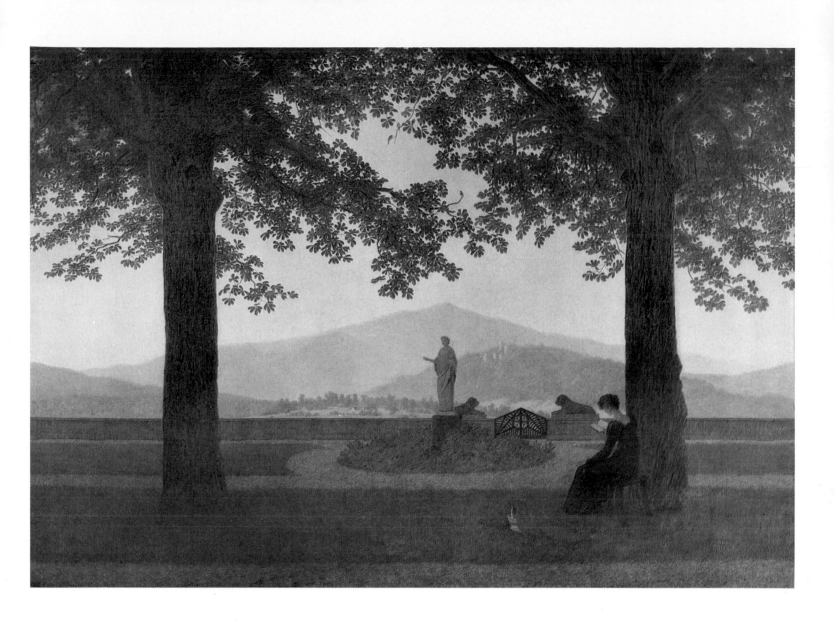

14. CHASSEUR IN THE FOREST (FIR FOREST WITH RAVEN)

1814. Oil on canvas, 25⅞ × 18⅜" (65.7 × 46.7 cm)
Private collection, Bielefeld (B-S 207)

Chasseur in the Forest is one of a group of patriotic pictures Friedrich painted in 1812–14. It was probably first shown at an exhibition of patriotic art mounted in Dresden in March 1814. We know for certain that it was included in the exhibition at the Berlin Academy in October of that year, shortly after it had been purchased by Prince Malte von Putbus. In the catalogue of his collection, Prince Putbus described it as follows: "It is a winter landscape, the cavalryman, who has already lost his horse, is rushing into the arms of death. A raven caws his funeral dirge. This picture too, like almost all paintings by this master, is mystical, grim, and bleak." The *Vossische Zeitung* discussed it in similar terms on the occasion of the Berlin exhibition: "A raven sitting on the stump of a tree is singing the death knell for a French cavalryman walking alone through the fir forest in the snow. Herr Friedrich's pictures are gloomy and strange."

Just as Napoléon's army had perished in the winter wastes of Russia, this straggling French soldier is lost in the depths of the German forest. He has stopped, not knowing which way to turn. The forest envelops him. Friedrich's pictures nearly always proceed from a dark foreground to a light background—the sky—opening out into infinity, but here the gradation of colors is reversed. The small island of light in the foreground gives way to the rusts and deep browns of the firs and spruces that barely permit a glimpse of a leaden, overcast winter sky. This is what produces the feeling of claustrophobia, of entrapment. The path leads no further. The soldier will leave no tracks.

We encounter the French cavalryman in a comparable situation in some other Friedrich pictures as well: in *Rocky Gorge (Grave of Arminius)* (fig. 15), he stands at the entrance to a cave in which there is an open sarcophagus. There too he has lost his way and stands at the end of his journey. In the picture *Graves of Fallen Freedom Fighters*, which depicts a similar tomblike cave surrounded by a number of tombstones and an obelisk, two foreign soldiers are standing guard; the dark opening threatens to pull them in like a vortex. In both pictures of graves, which go back to studies that Friedrich made in his tour through the gorges and valleys of the Harz Mountains in 1811, our gaze is drawn into the depths; rocky walls extend upward to the top edge of the picture, and no sky is visible. The effect is similar to that of the present painting, but here it is even more pointed and intense. One cannot imagine a more concise or forceful statement. This is Friedrich's definitive comment on the wars of liberation. He refers to them only twice more, in the lost *Memorial for a Fallen Soldier of the Wars of Liberation* and in *Ulrich von Hutten's Tomb* (fig. 24), in which a wanderer in the ruin at Oybin in the Riesengebirge muses on the story and lessons of the struggle for freedom.

Friedrich returned to the motif of *Chasseur in the Forest* fourteen years later in the painting *Early Snow* (fig. 52) in the Kunsthalle, Hamburg. There he has completely changed it. The composition of the picture is almost identical, and yet the effect is altogether different. The cavalryman is no longer there, the raven has vanished, the two tree stumps are gone, and the unmarked patch of snow in the foreground has become a definite road revealing fresh tracks. A protective blanket of snow covers the ground and dusts the fir saplings standing on either side of the track. Friedrich once called winter's covering of snow "the essence of absolute purity, beneath which nature readies itself for new life." The firs that were previously rendered in rusts and browns are now a dark green that only occasionally passes over into ocher and brownish tones. The clouds have parted, permitting us to see a patch of blue sky. The pure landscape, emptied of figures, is like a rebirth.

Friedrich's patriotism, and his dislike of the French, is confirmed in the writings of many who knew him, beginning with Gotthilf Heinrich von Schubert in 1808 and Theodor Körner in 1810, continuing with Karl Förster in 1820 and Johann Christian Clausen Dahl in 1840, and ending with Carl Gustav Carus, in comments in his reminiscences as late as 1865. In a fragment of what was to be the first monograph on the painter, published posthumously in 1915 under the revealing title *God, Freedom, Fatherland*, Friedrich's rediscoverer, Andreas Aubert, suggests that the first reading of Heinrich von Kleist's *Hermannsschlacht* may have taken place in Friedrich's studio in Dresden. It is true that Kleist wrote his patriotic drama while staying in that city. He finished it before the end of 1808, and it was then secretly passed from hand to hand in manuscript form. On occasion the poet also read it aloud to trusted friends. We know for certain that Friedrich knew the play: "If one considers what an appropriate setting Friedrich's bare-walled studio provided, given the mood of the times, one comes up with an altogether characteristic and intriguing historical picture: three or four men seated on chairs and benches brought in from the bedroom or the hall, listening breathlessly as Kleist read them his *Hermannsschlacht*."

Even though this may well be only a legend, it provides an accurate indication of Friedrich's "German" feelings during the years of French rule. We have seen evidence of his patriotism in his predilection for cairns and boulders, for solitary oaks, and for firs rooted in meager, rocky soil. It is even more apparent in the "old German" costumes with which he clothed his figures. These were seen as a provocation not only during the wars of liberation; even in the period that saw the restoration of the independent German states, they continued to argue for a liberal republican, all-embracing German homeland.

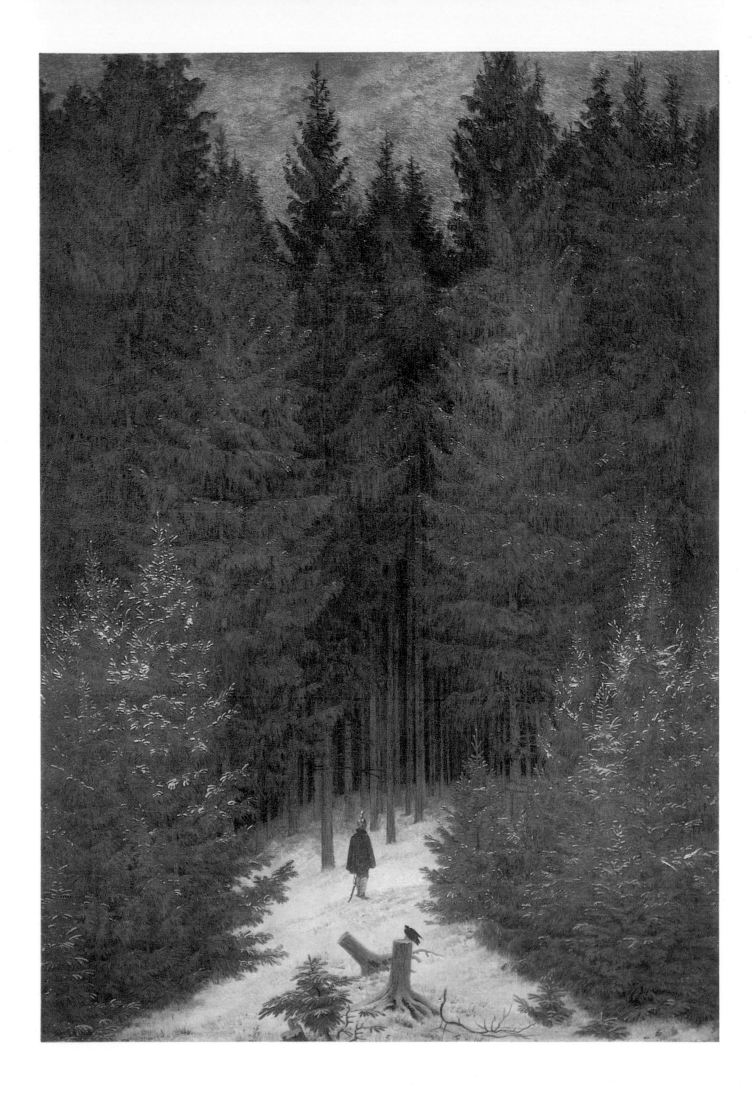

15. GREIFSWALD IN MOONLIGHT

1816–17. Oil on canvas, 8¾ × 12" (22.5 × 30.5 cm)
Nasjonalgalleriet, Oslo (B-S 224)

This picture is an enigma. It presents the silhouette of the city of Greifswald as it would appear from the land side, but here it is seen from a completely different vantage point, across the water, as though the city were an island in the sea. Our gaze proceeds from the shore, across a few overturned boats, past boulders that echo the contours of the boats' hulls, beyond two small sailboats at their moorings, to an approaching rowboat in the center of the picture. Our view then continues across the drying nets, which repeat the shape of the rowboat, and out onto open water. Just where we might expect only more sea and the horizon, we are suddenly confronted with Greifswald.

Can this indeed be Greifswald? Or is it a mirage? The city lies directly above the fishing nets, as though they had scooped it out of the water. It seems to be supported by the poles that hold the nets, which stretch across nearly the entire width of the picture, as if the city stood on piles.

The picture is clearly organized into two planes, a lower one rendered in dark browns that only gradually grow lighter, and an upper one consisting of the sky, which slowly becomes more overcast the higher it is from the horizon. The city appears at the point where the two zones meet, resting precisely on the line of the horizon, which is as straight as if drawn with a ruler. Its silhouette stands out distinctly against the twilight sky. Its uniformly gray shading, as though veiled in many layers of mist, distinguishes it from the brown tones of the foreground, revealing it and hiding it at the same time, lending it an unreal, luminous quality. Greifswald is there and yet it isn't.

This is the view of Greifswald from the banks of the upper Ryk just above its mouth, looking across the meadows to the east at the city and its towers. There is the slender spire of St. Nikolai, the squat one of the Jacobikirche next to it, the Rathaus, and the Marienkirche to the left. Friedrich incorporated this image of the city into his *Meadows near Greifswald* (fig. 28), a painting that appears to be a simple panorama, a rural idyll. Even there, however, the pale violet-gray shading that sets the city silhouette apart from the rest of the painting, and the placement of that silhouette precisely on the line of the horizon, betrays the fact that he painted the later work with *Greifswald in Moonlight* in mind. In that picture too there is something otherworldly about the city; it is both real and unreal, neither altogether one nor the other.

Friedrich painted *Greifswald in Moonlight* in 1816–17, and exhibited it as *A Landscape in the Moonlight* at the Dresden exhibition in August 1817. The reviews were brief but positive.

The work combines motifs from various earlier sketches. The two sailboats and the rowboat in the center are found in a drawing of August 3, 1815—Friedrich had come on a visit to Greifswald again in August of that year—and the drying nets and the row of stones in the water appear in a sketch dated October 7 and 8, 1815. The silhouette of Greifswald is almost exactly like the one that appears in a drawing entitled *Cow Pastures* that only recently came

to light and was shown in the exhibition at the Kunsthalle, Hamburg, in 1974. Sometime after 1820 Friedrich used this landscape sketch as the basis for the picture *Meadows near Greifswald*, and for that purpose inscribed a grid of squares across it.

It is not known just when he made the *Cow Pastures* drawing, but presumably it was on his visit to Greifswald in either 1809 or 1815. In the early 1820s, when for a time his work took on overtones of "view" painting, he went back into his stock of drawings in search of older works presenting complete landscapes. We see this, for example, in the case of *Afternoon* (plate 24) from his cycle *The Times of Day* or of *Scudding Clouds* (plate 27). It is perfectly conceivable that he had already copied the silhouette of Greifswald for the present picture from that sketch, simply omitting the windmills and causing structures that project forward toward the viewer to pull back and become part of the uniformly gray front of this "floating" city.

Gerhard Eimer has pointed out that Friedrich dramatically heightened the two church towers in the middle of the Greifswald silhouette so as to make them conform more closely to his vision of Gothic architecture. He writes:

The picture of Greifswald in Oslo [presents] the city in a more idealized form than that found in comparable examples . . . the two solitary figures in the moving boat that forms the focal point of this highly symmetrical composition are absorbed in contemplating the city's silhouette by night. Yet nowhere is Gothic architecture given such a prominent role as the goal of human aspirations as it is in the idealized Nordic city in the picture On the Sailboat *[plate 18].*

There is something else that is odd about the picture *Greifswald in Moonlight*. Once one gets beyond the barriers of the upended boats, the rocks, and the outspread nets, it becomes clear that the foreground extends continuously to the horizon, out into an infinite space that is clearly indicated at the left and right edges of the painting. Yet the nets are puzzling; though close to shore, at the same time they appear to be tied to the silhouette of the city by the poles poking up to the horizon line. The city begins only at the horizon, after an expanse of open water. We have no idea how far away it really is. If we think of it as being relatively close, cradled in the nearby fishermen's nets, it tends to dissolve into a mirage. If we understand it as being at a great distance, however, it becomes more real, a revelation. But where is it truly? Friedrich leaves the question open.

Any discussion of *Greifswald in Moonlight* must mention another painting, *The Nets* (fig. 65), in the State Hermitage Museum, St. Petersburg. It was produced about a decade and a half later, around 1830–35, and has approximately the same dimensions. It was apparently conceived as a companion piece to the vision of *Greifswald in Moonlight,* not merely a variant of the earlier work. It presents the same setting, the same twilight mood. Everything is just

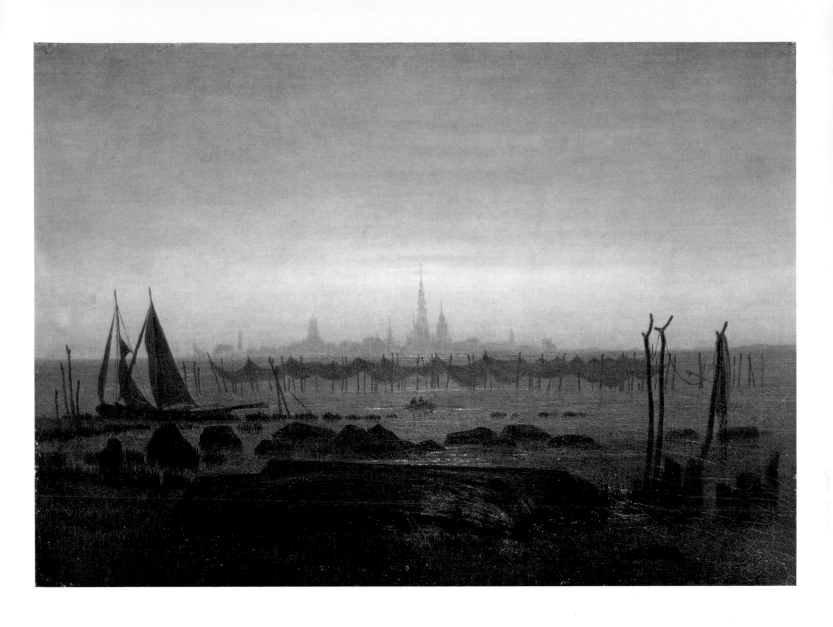

as in the earlier painting—the shore, the nets spread out over the entire width of the picture below the horizon line, the open sea. Only one thing is missing: the vision. One looks in vain for a floating city; the horizon is empty. The overturned boats on the shore have also disappeared, as have the sailboats on the left and the vertical poles at the edge of the water on the right. Instead we see a flock of dark birds swooping up into the evening sky.

There are a number of comparable paintings in Friedrich's oeuvre that can be called "emptied repetitions." In his late years again and again he took up motifs from earlier pictures and reused them, but this time leaving out their essential element—the vision. One need only compare *Chasseur in the Forest* (plate 14) with *Early Snow* (fig. 52), or *Chalk Cliffs on Rügen* (plate 17) with the later watercolor of the same title (fig. 53). In each case the later reworking seems suddenly void and somehow frightening. Nowhere do we feel the loss as acutely as in *The Nets*. It is as though nature had relinquished its meaning. A picture like *The Nets*, one suspects, can have been created only by one close to despair. ▦

16. SHIPS IN GREIFSWALD HARBOR

c. 1818–20. Oil on canvas, 35⅜ × 27½" (90 × 70 cm)
Staatliche Museen Preussischer Kulturbesitz, Nationalgalerie, Berlin (B-S 1)

This painting shows Greifswald's outer harbor after sunset. We see the city roughly from the point at which the Ryk flows into Greifswald Bay near Wyk. We are looking inland at the silhouette of the city, where the Marienkirche and the Cathedral of St. Nikolai are visible close together. In the haze next to the large ship crouches the Jacobikirche, and to the far right, next to the smaller ship, one can just make out the Fangel Tower. The silhouette conforms reasonably closely to the actual topography.

The city of Greifswald, which appears in pictures such as *Greifswald in Moonlight* (plate 15) or *Meadows near Greifswald* (fig. 28) as an otherworldly vision, is here conceived more soberly and realistically; it is placed firmly within the structure of the picture, overtowered by the tall masts of the sailing ships. The ships and the churches come from the same earthly sphere.

Ludwig Justi described this picture in 1920, shortly after it was acquired by the Nationalgalerie, Berlin, as follows:

The large sailing ship is to be thought of as the chief object in Friedrich's view of the harbor, studied and felt with Romantic affection. Its sails furled, the nautical skeleton stands against the sky, precisely and sharply drawn, looking like the leafless branches or the stark ruin in Monastery Graveyard in the Snow *[fig. 21]; and as there, the sky glows in a splendid show of color; in the harbor scene, however, the sea wind is still driving wisps of cirrus clouds high above, while stillness and emptiness lie above the graveyard. Accompanying the ship on the left is the lively outline of the many-towered city in the gray twilight, while to the right are the masts of the inner harbor. In the foreground, dark, unstressed, there is activity on the shore: fishermen in a boat and on land, nets hung out to dry. The old habit of forcing the rest of the picture back by means of a dark mass at the lower edge reveals itself here more clearly than in other Friedrich paintings, and one is also more aware of the calculation in the other space-creating devices: small sailboats and rowboats, bits of shoreline. His painterly touch appears to be less fresh than usual in the dark sections, but the sky and the large ship are delicate and rich. These are the bearers of the spiritual content of the picture: the solemn, glowing evening sky, the day closing with a dramatic show; and the tall-masted ship, come from far away and now at rest. The essence of this work only becomes apparent once we appreciate the secret magic that the painter perceived in masts and rigging. Ardor and longing and reverie lurk in these forms represented with what appears to be such realism—not exaggerated as in stage sets for Wagner, but painted delicately and with restraint.*

Ships in Greifswald Harbor, then in the collection of the Kirchhoff family in Greifswald, was first shown at the exhibition of a century of German art in Berlin in 1906. Various dates have been assigned to the picture by critics. Andreas Aubert, Friedrich's rediscoverer, suggests a date of 1808–12; Justi, c. 1815; Willi Wolfradt, c. 1810; Herbert von Einem, c. 1810; Hubert Schrade, before 1810; Sigrid Hinz, c. 1807; Irma Emmrich, Willi Geismeier, and L. D. Ettlinger, c. 1810; Werner Sumowski, c. 1820; and Willi Geismeier, again, c. 1815–16. The arguments of Werner Sumowski, who like others points out a drawing, dated 1818, of a ship similar to the one in the center of the painting, are the most convincing: the spacious and unforced composition and the sensitive coloring are stylistic features that speak for the period around 1820 (the year of *Monastery Graveyard in the Snow*, mentioned by Justi). A further point of reference is that the painting *Ships in Greifswald Harbor*, in contrast to *View of a Harbor* dating from 1815–16, is closely related in spirit to the *Greifswald Harbor* that belonged to the Kunsthalle, Hamburg, but was destroyed in the fire at the Crystal Palace exhibition in Munich in 1931. Willi Wolfradt remarked on the similarity of the two works and placed them opposite one another in his book. A date after 1818 is assured for the lost work, based on various drawings. Börsch-Supan described it as follows: "The painting belongs among the … viewlike pictures of the period around 1819–25, whose symbolic content is veiled. Because of its seemingly chance arrangement it is difficult to see that it is put together from a number of sketches."

Surprisingly, Börsch-Supan questioned the authenticity of the present picture, though no one ever had before. Choosing not to include it in his catalogue raisonné, he offered the following arguments: the painting in the foreground, in the area of the water, the nets, and the figures, is weak and indistinct, as in no other Friedrich work; the figures add only anecdotal narrative to the painting, and have no allegorical significance; and it is also impossible to see any symbolism in the closer deep-sea vessel—the central motif in the picture:

On the Ryk there is constant traffic in both directions. In Friedrich, the arrival of ships in a harbor in the evening would suggest death. The departure of a ship from the harbor at the same time would run counter to that meaning…. The sickle of the waxing moon is here hardly to be understood as a Christ symbol, for its curve echoes the filled sails of the boat beneath it, but is not related to the city's churches.

In my opinion, his exclusion of the picture from Friedrich's oeuvre is arbitrary, insufficiently argued, and—after weighing all of his arguments—unjustified. I would propose the following counter-arguments. The weakness and indistinctness of the painting in the foreground noticed by Börsch-Supan probably had to do with the earlier condition of the picture. The notes made during restoration work at the Nationalgalerie, Berlin, in June 1970 say this about it: "The foreground has an especially thick layer of colored varnish, obviously applied in order to mask a fine network of tiny white cracks and various repairs. In these sections the brown underpainting is visible and interrupts the originally quite precisely separated forms (grass, stones, nets, and poles)." An infrared photograph made in 1974 (fig. 27) shows that the foreground was painted over: beneath the boat form in the lower left a smaller boat is visible, one in a different scale than the two fishermen at work there. The figures, like the boat they are unloading, were therefore added to the picture in a later stage. When and by whom, we do not know. Perhaps they were done by someone else; they certainly look like foreign elements. In this connection let me only refer to a picture like 1820 *Crucifix in the Mountains* (also

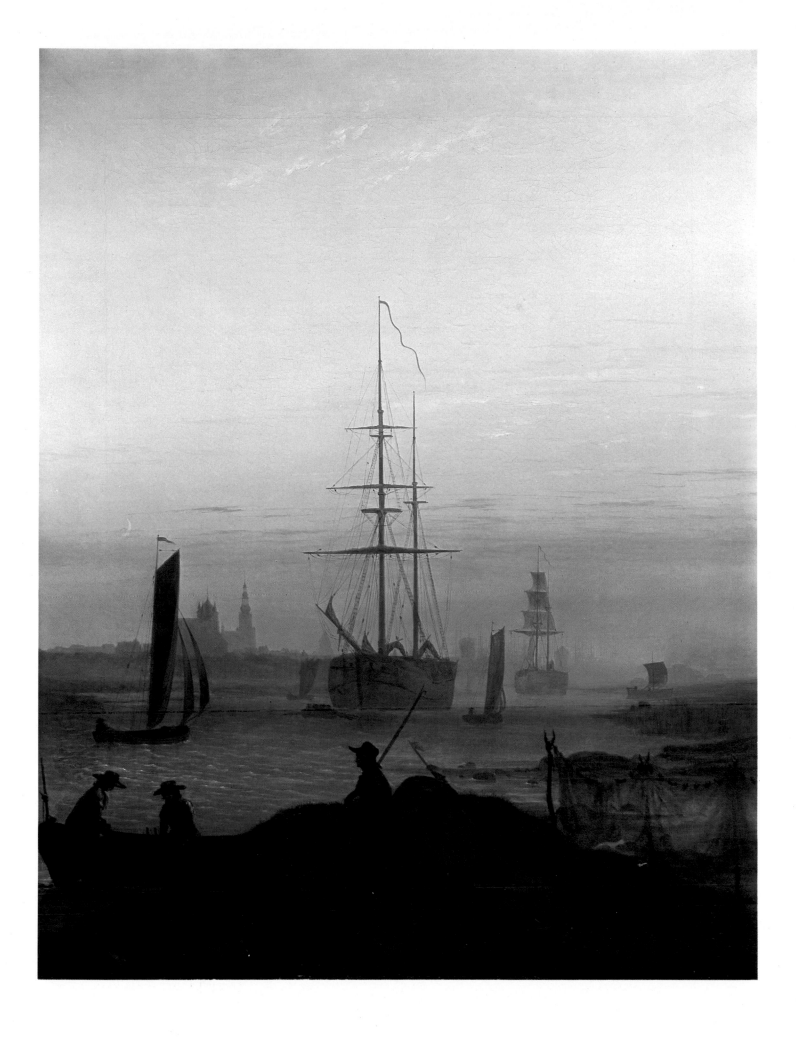

known as *The Ilsenstein* or *Crown of Thorns*), on which—possibly even while Friedrich was still alive—another painter added obtrusive blooming branches so as to fill what was perceived as an empty foreground. Perhaps the present case is a parallel instance. To be sure, Friedrich himself repeatedly included in his pictures what Schelling called "autochthonous figures," fishermen at their chores, shepherds, figures that blend in perfectly with the depicted scene in costume and bearing. But there is something markedly banal about the figures in the present picture. Yet even if we assume that they were a later addition, they still do not affect the authenticity of the picture as a whole.

Moreover, I am by no means in agreement with Börsch-Supan's opinion that even the smallest figures in Friedrich have to be laden with allegory; in the fishermen's daily routine there is meaning enough. Finally, what he says about the significance of arriving or departing ships as symbols of death or about the moon as a symbol of Christ and its specific relation to the church spires is pure speculation. Hans Werner Grohn, who diligently prepared the catalogue of the Hamburg Friedrich exhibition of 1974, in which the painting was shown, had this to say:

Two facts argue against these statements, which are highly subjective and therefore difficult to refute. The Hamburg Greifswald Harbor, *like the Potsdam painting* View of a Harbor, *shows departing and arriving ships, which Börsch-Supan here interprets as "death" and "resurrection." In both pictures there are staffage figures engaged in everyday activities like caulking, bathing, or doing laundry, the symbolic significance of which must be left to Börsch-Supan's high-flown imagination.*

Friedrich scholarship is indebted to Börsch-Supan for a wealth of crucial insights. In some of the painter's most important works he has discovered a meaning, but it is a mistake to expect that meaning to remain consistent and unchanging in all of the artist's paintings. In another part of the Hamburg catalogue, Werner Hofmann pointed out:

Any assumption that there is some constant gauge of meaning on the one hand leads to the questionable exclusion of pictures that fail to meet that measure, and on the other leaves the door wide open to overinterpretation. One can avoid this danger by making distinctions, that is by applying to Friedrich a pair of hypotheses valid for every artist's work—namely that there is an overall decline in the intensity of its meaning and that some paintings are more expressive than others.

In sum, Friedrich's authorship of the painting *Ships in Greifswald Harbor* has not been shaken. Börsch-Supan's suggestion that it is possibly the work of the unimposing Stralsund painter Johann Wilhelm Brüggemann, whom H. W. Grohn describes as "a modest painter of seascapes and landscapes in the Netherlandish style, who would scarcely have been capable of such an impressive picture," must be dismissed absolutely. The picture should be assigned a place in Friedrich's oeuvre in close proximity to the *Greifswald Harbor* formerly in the Kunsthalle, Hamburg. Its dating, 1818–20 or somewhat later, connects it with a group of pictures whose whole conception is more realistic, more concerned with detail, and more viewlike than that of the core works created around 1810 or 1830. The Romantic evening atmosphere above the harbor is altogether Friedrich. The drawing of the ship, as the infrared photograph has revealed, is systematic and constructive. The figures in the foreground do not altogether fit in with the character of the picture, to be sure, raising questions we are as yet unable to answer. ▩

17. CHALK CLIFFS ON RÜGEN

c. 1818. Oil on canvas, 35⅝ × 28" (90.5 × 71 cm)
Stiftung Oskar Reinhart, Winterthur (B-S 257)

This picture is a memento of Friedrich's honeymoon journey, which took him to Rügen. Friedrich had married Caroline Bommer, nineteen years younger than he, in Dresden on January 21, 1818. His friends were astonished, for they had thought of him—in the words of Marie Helene von Kügelgen from a letter written in 1808—as the "most single of singles." Carl Gustav Carus wrote:

Friedrich's friends were greatly surprised when he married about this time, for no one would have expected the shy, melancholic artist capable of taking such a step. He lived there next to the Elbe, on what they call the Elbberg, and the daughter of a middle-class family in the neighborhood ... was his choice; a simple, quiet woman who in time bore him several children, but who otherwise did nothing to change his nature or his habits.

He soon planned a wedding journey that included visits to his three brothers and their families in Greifswald, and which then in the summer took them further, to Wolgast, Rügen, and Stralsund. His favorite brother, Christian, and his wife joined the newlyweds on Rügen island. The painter's recollection of a happy August day on the island's steep coast resonates in the present picture, which was probably painted in Dresden the following winter and was perhaps the work that he gave notice of to Dr. Ludwig Puttrich in Greifswald in April 1819, requesting that he show it to friends and acquaintances but not enter it in any public exhibitions.

Opinions differ about just which part of Rügen is depicted in the painting. Is this the chalk headland of Jasmund, Klein-Stubbenkammer? Important objections have been raised against it. Gülzow, whom most scholars tend to follow, claims that this is Stubbenkammer and the Feuerregenfelsen. Sigrid Hinz, however, argues for identifying it with the Wissower Klinken. Radu Bogdan, the Romanian scholar, recently suggested a list of various locations, assuming that in his typical manner Friedrich here combined motifs from several nature studies into a unified whole. He believes—as he explained in a lecture given in Greifswald in 1974, in which he was able to draw on investigations and photographs he had made on the spot—that the cliff on the right is the gorge of the Königsstuhl, while the one on the left is part of the Viktoriasicht in Klein-Stubbenkammer; the two chalk pillars in the center would then have been taken from the ravine next to the Königsstuhl, though the spatial effect they produce is more reminiscent of the Wissower Klinken.

It may at first seem a waste of time to follow the discussion of topography in such detail and to establish so precisely the independence of the painting's composition from the actual Rügen landscape. Is it really important whether Friedrich used in his picture this cliff from Rügen's steep coast or that one? Or whether he adhered to a single impression or combined various studies from nature? Is it not immaterial whether he heightened a cliff that was part of the scenery of the Königsstuhl and made it more cleft than it really was, or whether he took this steep and bizarre gorge from

some other location? As a matter of fact these details are worth pursuing, for Friedrich's seemingly unimportant changes to the actual topography of the island as noted by Bogdan are precisely what permit us to understand the singular quality and effect of the composition. By isolating specific observations from nature and blending them into a compositional structure entirely his own, Friedrich managed to derive from them an entirely new feeling.

Just as scholars have failed to agree about the actual location Friedrich depicted in this painting, they have differing opinions about how its figures are to be interpreted. Though it would seem perfectly obvious that the woman in the red dress is Caroline Friedrich, it is not so easy to determine which of the two men is the painter himself, who surely must be present. Is he the man in a beret leaning against a decaying tree stump and gazing off into the distance? Or did the artist intend to represent himself in the figure lying on the ground? Is Friedrich captivated by the sight of the horizon and the ships on the open sea? Or does he identify himself with the other man, cautiously judging the depth of the abyss? While the man in the beret takes in the whole expanse of nature, the figure on the ground is caught up in a few of its details.

Jens Christian Jensen recently made an interesting suggestion that may help to resolve the question. He wonders if this is not in fact a double self-portrait, one in which Friedrich alludes to his still unfamiliar dual role as artist and husband. While the artist figure stands off to the side—his traditional German costume in a dark brown more closely tied to nature than the more colorful garments of the other figures, who appear to be city folk on an outing—the man in the center and the woman are obviously related. The woman appears to be attempting to draw the man's attention to something specific on the ground, a few low-growing flowers. He has bent down as though hoping to pick them and cautiously crawled forward to the edge of the cliff, only to become transfixed by the yawning chasm below. Perhaps the woman's gesture is meant to warn him of the drop. In any case, it is on that gesture that the ambiguity of the entire composition hinges. The figures are resting next to a precipice, a cliff by the sea, yet there is scarcely anything threatening about the picture. Friedrich often depicts figures standing next to an abyss, after all, so this is nothing unusual. They are altogether at home there. In this case, however, next to an especially steep, jagged drop and hanging onto only a tuft of grass or some dead roots, they are in a sense more closely tied to nature than ever before.

Nature has assimilated them. The sea and the sky shimmer in red and blue, blending the colors of the woman's dress and the man's frock coat. Red and blue caress each other in the play of countless waves, and the reflection from the white cliffs also reiterates the message that red and blue have become one. *Chalk Cliffs on Rügen* is truly a wedding picture in every sense. It is only the dreaming artist at the side, though seemingly closest to nature, who appears to be a stranger in the scene.

81

Jensen, to whom we are indebted for the suggestion that this is a double self-portrait, noted that the framing elements in the picture, consisting of the trees on either side and the grassy shelf in the foreground, have the form of a heart, its point marked by the notch in the grass between the woman and the kneeling man, which only serves to confirm our reading of the work as a symbolic wedding picture.

Werner Hofmann has discovered an entirely different feature: if one turns the picture upside down, the space too becomes reversed, and the cavernous prospect opening out between the cliffs becomes instead a sharply outlined mountain peak; a slice of the sea turns into a solid mountain massif:

An invasive spatial force cuts into the outline of the cliffs: the cliffs do not extrude their pinnacles and ridges out of themselves; rather it is space that takes the initiative, stamping and distributing their forms. The force of infinite space is so great that its "emptiness" takes on the density of something solid.

There is still another aspect of this picture worth noting: the passage of time. The stretch of sea confined between the cliffs resembles the sand in an hourglass, and the woman's hand points toward the very spot where the upper compartment empties into the unseen lower one. This impression is strengthened by the picture's confusing perspective. Looking down into the depth of the crevasse one cannot at the same time see the horizon, for in this picture it is understood to be too high up. Yet the height of the horizon is just as it appears in reality; this is the impression one has from the top of Rügen's chalk cliffs. How is it then—if not by distorting our point of view—that Friedrich managed to so upset our sense of space? It is a matter of his characteristic approach to composition (as described in my introductory text), the way he stacks distinct vertical planes one behind the other, parallel to the picture surface. In the center Friedrich has not only reduced the distance between the needles of rock and the flanking side walls and between the walls themselves; more importantly he has raised the bases of the two pinnacles higher than they actually are and pulled them up closer to the viewer. As a result, our gaze is concentrated in the chasm, and the whole of the middle distance is compressed into a single plane. Whether between the narrow strip of grass of the foreground and the plane of the cliffs, or in the yawning space between the cliffs and the open sea—there are no transitions.

The sea looms up before our gaze like a solid wall, as though its surface had been tipped up toward us. This impression is strengthened by the proportions of the two sailboats. The closer, lower one is the smaller of the two, while the one above and further away appears larger and more tangible. The sea does not continue to either edge of the picture, but rather is pressed into the narrow chasm between the chalk cliffs. Too much ocean has been poured into the funnel between the cliffs; it threatens to overflow. A spatial pressure is thus developed that the painter further heightens with more pressing and restless waves in the point of the funnel between the pinnacles and with the heavy, dark weight of the foliage that fills the sky and presses down on the horizon. It is as though this great pressure of space were forcing the figures into their positions—against the roots, the hollow tree, and the ground—and holding them there, preventing them from falling. The pleasant scene here tips over into the metaphysical, or the surreal—yet loses nothing of its serene cheerfulness. It is perhaps not surprising that in their attempt to get at the hidden foundations of German Romanticism the French have paid particular attention to this painting. Albert Béguin reproduced and discussed it in 1937 and again in 1949 in the *Cahiers du Sud,* and in 1939 it appeared in the Surrealist journal *Minotaure* as an example of *angoisse romantique.*

It seems as if Friedrich himself continued to think about *Chalk Cliffs on Rügen* for a long time afterward. From the last years of his life there is a watercolor (fig. 53) that bears the same title and in its general proportions—with the cliffs on either side and the needles at the bottom, the tree stump, the roots in the foreground, and the sailboats—contains many reminiscences of the painting, even though it probably depicts a slightly different spot southwest of the Königsstuhl known as the "Chasm with the Two Chalk Pillars," which opens out toward the sea to the right of the Feuerregenfelsen. It is the same view—yet everything is greatly changed. The expanse of the sea is no longer confined within the funnel of rock; the scene is empty, the cheerfulness has gone. The figures have disappeared, the trees are missing, the needles have settled lower, and everything speaks of emptiness. It is impossible to look at the later watercolor without being poignantly reminded of the August day in 1818 that inspired Friedrich to paint *Chalk Cliffs on Rügen.* ◈

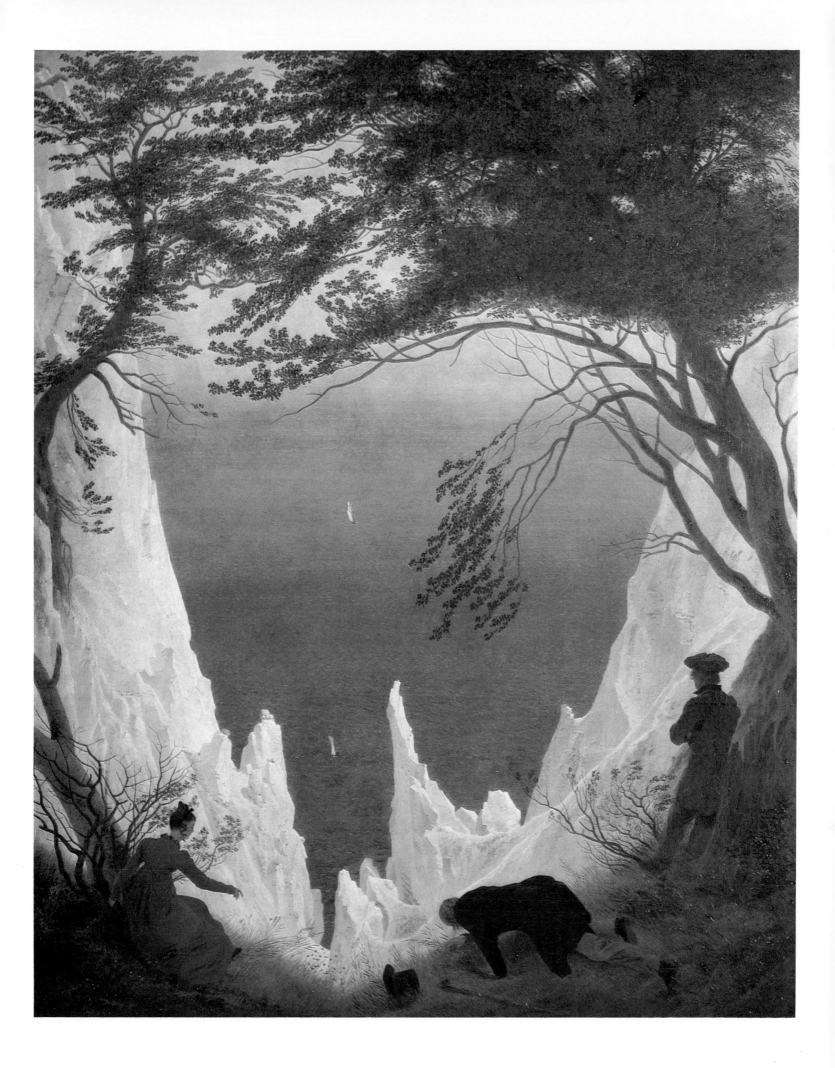

18. ON THE SAILBOAT

1818–19. Oil on canvas, 28 × 22" (71 × 56 cm)
The State Hermitage Museum, St. Petersburg (B-S 256)

Friedrich produced the painting *On the Sailboat* in Dresden in 1818–19, shortly after his honeymoon trip to Greifswald and Rügen. The two figures seated on the prow of the boat, holding hands and gazing at the vision of the city coming into view on the horizon, seem familiar enough from *Chalk Cliffs on Rügen* (plate 17): the woman in a red dress and the man with a beret gazing off into the distance at the sea. Here, even more than in *Chalk Cliffs on Rügen*, it is clear that the two are Friedrich and his wife, the newlyweds who have just begun their life's journey together, who are aboard the "ship of life" on their way toward a distant horizon.

While Friedrich scholars are essentially agreed that Caroline Friedrich served as the model for the female figure, some have questioned, surprisingly enough, whether we are to consider the man with the beret a self-portrait, inasmuch as this figure wears his hair longer than we are told the painter did. Their doubts are altogether unfounded. First of all we know that when reproducing buildings, mountain ranges, and trees Friedrich never stuck slavishly to reality, but always altered it to fit his composition—why should he have treated this male figure any differently? Secondly, it must be remembered that it was precisely long hair that was held to be a distinguishing mark of the so-called "demagogues," to which Friedrich subscribed, and in many places was forbidden along with "traditional German" dress. With this abundant, shoulder-length blond hair Friedrich is therefore simply identifying the man on the sailboat as a member of the opposition, a "demagogue." And thirdly, in that the two figures are turned away from us, she to the side, there is no reason to expect them to be actual portraits; they are simply types representing a specific moment in life. What mattered to Friedrich as a painter was the overall meaning, rather than the memory of his own individual experience.

And what is the picture's "overall meaning"? Friedrich scholarship is also divided on this issue. Some, most notably Antonina Isergina, who first published the work in 1956 (it was acquired in Dresden in 1820 by the future Tsar Nicholas I on his honeymoon, and had hung in the Hermitage since 1945), recognized the allusion to Friedrich's marriage only a short time before and interpreted the city the young couple is sailing toward as the "promise of imminent happiness." Others, among them especially Börsch-Supan, feel that the boat represents the couple's "wedded life drawing closer to death," and that the two are "absorbed in contemplation of the vision of the beyond." While Antonina Isergina sees it as the "depiction of a sunrise," Börsch-Supan speaks of "evening twilight," and emphasizes that "the port city is an otherworldly image."

Peter Märker takes yet another position. Having identified the couple as "demagogues," he stresses the significance of the ship as a symbol of movement, here directly visible: "In that the symmetry of the ship is shifted to the right, the boat tilting to the side in the wind and its bow rising up above the horizon, we are given the impression of motion toward a distant shore." Märker expressly opposes the interpretation of the city as otherworldly: "As the demagogues' goal, the Gothic vision on the far shore is above all the ideal image of their political hopes. The boat carrying the demagogues to their desired goal thus becomes a symbol of all historical progress."

Even earlier, Gerhard Eimer had seen the motif of the city silhouette floating on the horizon line—"an ideal image of the Nordic city"—as the "goal of human longing." His interpretation, with reference to a poem by Arndt, is essentially compatible with Märker's understanding of Friedrich's idealized notion of the Gothic as a political vision of the future.

Both Antonina Isergina, who saw in the city silhouette the "promise of imminent happiness," and Börsch-Supan, who spoke of the nearness of death, fail to note the sense of distance produced by the vision of the Gothic city on the horizon, in this picture as in all of the comparable ones. The couple on the sailboat, clearly quite young, is only beginning their life together. A great distance still lies ahead of them, and only at the end of it will they reach the twilit city.

The above interpretations focus on the fate of the particular couple, while Peter Märker's considers the general political situation and suggests that the Gothic city on the horizon represents the prospect that a Christian renewal will ultimately triumph. Can such different readings be reconciled? Undoubtedly one can put forward good arguments in support of Märker's hypothesis, but these do not necessarily have to refute those having to do with individual fulfillment and transcendental vision. It is possible to combine them, and interpret the picture to mean that the goal of the "demagogues'" generation, a world renewed in the spirit of Christ, lies so far in the future that it is beyond the reach of living men, that the ideal world their descendants may one day enjoy thus appears as another world. Though the goal is impossibly remote, it is nevertheless worth spending one's life steering toward it.

In this context one should note a feature that no one has mentioned heretofore. The young couple is obviously not sailing alone. A third person has to be steering the boat. Who is sitting at the tiller? Who is charting their course? As so often, Friedrich leaves a question unanswered. 🔹

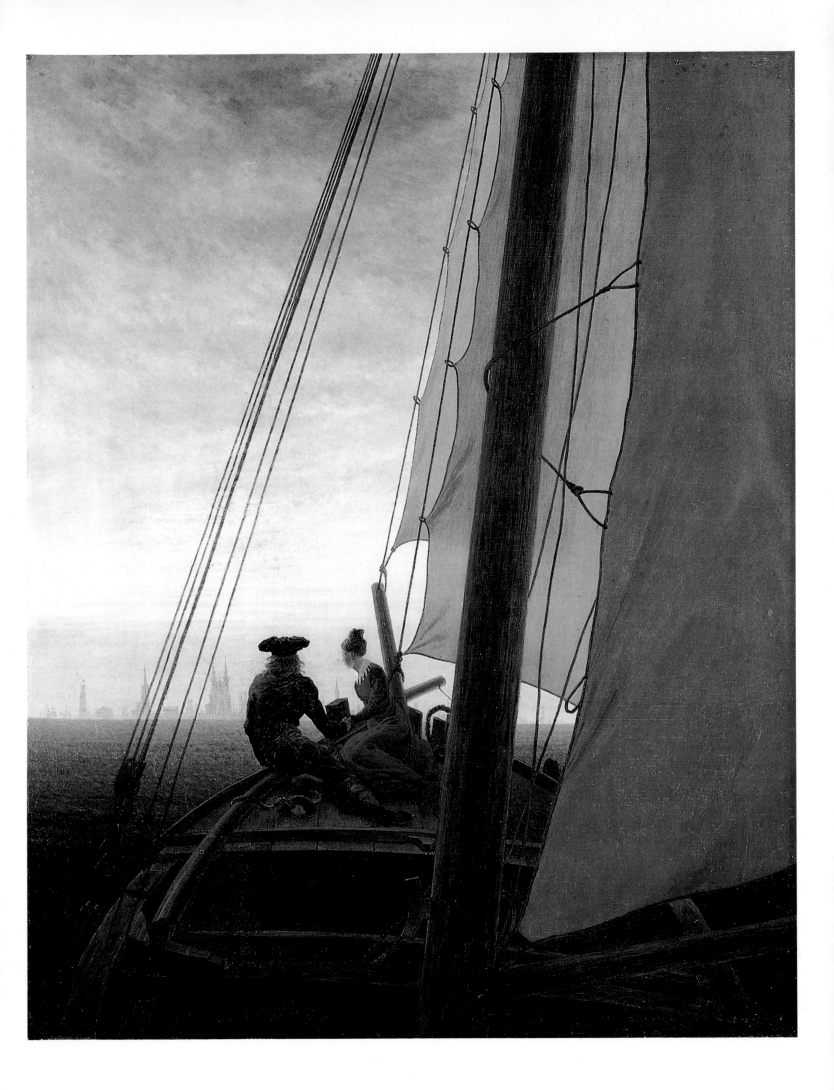

19. TWO MEN CONTEMPLATING THE MOON

1819. Oil on canvas, 13¾ × 17⅜" (35 × 44 cm)
Staatliche Kunstsammlungen, Gemäldegalerie, Dresden (B-S 261)

In about 1817–18 we encounter with increasing frequency in Friedrich's paintings a pair of figures gazing at the landscape in meditative wonder. There are the two hikers who have stopped in front of the silhouette of Neubrandenburg to marvel at the color of the sky above the morning mists. Another pair gazes at the horizon in *Two Men by the Sea at Moonrise*. Still another makes its way lost in thought in *Hikers by the Sea*. Two fishermen carry their fishing poles in *Moonlit Night at the Shore*. In *Shore Landscape in Evening Light* two other fishermen returning home in their boats cast a last glance back out at the water. In *Brother Adolf's Garden* it is a man and his wife who look out at Greifswald's Nikolaikirche from a vine-covered arbor. In *On the Sailboat* (plate 18) another couple marvels at the vision across the water, a city that appears to be an idealized silhouette of Stralsund. Two women take in the night in *Sisters on the Harbor Promenade* (plate 21), the towers of Halle's Marienkirche and a forest of ships' masts before them. Another pair of hikers appears in *Evening* (plate 25) from the cycle *The Times of Day* and in *Rocky Gorge* from the Harz Mountains. In the *Moonrise by the Sea* in the State Hermitage Museum, St. Petersburg, there are two such pairs, and in *Chalk Cliffs on Rügen* (plate 17) and the Berlin *Moonrise by the Sea* (plate 30) the pair is joined by a third figure. Friedrich uses such figures less often after 1822, though we see them still in *Cemetery Entrance* (1825, fig. 25), where a man and wife gaze at the grave of their dead child, in *Augustus Bridge in Dresden* and *Evening on the Baltic* (c. 1830), and a last time in *Evening Landscape with Two Men* (c. 1835).

The small picture *Two Men Contemplating the Moon* is another in this series of pairs of figures seen from behind. A brief note of Dahl's—"moonlight landscape, two male figures looking at the rising moon"—tells us that this work was painted in 1819. Dahl identifies the men as two of the painter's pupils, August Heinrich and Christian Wilhelm Bommer, the latter his brother-in-law. Another tradition, one supported by Wilhelm Wegener and one that I find more plausible, relates that the man with the walking stick is Friedrich himself, and that the one leaning against his shoulder is his pupil August Heinrich, at that time twenty-five years old. In Wegener we read the following description: "A small evening picture, autumn landscape; no stars are visible in the reddish gray sky. Friedrich and the landscape painter Heinrich stand in the foreground looking down into the valley, which is hidden from the viewer himself. A picture of wonderfully poetic coloring." Wegener's description is somewhat odd in its insistence that there are "no stars." Having failed to see either the moon or the evening star, he has his two men contemplating the valley below. Is this the same picture?

In a variant painted roughly a decade later, *Man and Wife Looking at the Moon* (Nationalgalerie, Berlin), the woman is leaning against the man, and we may assume that the figures are meant to represent Friedrich and Caroline.

Two Men Contemplating the Moon was among the pictures Karl

Förster and Peter Cornelius saw when they visited Friedrich's studio on April 19, 1820. On that occasion Friedrich suggested that the picture was political, but his visitors did not take him seriously. Förster relates: "Two youths wrapped in cloaks gaze enraptured, their arms around each other, at the moonlit landscape. By way of explanation, Friedrich noted ironically: 'They're up to some sort of demagogic intrigue.'" The remark is not as absurd as it might seem to us today. In the restoration period following the wars of liberation, "demagogue"-hunting, disciplinary punishment, and censorship were the rule, and wearing a cloak and beret—traditional German garb—was held to be a gesture of defiance. Friedrich's joke about "demagogic intrigue" was at the same time a perfectly serious allusion to the political conditions of the time, when two men innocently talking about the trees or the moon could be suspected of conspiracy. In fact in the very year this picture was painted, 1819, the writer August von Kotzebue was murdered and the persecution of the "demagogues" began in earnest. The Karlsbad Decrees imposed censorship and close surveillance of public life. Friedrich protested against those measures, and in their dress the two men who have sought out the solitude of a rocky path and are looking at the rising moon are quietly protesting as well, hoping for a change, a new era. One notes that from this time on, the figures in Friedrich's pictures appear with increasing frequency in traditional German costume, a sign of their liberal democratic leanings.

A political stance is by no means the only thing expressed in this picture. Its central motif, one that invites all sorts of interpretations, is the contemplation of the moon. Another remark Friedrich made to Förster and Cornelius alludes to the painter's fascination with moonlight. If we are transported to another world when we die, he said, then "surely he would end up on the moon."

The artist's friends knew of his predilection, and many of their descriptions of him contain references to it. "The twilight was his element," Carl Gustav Carus wrote in his reminiscences. "A solitary early walk in the first light of dawn and also a second one in the evening at sunset or after dark, when he was happy to have a friend accompany him: those were his sole diversions."

The present picture shows just such an evening walk in the company of a friend. The moon has risen; the two men stop and gaze at the delicate silver crescent of the waxing moon with the faintest hint of its full circle. Friedrich may have been thinking of the famous poem by Matthias Claudius that speaks of the moon as being only half visible, "yet beautiful and round."

Richard Hamann noted that this picture has no clear depth to it. Yet it is precisely the lack of perspective that produces the painting's effect. Everything belongs to the foreground: the rocky path, the trees—firs and oaks whose contrasting shapes give the picture a touch of drama—the boulders, the figures. Directly in front of the two men space breaks off. The distance is solely the province of the moon, whose light permeates a hazy sky. "Distance breeds closeness," Willi Wolfradt remarked in this regard, nicely alluding to the double effect of the picture. The depth of the moonlit night not only gives the things around us a unique dimension and significance; it also makes us press closer together.

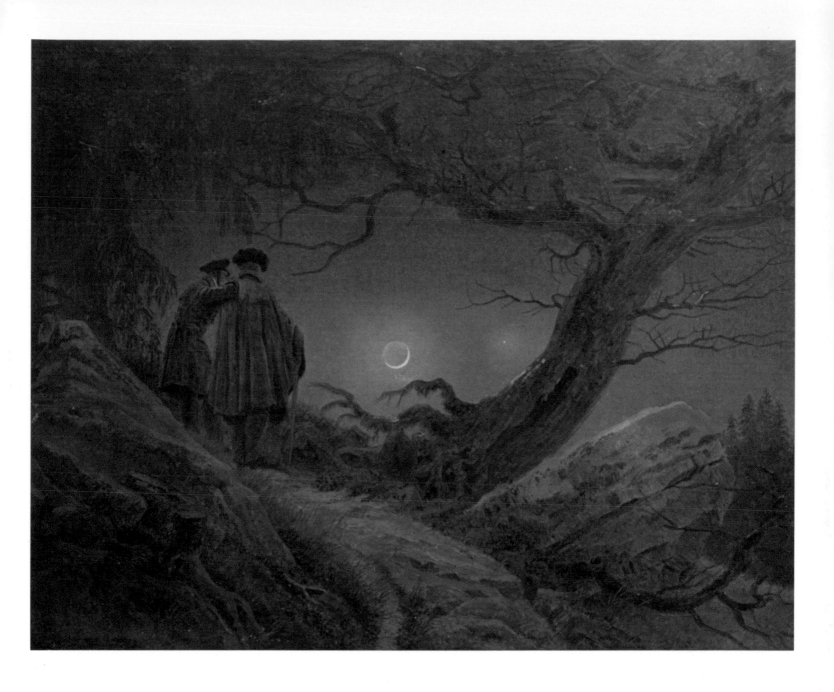

The younger man rests his arm fraternally on his friend's shoulder as they both surrender to the vision of the lunar radiance. They are united by their experience of the infinite. Wolfradt saw in this "nature's power to bring people together," and recalled the cult of friendship in this period, a central feature of Romanticism. Herbert von Einem saw this picture as an illustration of the intimate bonding between people in the presence of the numinous:

Corresponding to the experience of solitude there is the experience of being connected by identical fates. With the greatest subtlety, Friedrich depicts such self-revelation before the mystery of the unfathomable: in the calm, fixed, rooted stance of the older man in Two Men Contemplating the Moon *and the way the younger one lays his arm on the older one's shoulder and leans slightly toward him.*

Lankheit added to this, emphasizing that what is developed here is not "friendship by reason of individual qualities and experiences, but the bond between two creatures sharing the same mortality."

Two observations need to be added. One has to do with the colors. The picture is nearly monochromatic. The moon has suffused the nocturnal landscape with a uniformly reddish-brown twilight, one that ties all objects together as though they were composed of a single element. Only the two men stand out, strangers in nature with their gray-green cloaks and black caps.

The other observation has to do with the placement of the two hikers. They have climbed up a mountain trail and now look downward—the moon has risen below them. Bowing their heads, they stand absorbed in deep meditation. While gazing at the moon they are also looking into themselves. ▩

20. SWANS IN THE REEDS

1819–20. Oil on canvas, 14 × 17⅜" (35.5 × 44 cm)
Freies Deutsches Hochstift, Frankfurt am Main (B-S 266)

Peter Cornelius and Karl Förster saw this small painting in Friedrich's studio when they visited him on April 19, 1820. In his vanity, Cornelius did not at first identify himself to Friedrich, remarking only that it would become clear enough who he was. Doubtless Friedrich's reaction was to exaggerate his own shyness. In any case, Karl Förster's report of that visit reads as though Friedrich did not take the gentlemen altogether seriously. "The kind, admirable man was perfectly charming in his simple, child-like way, all cheerfulness and humility," Förster relates. Surely he was not seeing the real Friedrich. "He showed us a number of things, with a hesitation that did honor to the skillful artist." Perhaps Friedrich doubted his visitors' ability to understand him. He showed them a series of moonlight paintings, *Two Men Contemplating the Moon* (plate 19), *Sea in Moonlight,* and the present painting, *Swans in the Reeds,* and "joked that he painted nothing but moonlight." He then turned serious, and apropos of the picture of swans remarked: "The divine is everywhere, even in the grain of sand; here I decided to portray it in the reeds." There is a similar comment in his *Confessions:* "Anyone who foolishly maintains that anything in nature is unworthy of the fine arts doubtless deserves no notice.... Indeed anything in nature can become the subject of art if properly and worthily and sensibly perceived."

Friedrich submitted the picture to the Dresden exhibition in August 1820 under the title *Two Swans on the Pond in the Reeds: The Moon in Its First Quarter.* The critics were friendly. In *Schorns Kunstblatt* we read:

A pleasing trifle, only the horizon is so low that the viewer would have to be standing chest-deep in the water himself to see the scene as presented. Herr Friedrich probably took this poetic license so as to draw the viewer deep into the mystery of this little painting. The little picture is well painted, and leaves one with an impression of slight melancholy.

The *Wiener Zeitschrift für Kunst, Literatur, Theater und Mode* was also charmed:

In this ... very small picture ... one sees nothing but waving reeds between tufts of canes and water lilies. It is deep night; the crescent moon in its first quarter glows faintly in the sky. The air is so clear that one can make out the dark side of the moon. The pond reflects its still shimmer. Everything is extremely simple, one might even say artless, but an exquisite charm pervades the lovely little picture; it strikes us like a fairy tale, like a familiar sound from the inner world of our soul.

The *Literarisches Conversationsblatt* also praised the work:

The little picture depicting a pond densely grown over with reeds is inexpressibly charming. The moon in its first quarter is mirrored in it, the stars are coming out, and beneath the flowering rushes and reeds two swans
approach each other in complete privacy. Friedrich's works are closer to poetry than to landscape; one might speak of them as transitions between poetry and art.

It was long thought that *Swans in the Reeds* was the work of Carl Gustav Carus. The first scholar to recognize it as Friedrich's was Marianne Prause, who in 1968 identified it as the Friedrich painting in the 1820 Dresden exhibition, and remarked: "The somewhat hazy atmosphere, the individual reeds and grasses, and the cloudless sky are so subtly executed that Carus could not possibly have been the artist." Werner Sumowski confirmed this attribution: "In the composition in the Goethe-Museum a symbolic and poetic idea is given the form of a subtly abstract two-dimensional image composed of hieroglyphs from nature. Only Friedrich could have conceived it, painted it with such subtlety, and felt its atmosphere so poetically."

Both Carus and Friedrich painted a number of pictures with swans in them. From the literature, Sumowski traces the existence of at least five additional swan paintings from Friedrich's hand, all of them later than the present one. Marianne Prause's catalogue of the works of Carus lists six swan paintings, and it may be that another one or two lost landscapes depicting moonlight and reeds should be added to them. Carus entered the earliest of these pictures, *Lake with Three Swans,* in the Dresden exhibition for 1819. The *Kunstblatt* said:

In them there is a bit too much of the kind of fantasy that revels in mystical relationships here and there, and they also doubtless touch on Friedrich's concepts, however they are all conceived with taste, lovingly executed, and in those cases where painting from nature was called for, undertaken from good vantage points. The lake with the three swans was appealing.

It is possible that to Friedrich's thinking that lake was indeed much too appealing, and also that in his opinion Carus's fantasy touched far too fleetingly on his own concepts—as was always the case. Friedrich took up Carus's idea and countered it in the following year with a painting of his own—and with it showed how he felt a swan picture should be done. We can see something similar happening a few years later, when with his painting *The Watzmann* Friedrich produced his rejoinder to Ludwig Richter's depiction of the mountain shown previously at the exhibition of the Dresden Academy.

Friedrich de la Motte-Fouqué saw a painting similar to the present one in Friedrich's studio in July 1822. That one pictured only a single swan and is known as *The Hermit Swan.* A conversation later recorded by de la Motte-Fouqué must have taken place at that time. After Friedrich had shown his guest his workroom and his pictures, he asked: "Do you find me so monotonous? They say I can't paint anything but moonlight, sunsets, sunrises, the sea and the seashore, snow landscapes, churchyards, empty moors, forests, gorges, and such. What do you think?" De la Motte-Fouqué replied: "I feel that a person paints immeasurably more in such subjects when he thinks and paints as you do!" ◼

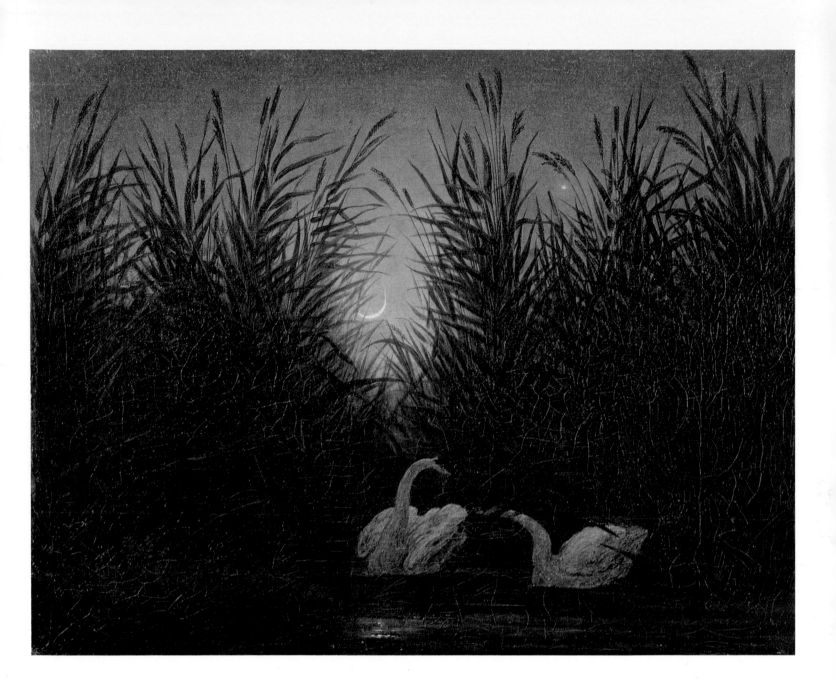

21. SISTERS ON THE HARBOR PROMENADE (HARBOR AT NIGHT)

c. 1820. Oil on canvas, 29⅛ × 20½″ (74 × 52 cm)
The State Hermitage Museum, St. Petersburg (B-S 263)

The picture *Sisters on the Harbor Promenade*, also known by the title *Harbor at Night*, is one of Friedrich's most mysterious works. It was certainly perceived as such by his contemporaries when it was first displayed along with four other paintings of his at the art exhibition in Dresden in August 1820. It appeared under the descriptive title *Two Sisters on the Harbor Promenade: Night—Starlight*, and moved various reviewers to pen thoughtful comments. In the *Literarisches Conversationsblatt*, for example, we read:

This harbor promenade has a magical effect. It is late at night, the air is heavy and warm, stars sparkle through the misty haze, two sisters, clinging to each other, look out into a dense forest of Gothic towers, monuments, and ships' masts with all their ropes and rigging. All this is steeped in mist and yet precisely and splendidly executed.

The description in the *Wiener Zeitschrift für Kunst, Literatur, Theater und Mode* goes into even greater detail, preferring to think of the work as a nature poem rather than an actual landscape. Its reviewer writes:

Here we find a promenade above the harbor; one looks out at Gothic church spires, monuments, and ships' masts and ropes and rigging, but everything is enveloped in the magical mist of a dark, warm summer night. One bright star sparkles at us and the longer you look, the more deceptive does its shimmering light become, and you see more and more stars appearing in the violet-colored ether. Two sisters gaze out from the promenade; we see their dark figures only from the back, and yet we feel how intimate their girlish gossiping must be in the stillness of the night. If only their postures were somewhat less stiff! The air is masterfully treated, with everything clear yet so softly veiled. Great poets often manage to stir with a single word all of the feeling in our souls, yet one might at times insist that their unwritten lines are the best. In the same way one finds in Friedrich infinitely more than what appears on the canvas.

Almost everything in these contemporary reviews still matches our present-day response. But what I do not see is the two sisters' "girlish gossiping." Quite the contrary. They are completely preoccupied with the "stillness of the night" and are absorbed in it—as is the viewer, looking at the view of the harbor at night through the eyes of the two sisters. For this reason I also do not agree that their postures might be "less stiff." The two female figures stand hushed and transfixed before a vision that in its realism, atmosphere, and mood conveys an intimation of the sublime. They are rapt. Nor can I see that they are "clinging to each other"; one is leaning on the balustrade of the promenade (or bridge?) while the other has gently placed her right hand on her sister's shoulder.

Some scholars have assumed that these two women are Friedrich's wife, Caroline, and her sister-in-law, the wife of Friedrich's brother Heinrich in Greifswald, with whom she became acquainted in 1818, while visiting her husband's homeland on her honeymoon. In this instance the identification of the figures with actual persons seems unimportant. In any case, the designation "sisters" is not to be taken literally. The women are sisters in the figurative sense—friends, sisters in spirit. They are linked also by the traditional German costumes they wear, with floor-length skirts and high collars, a common affirmation of a society very different from the reactionary one of their time.

Sisters on the Harbor Promenade occupies a unique place in Friedrich's oeuvre. As a rule the pairs of figures absorbed in contemplation of nature and seen from the back that Friedrich portrayed in the years around 1820—and in which he invited us to look on with the same inquisitive, knowing gaze—are either men or couples. They are nearly always stationed within the landscape itself, most often the Baltic seashore at the onset of evening. Twilight is for Friedrich the time for contemplation. Unimportant details recede, and the larger relationships become apparent. The hieroglyphs of nature hidden in the brightness of daylight reveal themselves. Here, however, the two figures are not confronted by a landscape but by the view of a city. Elsewhere in Friedrich the image of the Gothic city appeared only as a distant vision above the horizon—as in *Greifswald in Moonlight* (plate 15), *On the Sailboat* (plate 18), and *Meadows near Greifswald* (fig. 28). Now it has drawn quite close to us, but still preserves a mysterious quality as though not of this world.

This particular cityscape is compounded of elements from various places, as is typical of Friedrich, in this instance from Halle, Stralsund, and Greifswald. The church in the background has been identified as Halle's Marienkirche; the tower on the far left is the Red Tower in the same city. The proportions of the tower have been elongated, and the two church towers connected by a walkway have been heightened; it was typical for Friedrich to "Gothicize" existing monuments in this manner. The pointed church spires are also more slender than they actually were. The gable projecting from the west front of the church comes from a drawing of the Rathaus in Stralsund. The masts of the sailing ships at anchor suggest the Greifswald harbor.

Most unusual is the effect of symmetry between the church towers and the slender ships' masts looming up to the same height in the night sky, with their rigging suggestive of crosses. The two figures stand precisely in the center, between the ships and the church. The gaze of the sisters on the promenade holds the world in balance. ▨

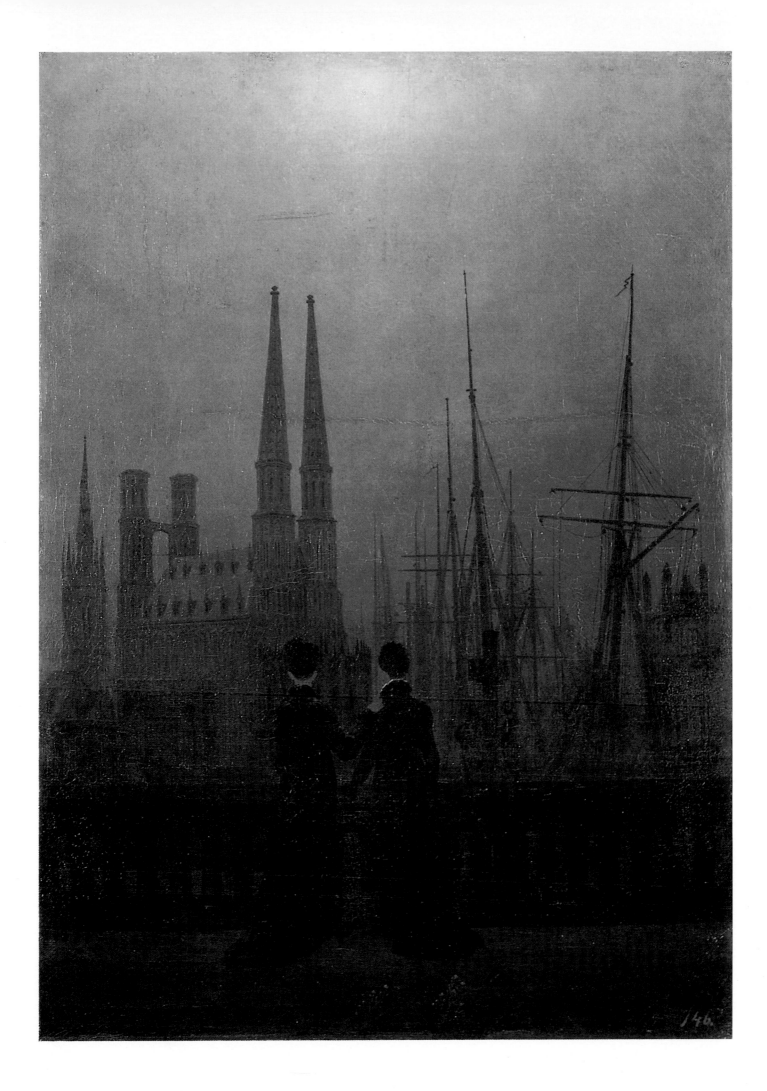

THE TIMES OF DAY (HARZ LANDSCAPES)

22. MORNING

1820–21. Oil on canvas, 8⅝ × 12" (22 × 30.5 cm)
Niedersächsische Landesgalerie, Hanover (B-S 274)

23. MIDDAY

1822. Oil on canvas, 8⅝ × 11¾" (22 × 30 cm)
Niedersächsische Landesgalerie, Hanover (B-S 296)

24. AFTERNOON

1822. Oil on canvas, 8⅝ × 12¼" (22 × 31 cm)
Niedersächsische Landesgalerie, Hanover (B-S 297)

25. EVENING

1820–21. Oil on canvas, 8¾ × 12¼" (22.3 × 31 cm)
Niedersächsische Landesgalerie, Hanover (B-S 275)

The major cycles of nature—the times of day, the seasons, the stages of life—are Friedrich's central subjects. He created his first cycle of the seasons in 1803, his last in 1834. In almost all of these sequences the three cycles are interwoven; for example, spring is associated with youth and morning, winter with old age and approaching night. As a result, especially in his early and later sepias, many of these compositions tend to be overburdened with allegorical content.

In the present cycle, *The Times of Day*, Friedrich has confined himself to the single subject of the progress of the day, setting aside the other cycles. It is only in the transition from the second picture to the third, from *Midday* (plate 23) to *Afternoon* (plate 24), that we sense the expected progression, from summer to fall. In *Morning* of the series (plate 22) it appears to be summer, possibly even late summer, rather than the expected spring, while *Evening* (plate 25) is clearly an autumn, not a winter, landscape. The figures we find here and there in these paintings all appear to be at a single stage in the cycle, at midlife; the only ones who could be older are the two men in *Evening*. There is a minimum of allegory in the sequence of these four paintings. Everything is concentrated on the landscape. What the artist wishes to say is expressed through landscape, and only through landscape.

Friedrich painted *The Times of Day* in 1820–22. The pictures were purchased by the collector Dr. Wilhelm Körte in Halberstadt. From two letters that Friedrich wrote to Körte in 1821 and 1822 Börsch-Supan is convinced that *Morning* and *Evening* were the first ones to be delivered, and that *Midday* and *Afternoon* were only undertaken later, once Körte had expressed his satisfaction and the wish to own still more pictures by Friedrich. The artist's somewhat complex bill, which amounted to a total of 25 louis d'or, may support Börsch-Supan's theory. *Midday* and *Afternoon* are in any case more closely related than *Morning* and *Evening*, seeming to be "in the misty atmosphere variants of a single mood." Had Friedrich been thinking of a suite of four pictures from the outset, it is possible that he would have followed *Midday* with *Evening* and then added a nighttime painting, as he did in a cycle of four seascapes he produced about 1816–18.

These pictures are generally referred to as Harz landscapes in the literature. Herbert von Einem speaks of "reminiscences of the Harz." Doubtless such reminiscences did play a part, yet it is difficult to pin down any specific locations. As is often the case with Friedrich, elements from various landscapes have been blended into a harmonious whole. The pine trees that dominate in *Midday, Afternoon,* and *Evening* are not atypical of the Harz region, but one associates them more readily with the Brandenburg marches. There is a drawing of the entire *Afternoon* landscape that may date from the period 1810–20, and surely has nothing to do with the Harz. In *Morning,* as Börsch-Supan has noted, motifs from the Baltic coast have been incorporated into what is essentially a Mittelgebirge landscape. The fisherman setting out in his boat comes from the coast near Greifswald. The mountain rising up behind him, however, could well be in the Harz.

Friedrich had visited the Harz in June 1811, accompanied by the sculptor Gottlieb Christian Kühn. On their return they visited Goethe in Weimar. Among the sketches made during his tour

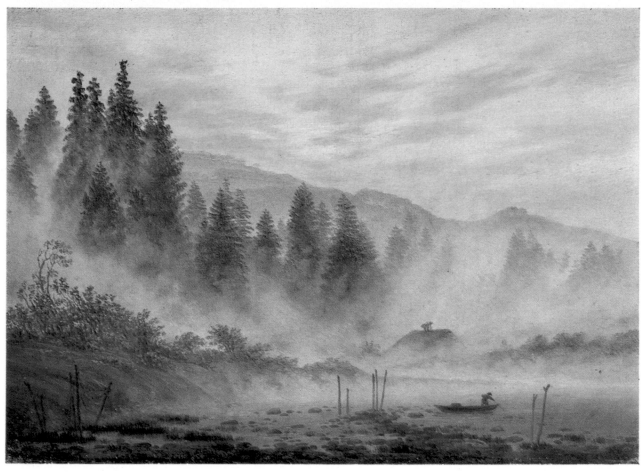

22

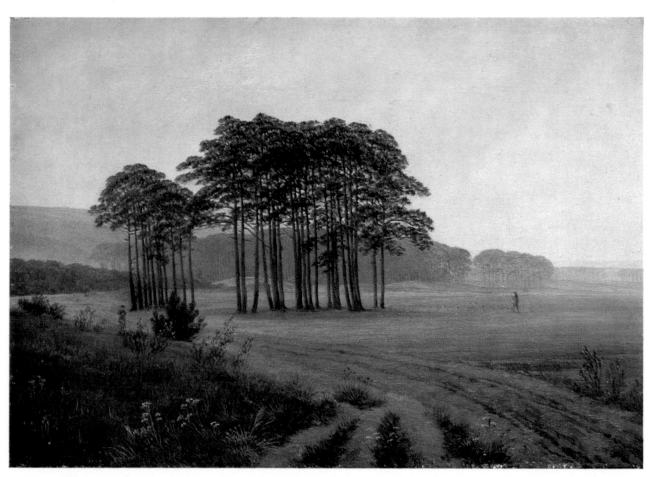

23

of the region are studies of caves and gorges like the marble quarry near Hartenberg that provided the gloomy background for *Rocky Gorge (Grave of Arminius)* (fig. 15). Again and again he appears to have associated the Harz with dramatic motifs. *The Times of Day* preserves more lighthearted memories of that journey, if indeed we choose to recognize the Harz in this landscape at all. One must also note that *The Times of Day* dates from an entirely different period than *Rocky Gorge (Grave of Arminius)* or *Tombstones of Ancient Heroes*.

For a time in the early 1820s we find Friedrich once again striving for a greater proximity to nature. His pictures from these years often seem more like realistic view paintings. One thinks of his *Landscape with Windmills, Meadows near Greifswald* (fig. 28), or *Eldena Ruins* in the Nationalgalerie, Berlin (fig. 40). This closeness to nature did not prevent Friedrich from constantly combining motifs from studies he had made in various places, as in his *View of the Baltic,* in *Elbe Landscape,* or in *Hill and Plowed Field near Dresden* (fig. 36), all of which date from the beginning of the decade.

Herbert von Einem wrote a brief and poetic description of *The Times of Day* that is worth quoting here:

In Morning, *the firs rise up out of thick mists; forms, still indistinct, that appear to be freeing themselves from the indefinite only with effort.* Midday *presents with the perfect clarity of daylight the contours of the created world. It is true that the height of the stand of trees is exaggerated, and that they contrast sharply with the level ground in which they are rooted, so that the anguish of existence appears to be expressed more strongly than the delight. In* Afternoon *we see the beginning of a process of dissolution. Individual forms are still distinct, but not so sharply as in the previous picture. In* Evening *those forms virtually expand to become one with the infinite. Two men are absorbed in contemplating this spectacle.*

In the picture *Morning* there is an echo of the morning of Creation. The world rises slowly and hesitantly out of the mist, gradually awakening in the early chill, being reborn into another summer day. But the fisherman is already under way as smoke rises from his cottage and blends with the mist. Everything seems close and accessible; nearness and distance are drawn together by the mist into a single plane without depth. The view of the horizon is blocked by a mountain ridge.

In *Midday* the landscape has become more expansive and clearer, even though the sky appears to be veiled by a layer of high clouds. A wide road fills the foreground, then curves out of the picture; a figure, possibly a woman, walks along it; a shepherd watches his flock. The focus is not on these people, however, but on a stand of trees, a scattering of pines against the backdrop of the forest.

Little appears to have changed in *Afternoon*, yet everything has become grayer. Rain clouds blow across the sky. Nature's colors, which at midday competed with one another, have now been sub-dued into a uniform grayish tone, against which the flowers of the foreground revolt. A farmer has harnessed his horse to a cart. The grain is ready to be harvested, and half of it has been mowed already. The field has been freshly plowed, and with the winter sowing a new cycle can begin.

All traces of activity have disappeared from *Evening*, the last picture in the series. Evening is given over to contemplation. The two strollers have no hand in the cultivation of nature, yet they appear to blend in organically. The line of closely set pine trunks through which they watch the sunset is echoed in the foreground by the looser rhythm of a row of young pine trees that also accommodates the two strollers. Some writers describing this picture have not even noticed the two figures, taking them to be shrubs. Like these two men, the trees have withdrawn into anonymity, yet we know how often Friedrich included fully individualized trees in his pictures, distinct personalities. There was still a trace of the possibility of individuation, of separate arboreal destinies, in the slender pines of *Afternoon*. Now there is only forest.

In the third of his "Nine Letters on Landscape Painting," written about 1820, perhaps after having seen this Friedrich cycle, Carl Gustav Carus discusses the correspondences between moods and natural states and examines the parallels between the fluctuations of the psyche and the changes in the times of day and the seasons:

What, then, are the specific moods expressed in the manifold changes in nature's landscape?—If we consider that all of these changes are nothing other than forms of living nature, then the various moods they express can represent nothing but life states, stages in the life of nature. Yet in essence life itself is infinite, and it is only its forms that are subject to constant change, caught up in a continual ebb and flow. We are therefore left with four distinctive stages for every individual life form: development, maturity, decay, and final dissolution.

Additional conditions arise, however, inasmuch as these four original states enter into combinations. Development can be curbed by disease, maturity found locked in a struggle with the onset of decay, or new development seen to emerge from dissolution.

To the extent that this can be depicted in landscapes, one can cite innumerable examples of it in the life of nature. Most obvious are the constantly changing seasons and the successive times of day, where morning, midday, evening and night, spring, summer, autumn, and winter, reflect these stages quite clearly. The intermediate conditions are also available: here we think of the morning clouding over, blossoming trees being touched by frost, plants withering in the heat of the sun, storms striking in the middle of the day, the moon rising at night, new buds appearing on dead branches, and countless other combinations.

And as for the soul itself, what sequence of moods can occur? Obviously here too, paralleling the rise and decline of individual life forms in the eternal life of nature, a waxing and waning of individual manifestations of the emotions in the eternal life of the soul. ❖

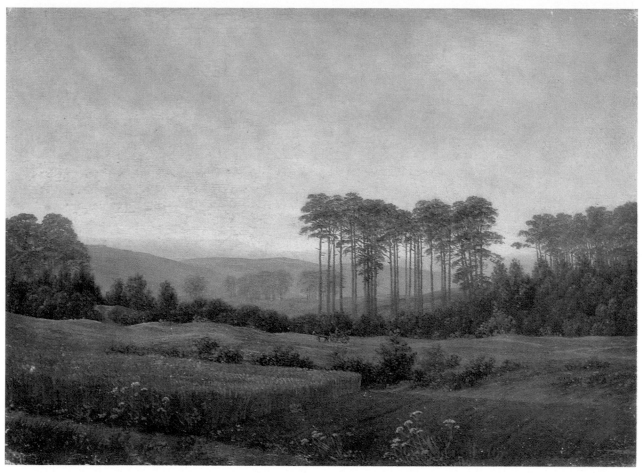

24

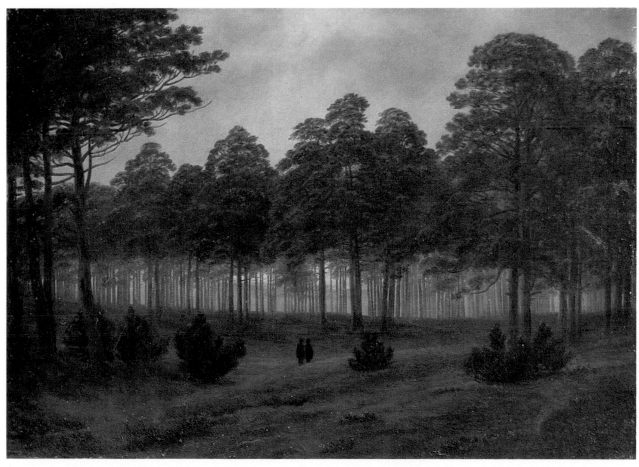

25

26. ELBE SKIFF IN THE MORNING MIST (MORNING MIST ON THE ELBE)

c. 1821. Oil on canvas, 8⅞ × 12⅛ " (22.5 × 30.8 cm)
Wallraf-Richartz-Museum, Cologne (B-S 183)

In 1940, while engaged in research on the princely houses of Mecklenburg, Carl von Lorck discovered this painting along with six others by Friedrich in the moated palace at Basedow, the property of Count Friedrich Hahn. He also found paintings by Johann Christian Clausen Dahl, Joseph Anton Koch, Karl Blechen, and Franz Catel. The present work hung unrecognized in the guest wing of the large palace, having only been kept, like the others, out of respect for the count's ancestors. Carl von Lorck relates:

At the end of our tour we descended to the living rooms, carefully carrying seven Friedrichs. There the astonished owner complained: "You keep saying Friedrich. What was the artist's last name?" His question revealed why the masterworks had remained unrecognized. The great to-do over Friedrich's rediscovery at the exhibition of German art in 1906 in Berlin and even the book on him in the Langewiesche series, Vom stillen Garten, *had failed to make any impression in this out-of-the-way part of the country.*

The painting dates from about 1821, and was probably purchased, like the other Friedrich works discovered in the palace, directly from the painter by Count Hahn. Its similarity to pictures like *Mist in the Elbe Valley, Scudding Clouds* (plate 27), or *Morning* (plate 22) from the cycle *The Times of Day* in Hanover is unmistakable. Friedrich showed two pictures with similar motifs, now lost, at the exhibitions of the Dresden Academy in 1821 and 1822. The description from a Viennese newspaper in 1821 could almost fit our *Elbe Skiff in the Morning Mist:*

Two very small landscapes ... one depicts a morning mist of the sort that is frequently seen rising off the river on cool mornings; thick white vapor boils up out of the river and envelops the shrubbery in such a way that distant trees look like gray will-of-the-wisps and only the tops of the ones closer to us manage to rise up into the clearer air. A gondola glides along the shore through the silent mist. An able boatman is steering it, and the man and woman seated inside it, without a care, have surrendered themselves to quiet daydreams.

Except for the daydreaming couple and the type of boat, this sounds like a description of the present work. The critic of the *Artistisches Notizenblatt* called the work shown in the next year a "Misty piece that scarcely amounts to a landscape," while the review in the Viennese newspaper already contained an obviously negative undertone:

This is even more the case (charmingly executed, but bizarre in its effect) with a morning mist above the Elbe, in which one can see only a hint of boats and the vineyards on the far shore. A thick, white fog lies so heavily over the whole that the famous artist's name is the only ray of sun illuminating the work. Undeniably nature sometimes looks like this, but at such times it is not picturesque. A quarter of an hour later, when the layer of fog has either lifted or settled, this might have made a proper picture.

The skiff in the present work is the sort of freight vessel that plied the Elbe in Friedrich's time. The masts of a similar sailboat appear outside Friedrich's studio on the Elbe in *Woman at the Window* (plate 28). The sails have been furled, and the boat glides smoothly downstream. The line of the near shore runs diagonally across the picture, but this diagonal does not connect the foreground with the distance. It separates them, dividing the picture into two zones. The tall grass, the scrubby willows with their branches hanging almost like grapes, the rhythm of the red, blue, white, and yellow flowers attempt to keep our gaze locked on the foreground, to snare it with their gentle movement and glowing colors. But they cannot. With seeming indifference it glides beyond them, scorning the safety of the foreground, attracted as if by magic to the boat in the fog, and then loses itself in the uncertainty of the morning mist.

Carl von Lorck wrote:

This picture is a jewel. It is colorful, extremely bright, in essence pale green and demonstrating a masterful treatment of the atmosphere. The many red, yellow, and blue flowers in the blooming meadow are exceptionally beautiful. They are painted with reverence before the reality of nature and filled with the convincing, devoted attention to the smallest weeds and grasses that distinguished Friedrich among his contemporaries.

Few of Friedrich's pictures come so close to what Carl Gustav Carus—arguing more against Friedrich than as a follower—called in his later letters on landscape painting the "art of earthly life." Carus had developed this concept under the influence of Goethe, and after having reflected on landscape as the mirror of psychic states in the earlier letters, when still in Friedrich's shadow, now targeted the "pure understanding of nature" that was only achieved by precise observation, scientific classification, and "artistic arrangement."

We know how far Carus had distanced himself from Friedrich in his enthusiasm for the "earthly life." Even in *Elbe Skiff in the Morning Mist* it is only the foreground that seems to illustrate Carus's concept. But the foreground is not the essential feature of the picture. What is essential appears veiled, suffused in mist, intangible. It is possible that we might catch it if we surrender the foreground and submit to uncertainty—as have the Elbe boatmen in their skiff in the mist, entrusting themselves to the current.

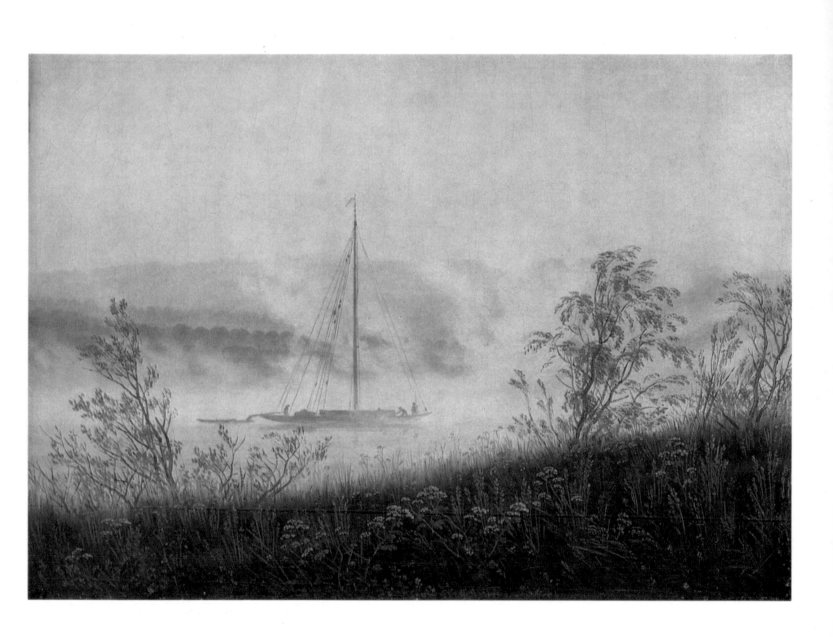

27. SCUDDING CLOUDS
(CLOUDS OVER THE RIESENGEBIRGE)

1821. Oil on canvas, 7¼×9⅝" (18.3×24.5 cm)
Kunsthalle, Hamburg (B-S 276)

Kurt Badt, viewing this painting with Goethe's eyes, saw only "drifting puffs of mist … formless vapors and billows stretching off into infinity." He felt that "the weakness and indecisiveness" with which these clouds are formed—or rather unformed—were the result of Friedrich's having frivolously ignored Goethe's admonition that he "avail himself of the Howard distinctions." Had he relied on them, "he would have succeeded in depicting clouds with a wholly different force, a wholly different approach, three-dimensionally instead of in silhouette."

Luke Howard, an Englishman, had published his famous "Essay on the Modification of Clouds" in London in 1803. An abbreviated German translation appeared in 1815, and Goethe found it especially fascinating. He dedicated a series of poems to Howard, titled after the individual cloud forms the Englishman described: "Stratus," "Cumulus," "Cirrus," and "Nimbus." He sent word to Friedrich to see if he might provide him with studies of clouds to help clarify Howard's essay. Perhaps he was recalling how he had praised Friedrich in 1808, by way of his friend Meyer, commenting that the clouds in a sepia of his were "very nicely observed." On July 10, 1816, he wrote to the painter Louise Seidler in Dresden, begging her to serve as a go-between and wondering "if you would mind asking Herr Friedrich about cloud studies and their various forms. If he were to furnish me with some they would be of use to me in my scientific work. If he were to have a look at *Gilberts Annalen* for 1815, numbers 9 and 10, he would see the fascinating way an Englishman has classified these seas of vapor."

But Friedrich had no interest in hunting down *Gilberts Annalen*. He had no interest in a theory of clouds. He was content with his observation of the natural phenomena and his careful rendering of them in his sketchbooks. By the same token, he never paid any attention to the scientific leanings his friend Carus exhibited in his letters, inspired by Goethe, on the subject of landscape painting.

The "boor"—as Louise Seidler called him—who chose not to send Goethe any cloud studies for his "scientific work" had already been engaged in his own careful study of clouds for at least a decade. In the so-called Oslo Sketchbook there are no fewer than sixteen studies devoted exclusively to clouds. He did these, at sunset and at night by moonlight, between the autumn of 1806 and the spring of 1807, most likely from his studio window in Loschwitz. In earlier sketches we note that he treated the sky in a much more general and summary fashion. One exception is his sepia *Crucifix in the Mountains* from roughly 1806, an early version of the *Tetschen Altarpiece*, in which the clouds curve upward like a cupola above the uprights of the cross and the firs. It was a version of this same motif that had inspired Goethe to compliment Friedrich on his way with clouds.

Ludwig Grote, who published the Oslo Sketchbook in a facsimile edition, wrote of these drawings as follows: "These studies reveal that for Friedrich clouds are anything but 'lawless vague-ness'; rather they disclose to him 'sublime sense and eternal significance.' The movement of his soul is mirrored in the movement of the sky." Badt quite rightly noted Grote's indebtedness to Carus, and chose to see the clouds Friedrich drew in the evening or at night, in twilight or moonlight, more as light phenomena than atmospheric forms. It might be more correct to say that Friedrich was less interested in drawing typical cloud formations than in understanding ethereal space.

He conceived of that space in the same way as terrestrial space, namely as a series of increasingly distant planes. For this reason his clouds generally appear not as single forms, or single objects, but coalesced into banks, fields, or walls, as zones of darkness or brightness. There are often openings in his cloud fields, and behind them we can see even lighter, more distant ones. Or perhaps the moon will break through from behind mountains of cloud. Almost always, however, there is a suggestion of still more remote clouds in the distance, if not perforated then at least less dense, less concentrated. And even though a number of clouds coalesce into solid forms, we never forget that they belong to different layers of space, indicating the depth of the sky.

Badt's objection that Friedrich's clouds lack three-dimensional form therefore fails to take into consideration his actual intentions and the unusual expressive means he developed. Friedrich's clouds have the same silhouettelike shapes as his mountain ranges or his stands of trees: they are equally inaccessible, equally intangible, equally elusive. It is only our gaze that can penetrate so far. Simulating plasticity, giving his clouds a tactile quality, would have struck Friedrich as wholly false. He could not have integrated them into the successive planes of his picture space in any way other than the way he conceived them and set them down in his sketches. "The spirit of nature manifests itself to each of us in a different way," Friedrich insisted, "and for that reason no one should impose his own theories and rules on anyone else as infallible laws."

Our picture is not only a picture of clouds. In addition to the passing clouds it depicts mists rising up from below. Mist plays a similar role in Friedrich's work: it ties separate natural forms together, and orders them in parallel pictorial planes. The line of the mist's upward movement from left to right runs perpendicular to the opposing movement of the clouds, all of which occupy a single layer of space let down like a veil or a curtain in front of the distant plain. Only here and there are there openings in this wall of clouds, permitting glimpses of fields, hills, ridges, and one area showing signs of human habitation. Stretching in front of this wall of clouds is a green meadow with a small, craterlike pond at its center, but the dark stones in the foreground make this space inaccessible as well.

Scudding Clouds recaptures a view from the Brocken in the Harz Mountains that Friedrich recorded in a drawing on June 29,

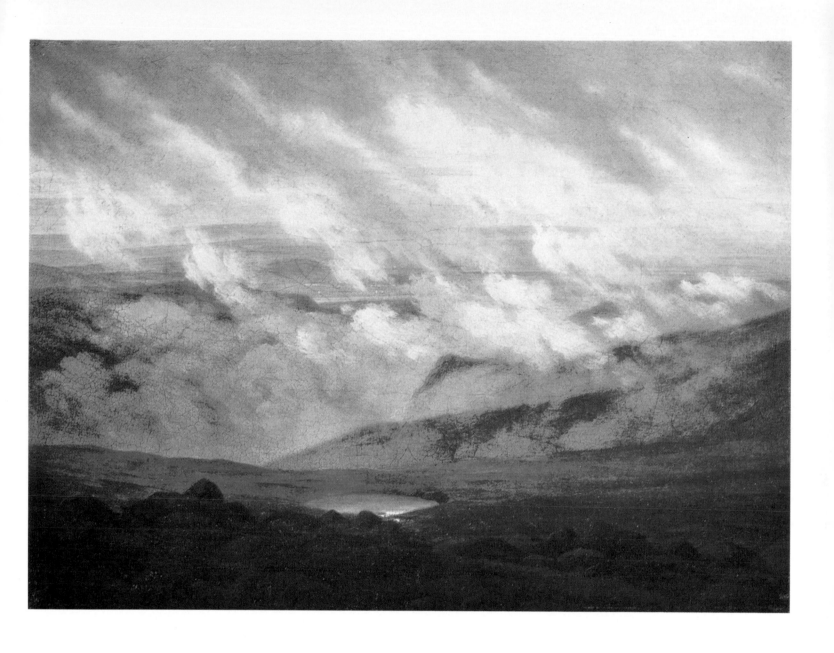

1811—one that omits any indication of the clouds. There was at one time a companion piece to the painting, for in a letter to the collector Wilhelm Körte in Halberstadt dated July 21, 1821, Friedrich mentions two pictures, "both reminiscences of the Brocken from the summit. Price 4 louis d'or." Körte doubtless bought this picture shortly afterward, for it seems that it was exhibited in Halberstadt in 1828: "The Brocken, with glimpses of great distances through clouds of mist." The companion piece could have found its way into the Reimer collection and been auctioned with the rest of his paintings in 1842: "Bare mountain peaks, between them drifting strands of mist"—though in fact this description could also apply to the present painting. In 1895 Andreas Aubert saw it in the Papperitz collection in Dresden: "Bleak mountaintop, a delicate little picture with a lovely sky of clouds." The Kunsthalle, Hamburg, bought it from that collection in 1906.

Börsch-Supan has written that this picture expresses the "feeling of a hiker standing on top of a mountain and looking out into the distance," and found it at the same time a "metaphor for a religious experience rooted in self-examination." With all of this I wholeheartedly agree. But when he tries to define this experience more precisely, I am lost. Can one really maintain that the background is a symbol of paradise? Börsch-Supan writes: "The hiker must first descend into the valley of death to reach this paradise, of which the clouds permit him only a fragmentary picture. The rocks in the foreground stand for the Christian faith. The pond represents the reflection of heaven on earth."

To my mind this small-format, realistic panorama offers a suggestion of distance into which we might project certain expectations, but is by no means freighted with meaning. If we were to accept Börsch-Supan's interpretation, the picture would have to assume an ambiguous, ironic quality, for the stones of the foreground—the Christian faith—would constitute a barrier on the way to paradise, and would have to be overcome at the outset. And the distance, the object of our gaze, would have to remain obscured by a wall of clouds to be perceived as paradise. ◈

28. WOMAN AT THE WINDOW

1822. Oil on canvas, 17⅜ × 14½" (44 × 37 cm)
Staatliche Museen Preussischer Kulturbesitz, Nationalgalerie, Berlin (B-S 293)

The woman at the window is Caroline, the painter's wife. Friedrich painted this picture in 1822, four years after their marriage. By that time the family had already moved out of its old quarters into the new apartment at An der Elbe 33 (later Terrassenufer 13). If one compares this interior with the studio Kersting painted in 1811 and 1812 (plate 2), one notes that Friedrich had apparently brought with him his window fittings with the wooden shutters and the slender cross above and adapted them to his new quarters. The window niche is similar, but the step at the bottom is missing. The side walls are thicker, and a horizontal framing element raises the shutters somewhat higher above the sill. The view includes a row of poplars on the opposite bank of the Elbe.

Friedrich submitted this small painting to the exhibition of the Dresden Academy in August 1822. As so often happened, he finished it too late, thanks to his overly painstaking and precise manner of working, so that *Woman at the Window*, along with two other pictures—one of them *The Wreck of the "Hoffnung"* (see plate 32)—could only be included among the addenda. There it is listed as "the artist's studio, painted from life by Friedrich, a member of the Academy." In the *Wiener Zeitschrift für Kunst, Literatur, Theater und Mode,* the picture was discussed as follows:

A small picture, showing the artist's studio in its unusual simplicity, with its window offering a view of the Elbe and the poplars on the opposite bank in the center of the background, would be very true and charming if Friedrich had not once again followed his whim, namely his love of portraying people from the back. His wife stands at the window in such a pose, to some extent most unadvantageously in lighting and placement, and he repeats such figures, all of which look the same, much too often.

Woman at the Window is the only known interior in Friedrich's oeuvre. Yet here too our gaze is directed out of the tiny room into the open air; through a narrow window in the center of the composition it fixes on a bright wall of trees with a vast sky above.

A woman has entered Friedrich's life. She has come into his studio and opened the window the artist kept closed so as not to be distracted in his work. She has opened the window for him; through her and with her—virtually with her eyes—he looks out into the world.

We find a female figure facing away from us in the center of a comparable small work that was possibly produced in 1818, known

alternately as *Dawn* and *Woman Facing the Setting Sun* (fig. 23). There she stands with her arms spread wide in front of a mountain massif, behind which is the sun. The twilight sky with its rays from the sun is reminiscent of the *Tetschen Altarpiece.* The picture presents a kind of communion: the figure draws the landscape into herself; the human soul and the landscape become one.

There is still an echo of that more pointedly religious motif in *Woman at the Window.* But here it is only a hint. Everything seems more domesticated, intimate, and restrained. While the woman in the sunset has deliberately taken a meaningful stance in front of the landscape, here she has stepped to the window quite casually. Her posture is perfectly relaxed as she leans on the windowsill and looks outside, watching the swaying of the masts of sailboats anchored in the river.

The slight tilts of both those masts and the woman herself are the only disruptions in the strict geometry of this picture, and accordingly serve to make it more obvious. The composition is based on the interplay of verticals and horizontals, the mullions at the top, the rectangles of the window opening and the niche. The rhomboids of the floor planking and the subtle triangles described by the taut ropes of the rigging only accentuate the prevalence of right angles. The horizontal molding below the window, the two bottles on the windowsill—the only objects in the bare room— even the row of poplars on the opposite bank obey the orthogonal system. One recalls Philipp Otto Runge's insistence that "strict regularity" is "most essential especially in works of art that arise straight out of the imagination and the mysticism of our soul." It would be difficult to imagine a stricter architecture than that of this symmetrical picture of a sterile interior, a bare cell. But everything leads our gaze outside, to the window: the gradations of the colors, the shape of the woman's dress, the perspective lines of the shutter. We cannot help but follow.

The woman facing away from us at the window only confirms our own impulse. She feasts her eyes on the river, the waves, the sailboats, the opposite shoreline, the trees, the distance beyond. The interior urges us to follow her example, and to my mind this is the picture's sole meaning. Erik Forssmann stated this problem more clearly and directly in his 1966 essay "Window Paintings from the Romantic to the Modern." In Romanticism, he wrote, "the figure seen from the back is meant to express the soul's yearning for the infinity of nature, freedom from its earthly bonds, or unsatisfied yearning in general." ▨

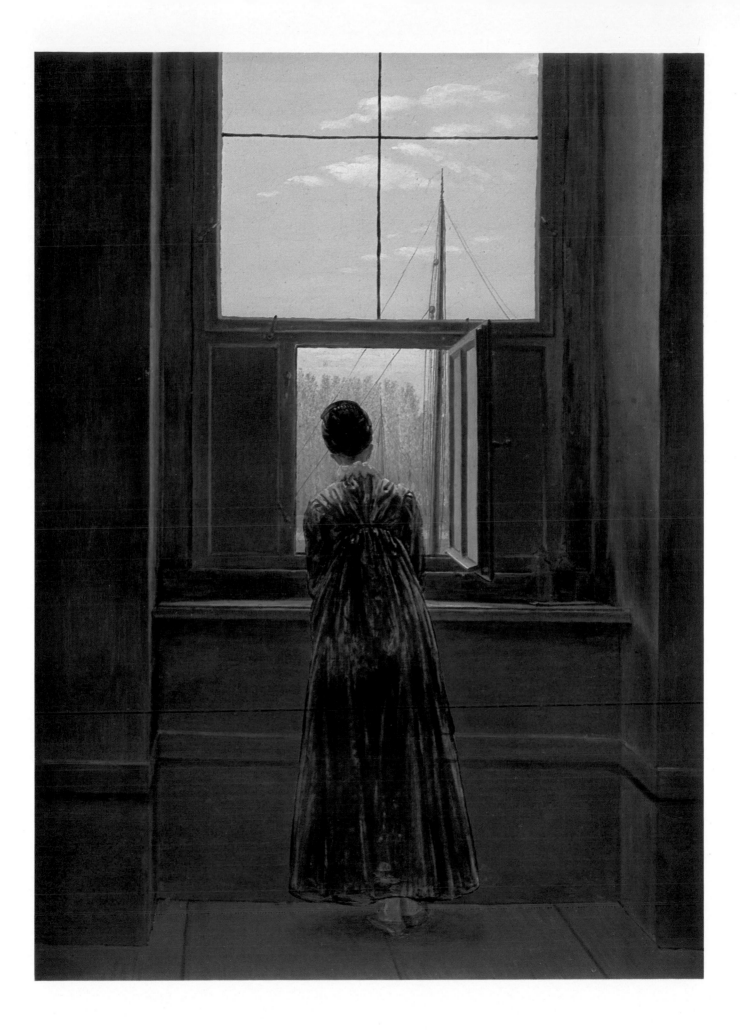

29. THE SOLITARY TREE
(VILLAGE LANDSCAPE IN MORNING LIGHT)

1822. Oil on canvas, 21⅝ × 28" (55 × 71 cm)
Staatliche Museen Preussischer Kulturbesitz, Nationalgalerie, Berlin (B-S 298)

In May 1806, on the way from Dresden to Greifswald, Friedrich stopped in Neubrandenburg, his parents' home and the town in which two of his brothers had also settled. In the nearby landscape—at times in hours of painstaking study—he produced a number of sketches of trees, especially oak trees, alone and in groups. On May 25, 1806, he drew *Old Oak with Stork's Nest* (fig. 6), now in the Kunsthalle, Hamburg.

This tree was to play a major role in Friedrich's later work. It first appeared, divested of its stork's nest, on the left in the group of three oaks standing guard over the boulders of *Cairn by the Sea*, a sepia of 1806–7. Sixteen years later, in 1822, he portrayed the old oak once again, this time placing it in the center of the present painting, *The Solitary Tree*.

In this instance it is perfectly correct to speak of a "portrait" of a tree. Each detail has been faithfully reproduced, with absolute respect for the tree's unique individuality. Its crown, splintered and forked, is even more prominent here than in the earlier drawing, where it was obscured by the stork's nest. For Friedrich a tree had just as much personality and history as a human being, perhaps more. In the present picture a shepherd stands in the shelter of the tree, leaning against its trunk. He is protected by it, but at the same time lost in its shadow. The tree was there before him, and it will still be standing there when the shepherd is no more. Another shepherd will then seek its shelter. The man is minuscule in comparison to the tree, whose proportions Friedrich clearly exaggerated for the purposes of this painting.

The other trees are also actual portraits. Friedrich drew them on a later sojourn in the Neubrandenburg region, on his way back from Greifswald to Dresden between June 9 and 16, 1809. He found them in the vicinity of Breesen, where he was the guest of the family of his deceased sister, Dorothea Sponholz, and selected them from a large number of tree studies when planning the present painting. The barrier of trees and brush extending across the middle distance also comes from a Breesen study, dated June 9, 1809, now in the Kunsthalle, Bremen.

For this painting Friedrich placed the mighty old oak in the center and the smaller trees related to it at a respectful distance away on either side. All of them appear in front of a background mountain landscape that Karl-Ludwig Hoch has only recently identified as the Jeschkengebirge in northern Bohemia. Friedrich had made two sketches of this mountain range while on his hiking tour of the Riesengebirge in 1810.

The painting's "official" title has been changed a number of times over the decades. Originally it was called *A Green Plain*, or at least that is the title given it in the catalogue of the Wagener collection in 1828, where it appears next to its companion piece, *Moonrise by the Sea* (plate 30). There we find an additional note that the work appears in "morning light." A catalogue from 1856 lists the painting as *Village Landscape in Morning Light*. Max Jordan, who

became the first director of the Nationalgalerie, Berlin, in 1876, later changed that title to *Harz Landscape in the Evening*. For the 1921 catalogue from the Nationalgalerie, Ludwig Thormaehlen changed the title once again. There he calls the picture *The Solitary Tree*, adding a note to the effect that the earlier title was misleading: "The landscape has more the feeling of the Sudeten region than the Harz Mountains." Since the landscape does indeed lie before us in the full light of morning, I agree with Karl-Ludwig Hoch's proposal that it would be best to settle on the title *Morning in the Jeschkengebirge*.

The old oak forms the painting's central axis. Willi Wolfradt appropriately referred to it as the "spine" of the picture. Everything is either directly aligned with it or otherwise related to it; all the horizontal forms emanate from it. The pond in the foreground suggests its hidden root system, and the one behind takes up the movement of its lower branches and extends it, while the clusters of trees cutting across the middle distance seem to extend its branches even further. The vertical line of the trunk is echoed by the other oaks, the church towers, and the rising smoke.

Everything related to man seems small in comparison with the tree: the shepherd is only a dot in the landscape; the farmsteads huddle close to the earth; the walls of a ruin are hidden by shrubbery. We cannot actually see the distant village on the left; the smoke is all that lets us know it is there. The church towers on the right, bracketed by oak branches, lie behind the line of a hill, hidden in a valley.

It is unclear where the viewer is standing. Looking at the tree, we perceive it to be quite close to us, and we appear to be on a hill looking out across the marshy meadows. It seems as though we would only have to wade across them to reach the tree. Yet if we concentrate on the shepherd and his flock, we realize how far away we actually are. As a result we seem to be drawn into the picture and at the same time kept at a distance. The inviting scene of the shepherd and his flock, by seeming a long way away, tends to draw us into the picture. However, the tree, because we think of it as being so close, places itself in our way, assuming truly gigantic proportions and forcing us back. And so our gaze moves forward and backward, each time obliged to refocus.

Friedrich arranged this picture in his typical fashion, with separate planes one behind the other. The tree grows upward, crossing each one in turn, until it reaches the sky—and dies. Closest to us, on the near side of the tree, the ground is marshy; the meadow begins at the point where the trunk rises up out of the earth. The meadow, in turn, reaches back to the larger pond, and with it a new zone is reached. Though the foreground is deeply shadowed, here everything glows with bright morning sunlight. We are now in the region of human habitation. The farthest plane comprises the mountains—blue, remote, only a vision.

In recent years various scholars have sought to interpret this sequence of picture planes as a metaphor for historical progress, in effect making Friedrich's landscape a symbol of human development. The suggestion was first advanced by Peter Märker. In his view we are to think of the strip of marsh and the pond in the foreground as prehistoric times, a nature untouched by man. The zone inhabited by the shepherd and his flock of sheep represents the

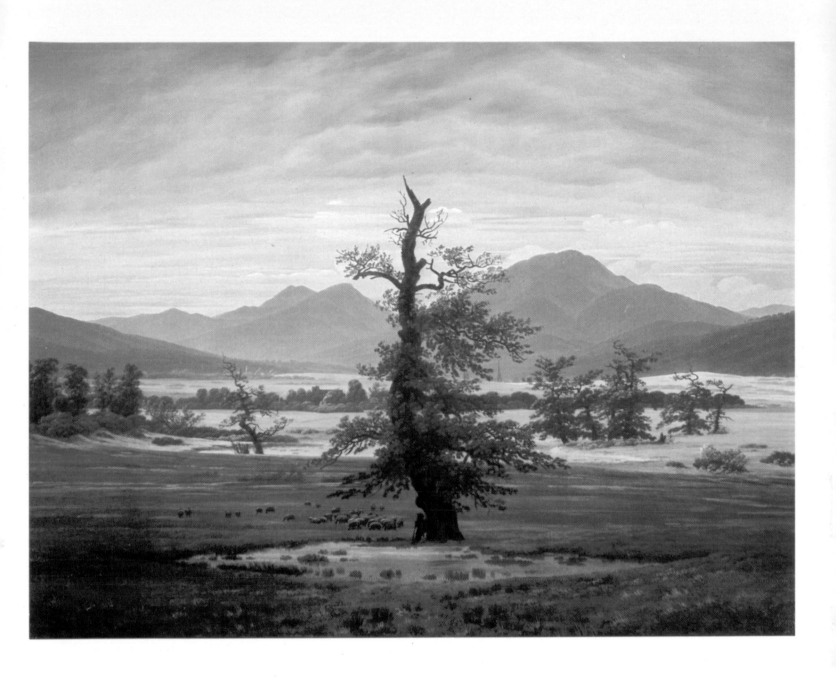

nomadic era of life, and suggests the bucolic, arcadian paganism of the ancients. The presence of the oak in this zone tends to support such a reading. Beyond the meadows is the strip of land in bright sunlight, which we are to think of as history's morning. Here we find a nature that mankind has made fruitful, settling in small hamlets; smoke rises up from the farmers' cottages; man and nature live in harmony. But the presence of a ruin suggests that this period too lies far back in time. The fields extend further back into a fourth region, at the back of which Gothic spires suggest a city. That region, together with the lower mountains on either side, might be understood as being symbolic of the Christian Middle Ages. We cannot judge the actual height of the spires for they rise up out of a sheltered valley at the foot of the distant hills. Consistent with such a reading of this landscape as a metaphor for history is Ludwig Justi's observation that as the eye moves back into

the picture it encounters increasing brightness and a "progressive refinement of forms."

Each of the separate zones begins with a basin shape. First comes the marshy pond in the foreground with its reflection of the sky; next comes the depression of the second pond, filled with light like a bowl; behind this lies the strip of woods, curving slightly forward, which protects the area of fields beyond; in the background, finally, the lines of the foothills slope into the picture from the left and right, creating a bowl-like setting for the mountains—landscape as vessel.

Where the tip of the oak tree stabs into the sky the clouds appear to lift up to form a cupola. As Wolfradt has written:

The sky, delicately shaded from light to dark, arches upward around the tip of the tree in a rhythmic succession of curves that opposes the curve estab-

lished by the grouping of trees around the second pond. The space behind the oak extends far into the distance, and it is clear that the dark mass of its trunk towering even higher than the mountain massif, which appears so insubstantial and flat in the distance, only serves to heighten this impression.

In his consistent repetition of the basin form it might be possible to see Friedrich trying to reconcile two contending interpretations of the world, one focusing on a nature governed by cyclical periods—the repetition of the times of day and the seasons—the other on the presence of man in nature, and a sense of linear historical development. Friedrich conceived of nature as a movement between pairs of opposites: viewing the morning, at the same time he automatically imagined evening; the thought of summer brought with it the image of winter; in every child he could imagine the mature adult and his decline into old age. But Friedrich was very much aware that his idea contained a hidden contradiction. While nature seemed to move in a continuous circular motion between the poles of birth and death, blossoming and decay, history—both the history of the world and the history of mankind—moved in a different way. To all of the important minds of early Romanticism as well as to the circle of those called "demagogues"—to which Friedrich felt allegiance, as we have seen—history was progressive, moving toward a definite goal, linked to a higher purpose, rushing toward ultimate fruition.

In *The Solitary Tree* Friedrich brilliantly succeeded in combining both kinds of motion, the cyclical and the linear. His sequence of separate basin forms—the marshy pond in front of the oak tree, the shadowed meadow behind it, the sunlit pond, the brighter meadow and fields set off by a dark barrier of trees and shrubs—suggests a linear progression. At the same time each of these ellipses is self-contained, holding a place in the cycle of nature. The distant mountain range brings both movements together and directs our gaze upward, where they are reconciled in a vast sky of clouds.

It is difficult enough to appreciate the past, to comprehend the course of the world and the cycles of nature. Nonetheless, Friedrich felt that he could entrust us with their images here without the mediation of a figure seen from behind. It is even more difficult to understand the present and envision the future. Only a reflective person at the right moment in time can hope to do so. Friedrich provided such a person in the companion piece to the present painting, *Moonrise by the Sea* (plate 30). ◈

30. **MOONRISE BY THE SEA**

1822. Oil on canvas, 21⅝ × 28" (55 × 71 cm)
Staatliche Museen Preussischer Kulturbesitz, Nationalgalerie, Berlin (B-S 229)

Friedrich produced the paintings *The Solitary Tree* (plate 29) and the present *Moonrise by the Sea* as a matching pair, one portraying morning and the other evening. They were commissioned by the Berlin collector Consul Wagener in 1822. On the consul's death, the Wagener collection became the property of the king of Prussia, forming the basis of the Nationalgalerie. It was only made available to the public in 1861, as the "Wagenersche und National-Galerie" in the Prussian Academy of Arts on Unter den Linden, then in 1876 the Nationalgalerie moved into its new building on Museum Island in the Spree.

Moonrise by the Sea is composed in every respect as a counterpoint to *The Solitary Tree*. There we see the radiance of morning, here the evening dusk. There the central image is nature—the tree; here it is a group of people who have sat down on a boulder on the shore to watch the moonrise and the homing ships. There a wealth of details catches our gaze; here we concentrate on a single image. There we see a Bohemian landscape, here the shore of the Baltic. There a range of mountains blocks our view of the horizon; here we can see beyond the horizon into the vastness of the sky. The only figure in *The Solitary Tree,* the shepherd, is part of the landscape; the three figures at the seashore are marked by their clothing as city folk, strangers in nature.

If we accept the interpretation of the separate planes of *The Solitary Tree* as segments of a historical process, then *Moonrise by the Sea* gives us the image of a present to which the figures have turned their backs. Their traditional German costume identifies the trio as sympathizers of the liberal reformers branded as "demagogues." They have left their urban surroundings in order to experience nature, seeking the shore. Forsaking human contact, they prefer the companionship of the rocks and the sea, a Romantic metaphor for discontent with society and dissatisfaction with the present.

While Friedrich often underscores the contrast between companion pieces, freighting pictures of morning and evening with suggestions of oppositions such as summer and winter, he has here—in what is perhaps his most mature and tranquil contrasting pair of paintings—omitted such references. It is summer in both pictures. Other details appear even to defy the usual pattern: the shepherd under the tree in the morning is an old man, while the trio on an evening outing to the shore is obviously quite young. The oak tree in the morning landscape is starting to die, while the sea and the rocks speak only of permanence. In the morning, death is already present; evening, however, shows no sign of it: the moon coming up over the horizon is full. The trio faces the future full of confidence.

For all its potential melancholy, primarily the effect of the violet tones, the message of this picture is reassuring. One cannot imagine a greater contrast than that between this scene of evening at the shore and the vision of *Monk by the Sea* (plate 7). There we saw only loneliness, exposure, and anguish. Here we are comforted by the proximity of other people—also suggested by the hom-

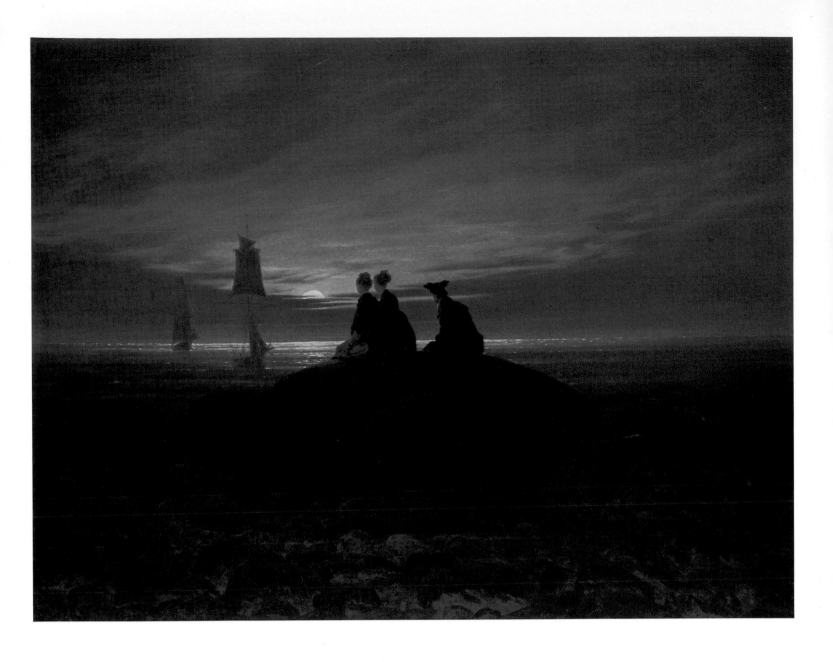

ing ships—by the sense of communal experience. This nature is anything but hostile. There is only a gentle movement in the sea, the clouds open to allow the moon to break through, and a silver glow shimmers on the water. While we can imagine the monk in the earlier picture listening to Jean Paul's "announcement by the dead Christ from the cosmos that there is no god," the present trio appears to be awaiting a message of joy.

Willi Wolfradt found in his analysis of this picture a compositional device typical of Friedrich, one that he chose to call his "hyperbolic scheme." The horizon line, which divides the picture in half, represents at the same time the coordinate between two hyperbolic curves: an upper one described by the clouds, sinking toward the center of the picture and gently rising again toward the edges, and a lower one created by the large boulder on which the figures are seated. The two halves of the picture arch toward

each other without touching. The hyperbolas belong to different planes: the boulder is fixed in the foreground, while the broad wall of cloud in front of the moon is part of a plane far off in the distance. The two planes, the tangible foreground and the remote distance, the realms of earth and of heaven, are linked by the three figures, the outlines of which, since they are seated on the tallest boulder, loom up into the upper region, as do the sails of the two ships, intersecting both curves.

The upper curve is filled with light like a bowl. Its reflection pours onto the sea and trickles into the hollows between the rocks in the foreground.

Two planes, two realms. In their colors they are reconciled. The orange-red, blue, and violet of the sky shimmer in the water below, are taken up again by the clothing of the two women, and echo in the gray violet of the sails. ▣

31. RIESENGEBIRGE LANDSCAPE

c. 1824 or c. 1830. Oil on canvas, 13¾ × 19¼" (35 × 48.8 cm)
Kunsthalle, Hamburg (B-S 304)

There is definitely a question about the dating of this picture. In his catalogue raisonné Börsch-Supan assigned it a date of c. 1825, arguing that it is similar "in painting style and coloring" to *The Solitary Tree* (plate 29), *Flat Rural Landscape,* and *Landscape with Windmills.* He is not altogether convincing. The character of this picture is totally different; it is far more spare, austere, and abstract. One could with equal justification propose a date of around 1828–32, relating the painting instead to the late Riesengebirge landscapes, as Hans Werner Grohn of the Kunsthalle, Hamburg, has recently tried to do. Grohn follows a suggestion by Werner Sumowski, who saw here analogies in pictorial arrangement and spatial construction to *Bohemian Landscape,* a watercolor inscribed "Teplitz, May 10, 1828." The Teplitz watercolor does indeed have some of the same feeling as *Riesengebirge Landscape.* Sumowski also wondered whether this might be the picture Friedrich entered in the art exhibition in Berlin in the fall of 1832, listed in the catalogue simply as *Landscape.* That work was discussed in detail by A. Schöll in the first number of *Das Museum* in 1833, and his description of it seems to capture the character of the present painting precisely:

Not that we would wish to challenge the truth of the forms and colors in themselves; rather it is the truth of the whole that we deny. An accurate excerpt from the realm of appearances is by no means necessarily a picture. What first strikes one, what is interesting about it, is precisely what it lacks. "What?" one asks. "Three colors and two lines—and this is supposed to be a landscape?" On second look, of course one has to admit that it is after all a view of a chunk of sky, a range of hills, and a stretch of valley. But what is so special about it? And why? Because this is the way they come together in nature—but not in such austere isolation, not so abstractly. What stands out in this picture, then, is the abstraction on the part of the artist: his selection. This requires, to be sure, the presupposition of a particular reason (for every choice demands one); but can it really be clearly and movingly expressed in this handful of exquisite colors and a few ordinary, though admittedly quite delicately rendered lines?

All of this could definitely refer to *Riesengebirge Landscape.* How else could a highly observant contemporary have indicated what is so unusual about it?

If we accept that the present picture is indeed the one displayed at the Berlin art exhibition as *Landscape,* it is certainly possible that it dates from around 1832. But we would still not be certain, for in the same exhibition Friedrich showed his *Oak in the Snow* (Nationalgalerie, Berlin), which he had actually painted as early as 1829. He could just as well have selected *Riesengebirge Landscape* for inclusion from among his works of the 1820s.

As the reviewer for *Das Museum* rightly noted, the painting displays a striking degree of abstraction. Almost nowhere—setting aside for the moment *Monk by the Sea* (plate 7)—did Friedrich come closer to abstract painting in the modern sense than in this picture. The earth is a deserted stage. No one goes about his daily tasks; there is not a tree, a shrub, or a rock to be seen. This is not at all the "art of earthly life" that Carl Gustav Carus championed. Nor is it the "tragedy of landscape" that David d'Angers spoke of. There is no drama here. Everything is still. The only action is in the sky, confined to the ominous and fast-moving clouds.

It might even be appropriate to place a question mark after the picture's title. Is this really a landscape from the Riesengebirge? Andreas Aubert felt that this was "unquestionably" a Bohemian scene, and called the painting *Summer Landscape from Bohemia.* Günther Grundmann thought at first that the picture represented the view of the Riesengebirge from Warmbrunn, but then recognized that the line of the mountains did not match the actual one and subsequently wondered if Friedrich was here presenting something he had seen in the Harz. When Alfred Lichtwark bought the painting in 1904 from the Friedrich family in Greifswald they referred to it as *Harz Landscape,* and that was the name given it for a long time in the literature. E. Sigismund, R. Hamann, K. K. Eberlein, and H. von Einem all felt that it represented some spot in the Harz Mountains, and accordingly assumed that Friedrich had painted it shortly after his sojourn in that region. W. Niemeyer and H. Stehr objected to that assumption already in the 1930s, arguing instead for the view from Warmbrunn toward the foothills of the Riesengebirge, with the Schneekoppe in the background. Börsch-Supan and Grohn both adopted this opinion, which was supported by expert testimony from the Geographic Institute of the University of Hamburg. But even expert opinion does not necessarily constitute the last word. Karl-Ludwig Hoch, armed with convincing arguments and photographic evidence, has recently transferred the inspiration for this picture to the Bohemian Mittelgebirge, and proposed that in future the work should bear the title *Mountain Landscape in Bohemia.* It is his opinion that the mountain in the background is the Kleis (or Klíč) in northern Bohemia. Friedrich could have sketched it as early as 1803, on what is thought to have been his first hiking tour of Bohemia.

It is of course immaterial just what setting Friedrich had in mind. The painting is not about a specific landscape. No other Friedrich landscape is as generalized, abstract, and devoid of identifying features. Karl Schnaase insisted in 1834 that if nature is actually "destroyed" in any of Friedrich's pictures it is this one. And Count Athanasius Raczynski remarked of Friedrich's painting in general in 1840 that if ever one of his works offered "nothing but emptiness" and was "lacking in details" it was this *Riesengebirge Landscape.* Ernst Förster in 1860 characterized Friedrich's work as being overly concerned with "phenomena related to nothingness." Nowhere is this so evident as here.

Everything is reduced to a minimum. Nothing else could have been left out. The simplest of appearances has taken on grandeur. The unimposing has become monumental. This picture is one of Friedrich's smaller paintings, but where else has he given us a glimpse of nature, a mountain range, a meadow, more nobly conceived, with a greater sense of monumentality, than in this modest painting with its "three colors and two lines"?

"Three colors and two lines—and this is supposed to be a landscape?" That was the question of Friedrich's contemporaries. Yet

in Friedrich's painting these elements give rise to a whole world. We could not possibly explore the remote slopes of the mountain ridges stacked one behind the other. These mountains, like the valley floor in front of them, are endless; they stretch to either side into space we cannot experience, who knows how far. Our limited view captures only a small segment of a larger continuum. Three colors—the yellowish gray of the sky, the blue violet of the mountains, the greenish brown of the meadows—and two lines that define them; yet what tension is created. The restlessness of the sky contrasts with the stillness of the meadows, with the imperturbable remoteness of the mountains. The undulating outlines of the mountain ridges provide a contrast to the two straight lines cutting through the fields in the foreground. Though the mountains rest on the valley floor in a line as straight as a ruler, their peaks lift up into the clouds. The curving lines of their various ridges are echoed by the undulations of the foreground, with their suggestion of breaking waves. The yellow of the sky is taken up in the one delicate line of yellow that leads from the right side of the picture to the center, where it forms a sharp angle with the baseline of the mountains, enclosing a field of grain. Willi Wol-

fradt found this dividing line a clue to the crucial feature of the painting, its "structural secret," namely the fact that the line marking the base of the mountains runs at an angle. He saw in this the "breath of a giant organism in the floor of the steppe," and found the sky to be streaming "as if carried along by the momentum of the spatial shift." His conclusion: "Nothing could be clearer: what we are seeing is the primal relationship between level and ascending forms."

Wolfradt's observations lead us to another insight, concerning the energies immanent in this picture. This space emptied of all objects seems like an electrical field; the lines cutting through it are lines of force, and the ground waves seem to register secret shocks. A motion originating somewhere in the remote distance here makes itself known in the curving contours of the mountains, in the waving grasses, in the rushing clouds, then passes on into another great distance. Many writers have characterized Friedrich's landscapes as "infinite," but in this picture the infinite assumes a transitory quality. The particular has been swept out of view. Nature is no longer specific objects but hidden forces. Here they are manifest in three colors and two lines. 🔲

Friedrich's *The Polar Sea* has often been compared to Géricault's painting in an attempt to distinguish between Romanticism in Germany and in France. Scholars have found it telling that the Frenchman presents us with a scene of high drama, the German a silent, frozen landscape—that the one painting celebrates the self-preservation of mankind, the other the triumph of nature.

The Polar Sea is possibly Friedrich's most forbidding picture. The ice layer has cracked, and splinters from it have piled up on top of each other. The resulting pyramid serves as a massive funerary monument, its sharp edges pointing toward the heavens. The blocks of ice impress us as being both magnificent and unapproachable. To venture into such a region is to court certain death. It is no place for mankind. The ship has been swallowed up by the ice, and as yet lies sheltered in it; it will eventually sink altogether, becoming one with majestic nature.

To do full justice to the picture, I prefer to see it as an image of hope as well as disaster. Though the polar region is presented as utterly forbidding and unapproachable, it is nevertheless sublime, an image of the numinous like the ice-covered peak of the Watzmann. For Friedrich the North always held a unique, almost magnetic attraction. To him it was a place of freedom, and not only in the political sense. He thought of it in much the same way as he did of mountain summits or the vast open sea. At one and the same time it was for him a realm of loss and transformation, of death and renewal.

Two lines of thinking compete with each other in Friedrich's painting. One holds that the frozen waste is forbidding, and that nothing living can survive in it. The other celebrates the incomparable clarity and beauty of the Northern landscape. One sees the menace in the towering masses of ice in the foreground—the plane corresponding to the present—a pyramid of icy splinters that have buried the wreckage of the ship that dared to sail too far. The other registers the ice structure bathed in deep blue light to the left in the background. This second pyramid evokes the notion of a transparent cathedral—Thomson's ice palace, a temple formed exclusively by the forces of nature. What we now see as an icy tomb will one day be transformed into a crystal shrine.

There is no denying that *The Polar Sea* is first of all a portrayal of death. Yet even the undertaking that gave Friedrich his inspiration for the work, Parry's attempt to find the Northwest Passage to the Pacific, suggests a mitigating aspect of death. Death in the icy sea is a disaster, but it is also a passage. In its demise the ship has found the way to another world. ✵

33. THE WATZMANN

1824—25. Oil on canvas, 52¼ × 67" (133 × 170 cm)
Staatliche Museen Preussischer Kulturbesitz, Nationalgalerie, Berlin (B-S 330)

High mountains can be just as majestic, forbidding, and unapproachable as the polar sea. The gradual slopes and sharp cliffs of the Watzmann are quite reminiscent of the pyramid of tumbled, jagged floes in *The Polar Sea* (plate 32). The perpetual ice of the glaciers is perhaps even more sublime and remote than that of the frozen sea, for a ship had at least tried to venture into the latter.

Friedrich had no more firsthand knowledge of high mountains than he did of the Arctic. For an Alpine landscape he painted in 1824, depicting the view of Mont Blanc from Mont Anvert, he utilized a drawing by Carl Gustav Carus. For this slightly later view of the Watzmann with a smaller mountain looming up in front of it, his source was a watercolor sketch by his favorite pupil, August Heinrich. Heinrich had made the sketch on a tour of the Salzburg region in 1821, and after his premature death it had been discovered among his effects. Johan Christian Clausen Dahl had bought the watercolor, and he too used it as the basis for a painting. Since Heinrich was already dead when Friedrich came to know his small sketch, it may be that with this painting from it he hoped to create a memorial for his pupil.

The oddly shaped rock formation in the middle distance comes from a drawing Friedrich made on his journey to the Harz in 1811. According to Tina Grütter it depicts the granite pinnacle known as the Ahrensklint, near the Brocken. Other boulders and outcroppings appear to have been based on features of landscapes in the Riesengebirge or in Saxon Switzerland. As always, Friedrich here combined motifs from a number of different sketches.

In its construction, *The Watzmann* presents a series of triangle shapes pointing upward, one behind the other, each in its own plane. These vary in color from nearly black to the brightest white. The first of these triangles is described by the outcroppings of the foreground, where it would be more accurate to speak of cones or pyramids, for here there is an indication of three-dimensional modeling. The tops of these rocks are jagged, so that even the foreground seems impassable. In a second plane the Ahrensklint with its low cave forms another triangle, as does the small fir tree growing out of it. The bizarre formation is like a tomb, and marks a definite boundary.

Strangely enough this section in the middle distance is the only part of the picture, aside from the pinnacle of the mountain, that appears to reflect the sunlight. Behind it come darker areas. The foreground and the mountain massif in the center lie in shadow, though the sky seems perfectly clear.

Behind a slope indicating the third plane (to be thought of as the side of a triangle that comes to a point only outside the picture) a flatter, blunter triangle shape appears further back in the thin fourth plane. It is echoed in the fifth plane by the dark, looming triangle of the mountain in front of the peak. This rises up like a barrier, or shield, guarding the smaller sixth plane, which does not quite extend across the whole of the picture, and ultimately the all-important seventh one, comprising the Watzmann itself. In the latter, the triangles are perfectly obvious.

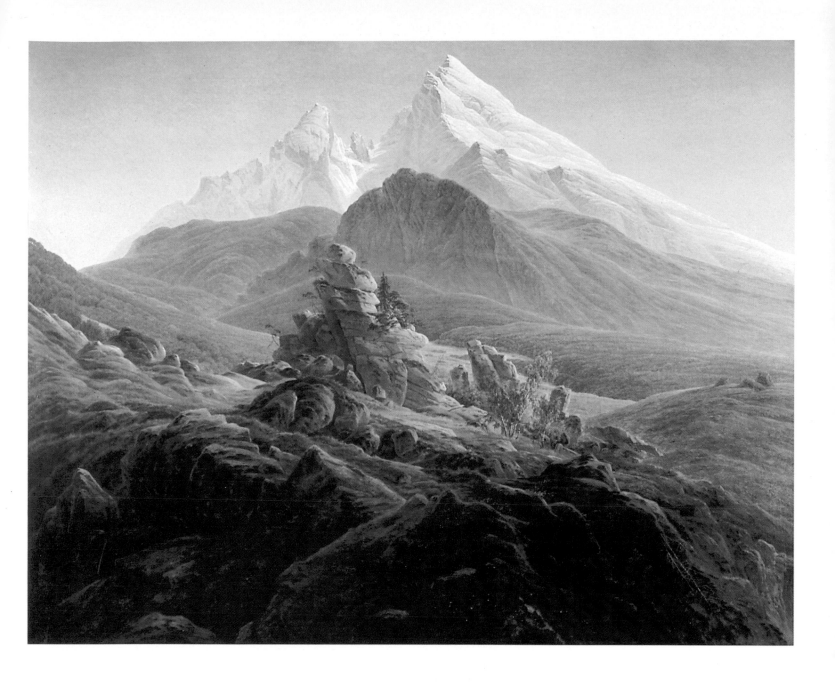

The barrier of the fifth plane is actually unnecessary, for between the third and fourth planes and again between the fourth and fifth there are deep chasms that serve to divide the picture into different zones. The front zone is rendered with what Börsch-Supan repeatedly calls Friedrich's "comprehending vision," while the back one is given over to the incomprehensible. But even in the front zone we are not altogether at home. It is not only that it is impassable, that the picture space breaks off sharply just before the lower edge of the frame. The proportions of the objects presented in it are confusing, and it is impossible for us to orient ourselves.

How are we to know what scale to use? How big *are* the rocks that make up the Ahrensklint? How big is the entrance to the cave we see beneath it? How tall is the fir tree? No, this region is just as unapproachable as the realm of the polar sea. We can only enter it with our eyes, hesitantly feeling our way and losing ourselves in its vast distances. Everything in this picture, the triangle shapes, the color gradation from dark to light, is designed to draw our gaze upward to the towering peaks. And it is only with our gaze that we

can appreciate it, leaping across its formidable pinnacles and crevasses and scaling its steepest slopes. There are no trails we could follow.

Even our gaze has difficulty exploring the summit. There is nothing on its blinding surfaces to hold onto; we keep slipping off into the blue of the sky. Friedrich's presentation of the peak as something far grander than it actually is suggests that he thought of it as a symbol. In the early nineteenth century the Watzmann was frequently celebrated as a symbol of the divine, and undoubtedly that is how Friedrich wished us to see it.

Friedrich first exhibited *The Watzmann,* one of his largest paintings, at the Dresden Academy in August 1825. The previous spring another picture by that name had been displayed in the same gallery, that one by Ludwig Richter. It is quite possible that. as Börsch-Supan suspects, Friedrich decided to respond to Richter's composition with one of his own. In the early 1820s Richter had been greatly influenced by Friedrich, but he later looked back at that phase in his career as an aberration. Like so many other German painters, Richter then moved to Rome—against Friedrich's

advice—where he came under the spell of Joseph Anton Koch. As we know from a number of Friedrich's comments, Koch's ideas about landscape painting were altogether unacceptable to him. More than likely he was referring to Richter when he noted: "Had he not traveled to Rome, perhaps he would now be further along in art.... He also became a slave to fashion in Rome and a follower of Koch, no longer a student of nature." It seems certain that the following remarks were inspired by Richter: "He sees in everyday life only the ordinary; anything more profound escapes him. He lacks the compass, the inner magnet, that would help him find his way through such territory."

Richter sent his Watzmann painting to the Dresden exhibition from Rome in 1824. The picture was wholly derivative of Koch's famous *Schmadribach Falls*. With many stops along the way it leads our gaze from a small milking shed in the foreground past a little chapel and on up, slowly and easily, across the wooded slopes. Here there are any number of paths; a climb is perfectly possible. It is only where the glaciers begin that the grades become steeper. One can see a number of things about the picture that Friedrich would have found disturbing: its naive conception of nature as charming, inviting us upward step-by-step into the higher regions; its proliferation of secondary motifs that only detract from the central idea, the massive mountain peak; its insistence on accurate details, here the precise way the water cascades down the slope, there the carefully rendered stones on the shed roof, or the trunk of a tree, all without any thought of the overall composition. Doubtless it was the whole trend in landscape painting to lose itself in realistic details that did not sit well with Friedrich. In its fascination with isolated phenomena it lost sight of nature, as he understood it. But the times were passing Friedrich by. Richter's picture was far more favorably received than his was.

When one thinks of all of the things that Friedrich wanted to express in his picture in contrast to what Richter had said, the criticisms of Carl Töpfer, written on the occasion of the painting's exhibition in Hamburg in 1826, must have seemed to him the height of irony, turning all of his intentions on their heads. Töpfer wrote:

The artist has neglected to provide us with a view down into the valley. Anyone who wishes to convey to us the dizzying height of a given vantage point must not cover the valleys swimming in mist beneath our feet with the bottom of the frame. We have to be able to pick out the tops of church steeples, so that we are cheered by the imagined pealing of bells in the distance, so that in the freezing wasteland of an Alpine peak we can imagine the signpost that guides us back down into the world of plants and men.

Töpfer's notion of what landscape ought to be was precisely what Koch and Richter were producing. The reviewer laments the absence of everything that Friedrich so consciously omitted. To him Friedrich's picture was only a fragment, a "painting that we might call the upper half of what could be a superb, colossal Alpine picture." ▧

34. THE TEMPLE OF JUNO AT AGRIGENTO

c. 1830. Oil on canvas, 21¼ × 28⅜" (54 × 72 cm)
Museum für Kunst und Kulturgeschichte, Dortmund (B-S 381)

Is this painting of the Temple of Juno at Agrigento the work of Friedrich? Or is it actually by Carl Gustav Carus, as was long thought? Opinion is divided on the issue even today. Thus it happens that we find one and the same painting listed in the catalogues raisonnés of two different artists. Marianne Prause included it in the oeuvre of Carus as number 14 in the section entitled "Antiquity," furnishing it with the date 1854 on the basis of a passage from Carus's reminiscences. Börsch-Supan claims it for Friedrich without question, assigning it the catalogue number 381 and dating it to the period around 1828–30. The Hamburg Friedrich catalogue from 1974 entered into the fray with a number of new arguments, and urged that the question of authorship be reconsidered.

If Friedrich painted the picture, then it is the only known painting from his hand to feature an Italian landscape motif. The only other work one can point to as a remote parallel is an early engraving, produced around 1803, that also depicts the ruins of an ancient temple, but in a landscape that is hardly Mediterranean. We know how devoted Friedrich was to his homeland. All his life he felt disinclined to travel to Italy—he was much more tempted to visit Iceland. Surely the most significant evidence of this is the frequently quoted passage in a letter from 1816 to his friend Lund in Rome, in which he declines an invitation to visit—his "soul has never been drawn to [Italy]." Surprisingly, as he then goes on to justify his response he admits that he had almost changed his mind: "I can now well imagine my going to Rome and living there. But the thought of returning to the North from there makes me shudder; to my mind that would be like being buried alive. Standing still I accept without complaint, if fate so wills it; but going backwards is repugnant to me. My whole being rises up in indignation against it."

If we choose to see more in this letter than a friendly gesture to an old acquaintance whose invitation he is turning down—and we have every reason to do so, for Friedrich was not a person to indulge in empty pleasantries—then it tells us at the very least that his attitude toward Italy was ambivalent. He may not have felt a powerful yearning for Italy, yet at a certain period in his life he did not consider it unthinkable that he go there. When Friedrich spoke so dismissively about Italy in his "Observations on Viewing a Collection of Paintings" of about 1830, it was probably not because he held the Mediterranean landscape or the South in low esteem, but rather because of his dislike for the schools of painters identified with Rome, namely the Nazarenes and even more the Koch circle and its idea of landscape. He there turned his wrath on art critics, for whom "everything [had] to be Italian.... It would have been possible to do this at home from engravings, without having to make a special trip to Rome." Perhaps he painted *The Temple of Juno at Agrigento* at home from an engraving as part of this same polemic.

Hermann Beenken interpreted the picture in much this same

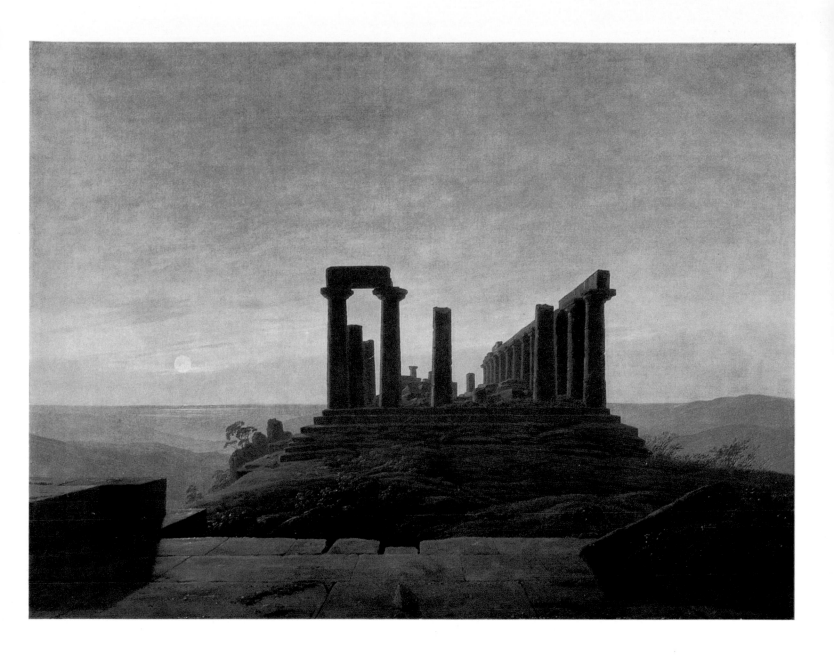

vein when he first published it in 1943. He saw a parallel in the reflection of the moonlight on the water to pictures like *Moonrise by the Sea* (plate 30). He also claimed to recognize Friedrich's signature in the "delicate cloud formations," and compared details of the vegetation like the shrubs to the right of the temple with similar details in Friedrich's *Mist in the Elbe Valley*. Then he asks: "Is it not typical of Friedrich to completely transform a southern landscape into a Nordic one, placing the ruin in front of an infinite distance as the mute and magnificent monument from a long dead past?"

After all these observations it is surprising that Beenken nevertheless chose to attribute the painting to Carus—doubtless overestimating that artist's abilities—and proposes that we accept it as a work from 1854, one that Carus vaguely refers to in his reminiscences as an "oil painting composed in the spirit of Sicilian ruins." One thing seems certain: if Carus did paint this picture, it is in any case, as Beenken remarks, full of "Friedrich's spirit," and must therefore date from the time when Carus was still under his influ-

ence. If I were forced to give the picture to Carus, despite all my better judgment, I would therefore prefer to date it to c. 1828–30. Carus undertook a trip to Italy in the spring and summer of 1828, but it took him only as far as Paestum. After his return, once again immersed in the familiar world of home, he could have produced this picture in an effort to work up the memories of his journey. But I still do not think it is his. The manner in which the painter has taken what was obviously someone else's work and assimilated it to an independent vision makes it much more likely that it is by the master himself.

Thanks to P. O. Rave, we know precisely what served as the inspiration for the painting. It was an aquatint executed by the Swiss engraver Franz Hegi after a work by the Karlsruhe draftsman Carl Ludwig Frommel, which was included in the 1826 publication *Voyage pittoresque en Sicile*. When we compare the aquatint with the painting, we are first struck by the degree to which the painter has simplified his motif. The figures have been banished; there are no longer any tourists climbing about among the

columns, and the mother and child in the foreground have disappeared. Instead, we now see a yawning gulf between the forward terrace and the temple. The vegetation is more sparse; the olive trees and aloes have gone. Börsch-Supan rightly observed that the artist has reinterpreted a few fallen blocks to the left of the temple as boulders reminiscent of those in the Elbsandsteingebirge.

Even so, I do not share his opinion that in this picture the artist wished to express a condemnation of paganism, its temples reduced to ruins, and to hold up to it in admonition the moon as an image of Christ. On the contrary, the temple ruin is seen as something monumental, and for all its decay it retains a sovereign grandeur like any one of Friedrich's ruined churches or monasteries. Paganism is here accorded the same respect as it is in the symbol of the oak tree. Perhaps we can best understand this picture if we think of it as a salutation from Friedrich to the realm of the South that is closed to him, to a world he attempts to enter for a moment by placing its most characteristic motif, the ancient temple, against an evening landscape in which the North and South appear to be united and reconciled.

Perhaps. If this is Friedrich's work.

In his Hamburg catalogue, Hans Werner Grohn called the painting's attribution to Friedrich into question once again. He points out "the density of the forms," which "like the extreme foreshortening of the massive structure stands in contrast to [Friedrich's] usually two-dimensional architectural motifs placed like theater flats parallel to the picture plane." His argument is only partially correct. The perspective foreshortening of the temple was already established in the Hegi-Frommel view, and was taken over from it—like a stage flat—almost verbatim. Moreover, we can see even in this picture Friedrich's typical use of parallel planes, progressing from the foreground to the temple mount, and to the separate lines of the hills stacked one behind the other. The aquatint reveals no such arrangement: there the temple lies in a three-dimensional space perceived in terms of classical perspective, embedded in the landscape and at one with it. The painting highlights the temple ruin, isolates it, places it in a foreign setting. Friedrich—or Carus working in Friedrich's manner—conceived it as a testament from the past, one that speaks of the magnificence and the vanity of human endeavor and moves us so powerfully, and with no hint of tragedy, precisely by being only a relic. ▨

35. RUINS OF ELDENA ABBEY AND THE RIESENGEBIRGE

c. 1830–35. Oil on canvas, 28¾ × 40½" (73 × 103 cm)
Städtisches Museum, Greifswald (B-S 415)

Eldena Abbey in the Riesengebirge? Friedrich transported these ruins, familiar to him since his childhood in Greifswald, from the Baltic coast to the landscape of the Riesengebirge. In the process he reduced them to a single empty window arch and the fragment of a side wall. In an essay on the motif of the Eldena ruins written in 1944, Otto Schmitt could only marvel: "Eldena with the Riesengebirge as background? A most unusual juxtaposition … and yet as a work of art wholly convincing, and uncommonly revealing, both of Friedrich the man and the artist. Out of totally heterogenous ideas, but in both respects taking something real as a starting point, hopelessly blending fact and fiction and infusing reality with poetry, Friedrich set about creating his painting."

In his "Notes," speaking about himself in the third person, Friedrich defended his practice of arbitrarily combining motifs from nature according to their inner relationships, obeying nothing but his own feelings:

Typical of this artist was his habit of using whatever especially appealed to him in nature, often without any consideration for time, subject, or setting. He loved the evening sky just at sunset, for example, with all its glowing color, but his landscape was always still in sunlight, and the shadows of things were very short, as at midday. His eye was delighted by the actual colors of a pine forest, and he unhesitatingly used them for deciduous woods. He thought nothing of transporting tumbled ruins he had seen in ravines to the tops of mountains, where they could never have fallen.

"Without any consideration for time, subject, or setting," Friedrich drew on studies made at different times and in very different locations for his picture *Ruins of Eldena Abbey and the Riesengebirge.* For the background he reversed a drawing he had made on July 14, 1810, during his tour of the Riesengebirge. It recorded the view of cirques and summits from Heinbergshöh. He must have traced his sketch and then turned the tracing paper over, a procedure he is known to have followed with other drawings.

The depiction of the ruins of Eldena Abbey with a farmhouse in front of them comes from a study he made while visiting Greifswald in the summer of 1815. He nevertheless omitted the masonry indicated in the window arch in the drawing and a second house to the right of the ruined abbey. The horse is all that survives to remind us of it. The man lazily leaning on his cane in front of the house is taken from a sketch dated September 1824—again reversed—as is the small dog at his feet. For the broken branch in the left foreground he relied on a study from 1808–10. The road leading into the picture can also be seen in *Bohemian Landscape (with the Milleschauer)* (1810, plate 10); Friedrich had drawn it in Saxon Switzerland.

In the drawing used here the ruins of Eldena Abbey are viewed from the west. From the other direction we might have seen traces of the squatter's lean-to nestled against the window wall

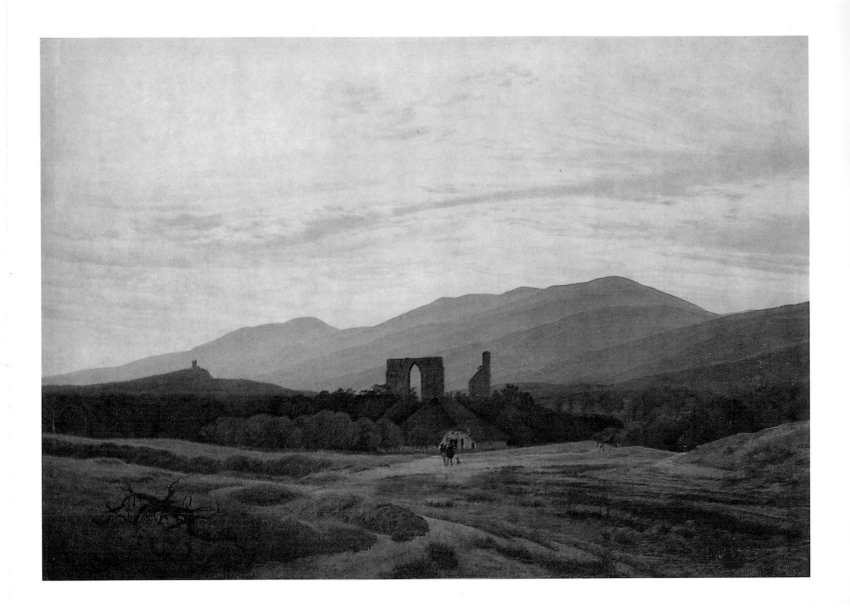

that is shown in the painting in the Nationalgalerie, Berlin, from 1824–25 and the watercolor from 1836. There Friedrich fully exploited the contrast between the ancient, towering stonework and the squatter's miserable hut. Here the vertical thrust of the ruin, which has not been exaggerated, and the spreading farmhouse resting comfortably on the ground suggest a softening of that contrast. In many of his depictions of Eldena the ruin stands out as the central motif, but here the emphasis has shifted. The ruin no longer dominates: it is accorded the same attention as the farmhouse in front of it. The evening light—the brownish tones of the foreground and middle distance and the blue-violet of the mountain—has reconciled all of the details. The yellow-violet of the sky has drawn them together into a single statement, the symbol of a nature into which everything born of it sinks back again. Once we recognize this, the transposition of the Eldena ruins into the Riesengebirge seems like a homecoming. ▨

38. THE EVENING STAR

c. 1830–35. Oil on canvas, 12¾ × 17¾" (32.2 × 45 cm)
Freies Deutsches Hochstift, Frankfurt am Main (B-S 389)

Three people are returning home from an evening stroll. They have been walking through the fields, and it is now beginning to grow dark. The young woman and the girl walk close together, while the young boy has run ahead of them. He stops at the top of the rise, sees the city silhouetted against the sunset, and lifts his arm to wave, greeting the familiar image. Is this Friedrich's own family, which we feel we can recognize as well in *The Stages of Life* (plate 40)? His younger daughter would have been ten years old in 1833, his son nine.

The city, visible along a narrow line through the picture, just this side of the horizon, and framed by poplars to the left and right, is Dresden. One can make out its Kreuzkirche, Frauenkirche, palace tower, and Hofkirche as seen from the east. The evening star hangs above the cupola of the Frauenkirche.

The dark earth of the foreground arches upward toward the horizon; a contrasting downward curve, much gentler and extended to either side, is suggested by the clouds. From the rise in the foreground the eye leaps into the middle distance, where the city lies nestled in the valley. The horizon is formed by a line of gentle hills in the background, which finally reaches the level plain on the right, extending back to infinity. These three zones, the simple fields in the foreground, the articulated—but largely hidden—zone of the city, and the level plain in the background, lie before us in stillness, their colors blending into a monotone, as though ready for sleep. The only movement is in the sky, where the two different cloud fronts create a degree of dramatic tension.

Our gaze is drawn to the right, following the direction of the strolling figures, to the cupola and the church spires. But the whole movement of the picture pulls it even further. The line of the upper wall of clouds runs downward toward the right, answered from below by a furrow that cuts through the field and gently rises to meet it. The two lines will come together at the horizon only beyond the picture, far to the right, and we cannot help but try to follow them.

Opposing this gathering of horizontal lines, and the curve of the hill that spans the separate strips of fields, we find a succession of verticals: first the poplars on the left, then the three figures and the silhouetted city spires, and finally another stand of poplars. In terms of scale, the three people, though clearly in the foreground, find a quite natural place in the line of trees and towers in the middle plane, taking up their rhythm and giving it an added accent.

Börsch-Supan has pointed out that poplars are symbols of death, and accordingly interpreted this "return from the walk" as "an image of the approaching end of life." To my mind this interpretation is far from certain, to say the least. These are young people, after all, mere children, and I cannot agree that the joyous abandon displayed by the boy is actually an "expression of unconscious yearning for death."

Even so, Börsch-Supan is surely correct in pointing out that this simple return from an evening stroll is indeed a metaphor. At a deeper level, the picture does appeal to our longing for transcendence, for the ultimate homecoming, remote as it might be from the people on the brow of the hill. For they are by no means nearing the end of their walk. Are they not on a course that leads far outside the picture, where the lines of the field and the strips of cloud will finally come together?

The message of this picture is ambiguous, as is the symbol of the evening star, which is also the star of morning. We are presented with a vision of nature in autumn. A walk is coming to an end. But this has been only a walk, and the people who decided to take it are very young. Now they are returning home, and it is only thanks to a number of subtle suggestions that we may deduce that Friedrich sees every homecoming in a larger context. I fully agree with Börsch-Supan in his characterization of this autumnal evening mood as one in which "melancholy and joy, apprehension and solace blend into a unique harmony." It is difficult to think of another painting in which Friedrich presents intimations of death as tenderly and comfortingly as he does in *The Evening Star.* ◼

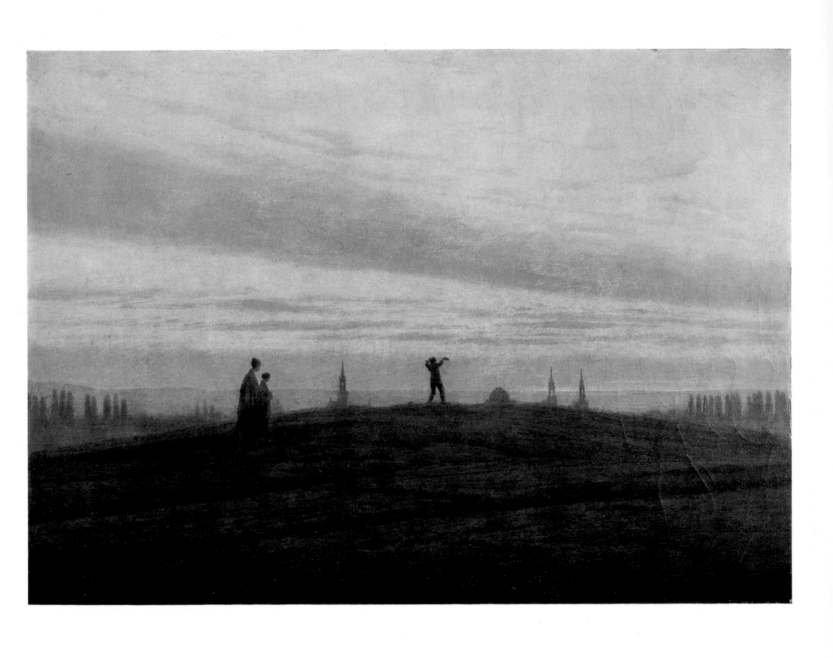

39. THE GREAT PRESERVE

1832. Oil on canvas, 29 × 40⅜" (73.5 × 102.5 cm)
Staatliche Kunstsammlungen, Gemäldegalerie, Dresden (B-S 399)

The Great Preserve, a marsh traversed by carriageways, was located to the northwest of Dresden. It had been laid out as a hunting ground by the Saxon electors in the seventeenth century. It formed a sort of peninsula inside a curve of the Elbe to the north. To the east, separated from it only by the Weisseritz, began the Smaller Preserve. From the bank of the Weisseritz, three broad alleys of linden trees radiated out toward the west through the Great Preserve. They had been planted in 1744 by Friedrich August III. One of these can be seen entering this picture from the left, only to end somewhat abruptly in the middle of the fields. It is difficult to determine whether the water in the foreground with a small barge on it is meant to be the Elbe itself—at that time still unregulated—or part of its floodplain, the edge of a river or a side arm. The engraving made from this painting by Johann Philipp Veith in 1832 for inclusion in the Bilderchronik of the Saxon Kunstverein—the group had bought the work to be given away at its annual raffle—bore the title *Evening on the Elbe*. Contemporaries must therefore have recognized this as the Elbe despite the alarmingly low level of the water.

Today what was once the Great Preserve has been given over to factories and a large harbor.

This picture is a typical example of the richness of color in Friedrich's late style. Its geometric structure is softened, as in other works from the 1830s, by atmospheric values, giving it an ideal balance.

Parallel to the horizon, a series of ruler-straight lines cuts across the picture, describing the clumps of trees in the middle distance, the alley to the left, the low shrubbery to the right, and the edge of the woods at the back. From above and below two curves converge on these horizontal lines of trees, another instance of a compositional device the painter loved, the one that Willi Wolfradt has called Friedrich's "hyperbolic principle." The upper curve is formed by the edge of the gray-blue bank of clouds, and is taken up and varied by several narrower strips of cloud above it. The lower one is described by the edge of the riverbank entering on the right and bending closer to us at the bottom left.

It is echoed in turn by the numerous islands and stretches of exposed riverbed.

The river is the Elbe and yet it isn't. At our feet it appears to trickle into the ground as though ending here, though it reflects the sky. The barge with its single sail seems to have run aground; surely it cannot proceed much further. It is an evening in late summer, at the moment just after sunset. The sky still glows. We find a similar richness of color in the skies of *The Evening Star* (plate 38) and *The Stages of Life* (plate 40).

Our vantage point is somewhat elevated, as though we were somehow hovering above the last trickling of the river. Our gaze floats freely across the barrier of trees into the distance, is caught up by the wall of clouds, and loses itself in the harmony of twilight. We are not standing on the ground in this picture, are no longer part of this landscape. We are now free of all earthly bond, and in a moment we may take our leave.

The harmony of the picture is created by its blend of three color sonorities. There is the saffron yellow of the sky above the bank of clouds, which, shaded to a brown and violet, is reflected in the channels of the stream; the blue-gray tinged with violet of the weather front above the horizon; and the olive brown, yellow green, and dark green of the foreground, appearing in numerous shadings from those of the exposed river bottom to the bushes along the bank, the meadows, and the distant rows of trees. In the center, to the left of the grayish white of the sail, an accent is provided by the shimmering light on the surface of the water on either side of the reflected solitary tree. This is the spot where the curves of earth and sky come closest together. Above the bank of clouds we can just see the faint glow of the crescent moon.

In *The Great Preserve* Friedrich has captured a moment of transition—from late summer to fall, from evening to night, from life to death. An alley suddenly breaks off; a river peters out in a series of shallow pools; a boat is about to run aground. The colors of twilight gleam forth one last time before they dissolve into gray. The contrasts appear to be reconciled. Our gaze floats freely above the scene, with no specific details to hold it. The rest is silence. ▨

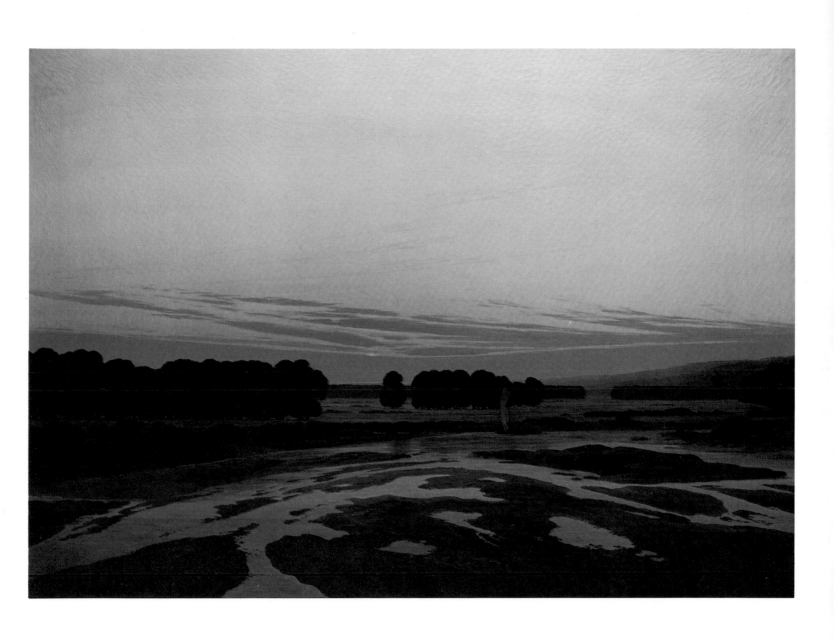

40. THE STAGES OF LIFE

c. 1835. Oil on canvas, 28½×37" (72.5 ×94 cm)
Museum der Bildenden Künste, Leipzig (B-S 411)

This is surely one of Friedrich's most profound pictures, one whose complex meaning, despite the many attempts at interpretation, has yet to be fully revealed.

The painting presents a bit of shoreline in the evening twilight, a small harbor—actually only a mooring place for boats and a place to drop anchor. Out to sea we can see three sailing ships that appear to be returning home; on the large one in the center of the picture, not far from shore, they have already begun to gather in the sails. Two smaller boats are already quite close to the landing place. The one on the right, with two men sitting in it, is headed straight for the spot where a cluster of five people is gathered on the shore. These are city folk, not fishermen. In the center of the group, out on a slight rise that is the farthest projection of land, a pair of children is playing, a boy and a girl. Sitting close to the water, the boy holds up a tiny flag. The scrap of blue cloth emblazoned with a yellow cross is caught by a gentle breeze. The girl is reaching for the flag, for she would also like to hold it, but the boy resists, pulling it slightly to the left and away from her. Next to them on the right sits their mother—or is this an older sister? She is leaning toward the children, admonishing them, gesturing with her right hand. Two men are standing to the left of this group. One seems to be of middle age, and wears a frock coat and a top hat. He has turned toward us, inviting us into the picture. The other, old and stooped, is turned away from us. He is wearing a heavy coat and carries a walking stick. An ordinary collection of people, perhaps the painter and his family. The old man is prepared to leave.

Everything indicates that this is a warm evening in summer, possibly late summer. The woman and the children wear light clothing. The old man is the only one dressed for cold. His long, brownish gray coat has a fur collar and his beret also appears to be made of fur. He relies on his stick, feels the approach of winter. It almost seems as though he is already living in a colder season than the one his loved ones are enjoying. He faces the open sea, gazes out past his family into the distance. The younger man, waving at him with his right hand, hopes to draw his attention to the children, pointing to them with his left hand. The mother also points to them. But it appears they will not succeed in capturing the old man's attention; his eyes are almost precisely at the level of the horizon.

The five figures form a semicircle, a curve repeated in the shape of the shoreline, which points out to sea like a bow toward the homing ship with its slack sails. The children sit at the outer point of the curve. They are flanked on the left and right by the younger man and the woman, while further to the left, and closer to the viewer, the old man already appears to be less a part of the group. He clearly comes from another time—his old-fashioned coat and beret tell us as much—and he is chilled. The moon is rising. Its delicate crescent, in the first phase after the new moon, stands above the violet cloud bank in the yellow of the sky, between the old man and the rest of his family.

Then there are the ships, which appear to correspond in some strange way with the figures: five people on the shore; five ships on the sea. All the ships are pointing landward, but their arrangements are different. The bow of the large ship in the very center points directly toward the two children with the tiny flag, and its sails spread above them almost like a sheltering roof. Clearly it stands in a special relationship to them. At first one is inclined to relate this ship, the closest of the three large ships, to the largest and closest of the figures, the old man. But it is not isolated; it is flanked by the two small sailboats, which appear to belong to it. The two other large ships are still far out to sea, and it will be dark before they can drop anchor. Are the ships coming to fetch the old man? Is one of the smaller boats going to ferry him out to them? Or are they in their homing only suggestive of the evening that draws over the scene and colors the sky?

There is still another boat to consider. This one is lying upside down on the shore. In outline it reminds one of a coffin, and its bow points directly toward the old man. At the same time the shape of the overturned rowboat repeats the shape of the inlet just beyond it, where the clear water reflects the sky.

And then there is the matter of the flag in the center of the picture with a yellow cross on it—the flag of Sweden. The boy is raising it up toward the ship. As we have seen, Sweden held a special attraction for Friedrich. Daniel Amadeus Atterbom tells us that the artist often called himself "half Swede," and we have noted that Friedrich named his son after the great Swedish king Gustavus Adolphus. At one time Sweden had extended to the place where he was born, Swedish Pomerania. Now it lies across the sea. Is Sweden the destination of this journey?

Almost all scholars agree that we may interpret the figures in the painting as Friedrich's family. The only question is whether the female figure on the right is the painter's wife or his older daughter. The male figure in the top hat could be one of his nephews, possibly his godson, Heinrich Wilhelm, whose father owned this picture and who was living with Friedrich in Dresden when the painter suffered his stroke in 1835. It may well be that Friedrich meant this picture as a kind of last self-portrait; the earliest in an oil painting is the disguised one in *Monk by the Sea* (plate 7). In both of them the figure looks out at the open sea, yet what a distance lies between these two pictures—the span of a lifetime.

We do not know exactly what spot is depicted in the picture. Most scholars assume that it is the Utkieck in Wyk, near Greifswald, a good place from which to watch the ship traffic. Gerhard Eimer recently suggested that it could be the shore of Wiltow, on Rügen. He points out that the Swedish mail ships put in there before sailing on to Stralsund, and that the transfer to shore was effected by small longboats. Is the painter waiting for news from Sweden? In a larger sense the mail ship may have meant something like a vision of home.

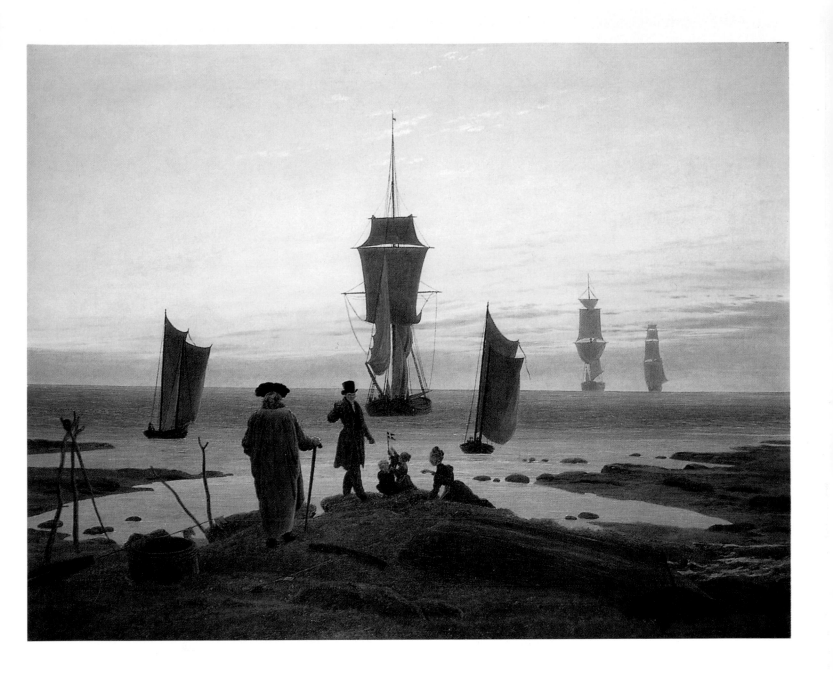

The Stages of Life is one of Friedrich's most comprehensive allegories. Its title, which did not originate with Friedrich himself, only begins to suggest what it contains. The cycles of the times of day and the seasons are here combined with the cycle of life in a single picture.

The picture's structure is quite simple and convincing: the opposing curves the artist was so fond of are controlled by the coordinates created by the horizon line and the mast of the ship, which divide the surface of the painting horizontally and vertically at the very center. The upper curve is suggested by the clouds rising gently toward the edges, and repeated in the placement of the ships. The lower one is provided by the small peninsula framed by two inlets. It too is repeated in the grouping of the figures. The approaching ships link the two realms.

SELECTED BIBLIOGRAPHY

It has been possible to list only the most important works, giving particular pref-erence to those of more recent date. Extensive bibliographies of the Friedrich liter-ature can be found in the monographs by Werner Sumowski (1970) and by Helmut Börsch-Supan and Karl Wilhelm Jähnig (1973).

Notes and Letters by Caspar David Friedrich

1841 *Friedrich der Landschaftsmaler: Zu seinem Gedächtnis nebst Fragmenten aus seinen nachgelassenen Papieren, seinem Bildnis und seinem Facsimile.* Edited by C. G. Carus. Dresden, 1841.

1924 Caspar David Friedrich. *Bekenntnisse.* Selected and edited by Kurt Karl Eberlein. Leipzig, 1924.
Aus dem Leben Caspar David Friedrichs: Geschwisterbriefe. Edited by Friedrich Wiegand. Greifswald, 1924

1939 Caspar David Friedrich. *Bekenntnisse im Wort.* Selected by Kurt Karl Eberlein. Berlin, 1939.

1968 *Caspar David Friedrich in Briefen und Bekenntnissen.* Edited by Sigrid Hinz. Berlin and Munich, 1968. 2nd ed., 1974.

Romantic Painting

1922 Oskar Beyer. *Die unendliche Landschaft: Über religiöse Naturmalerei und ihre Meister.* Berlin, 1922.
Paul Ferdinand Schmidt. *Deutsche Landschaftsmalerei von 1750 bis 1830.* Munich, 1922.

1948 Wilhelm Boeck. "Malerei der Romantik." In *Romantik: Ein Zyklus Tübinger Vorlesungen.* Tübingen, 1948.

1951 Klaus Lankheit. "Die Frühromantik und die Grundlagen der 'gegenstandslosen' Malerei." *Neue Heidelberger Jahrbücher,* N.F., 1951, pp. 55–99.

1959 Konrad Kaiser. *Deutsche Malerei um 1800.* Leipzig, 1959.

1960 Kurt Badt. *Wolkenbilder und Wolkengedichte der Romantik.* Berlin, 1960.
Marcel Brion. *Kunst der Romantik.* Munich and Zurich, 1960.
Werner Hofmann. *Das Irdische Paradies: Kunst im 19. Jahrhundert.* Munich, 1960.

1965 Eugénie de Keyser. *Das Abendland der Romantik 1789–1850.* Geneva, 1965.

1967 Hubert Schrade. *Deutsche Maler der Romantik.* Cologne, 1967.

1969 Eckart Klessmann. *Die Welt der Romantik.* Munich, 1969.

1970 *German Painting of the Nineteenth Century.* Catalogue by Kermit S. Champa with Kate H. Champa. Yale University Art Gallery, New Haven; Cleveland Museum of Art; The Art Institute of Chicago, 1970.

1972 Albert Béguin. *Traumwelt und Romantik: Versuch über die romantische Seele in Deutschland und in der Dichtung Frankreichs.* Bern and Munich, 1972.
Helmut Börsch-Supan. *Deutsche Romantiker: Deutsche Maler zwischen 1800–50.* Gütersloh, 1972.

1973 Marianne Bernhard. *Deutsche Romantik: Handzeichnungen.* After-word by Petra Kipphoff. Munich, 1973.

1974 Fritz Baumgart. *Vom Klassizismus zur Romantik, 1750–1832: Die Malerei im Jahrhundert der Aufklärung, Revolution und Restauration.* Cologne, 1974.

1975 Robert Rosenblum. *Modern Painting and the Northern Romantic Tra-dition: Friedrich to Rothko.* New York, Evanston, and London, 1975.

1980 William Vaughan. *German Romantic Painting.* London and New Haven, 1980.

Catalogues

1906 *Ausstellung deutscher Kunst aus der Zeit 1775–1875.* Nationalgalerie, Berlin, 1906.

1940 *Caspar David Friedrich: Gedächtnisausstellung zum 100. Todestag.* Gemäldegalerie, Dresden, 1940.

1956 *Caspar David Friedrich: Ausstellung Museum Greifswald* (on the occa-sion of the 500th anniversary of the Ernst Moritz Arndt Universi-ty, Greifswald). Museum Greifswald, 1956.

1966 *Klassizismus und Romantik in Deutschland: Gemälde und Zeichnungen aus der Sammlung Georg Schäfer, Schweinfurt.* Essays by Herbert von Einem, Werner Sumowski, Siegfried Wichmann. Germanisches Nationalmuseum Nürnberg, 1966.

1972 *Caspar David Friedrich: Romantic Landscape Painting in Dresden.* Essay by William Vaughan; catalogue and bibliography by Helmut Börsch-Supan. The Tate Gallery, London, 1972.

1973 *Die Gemälde Caspar David Friedrichs im Schinkel-Pavillon.* Text by Helmut Börsch-Supan. Berlin, 1973.

1974 *Caspar David Friedrich: Ausstellung in der Hamburger Kunsthalle.* Essay by Werner Hofmann. Kunstalle, Hamburg, 1974.
Caspar David Friedrich und sein Kreis. Essays by Peter H. Feist, Irma Emmrich, Hans J. Neidhardt, Sigrid Hinz. Gemäldegalerie Neue Meister, Dresden, 1974.

1981 *German Masters of the Nineteenth Century: Paintings and Drawings from the Federal Republic of Germany.* Essays by Gert Schiff and Stephan Waetzoldt. The Metropolitan Museum of Art, New York; Art Gallery of Ontario, 1981.

1985 *Deutsche Romantiker.* Kunsthalle der Hypo-Kulturstiftung, Munich, 1985.
Gemälde der deutschen Romantik (from the Nationalgalerie, Berlin). Essays by Peter Krieger, Hans G. Hannesen, Lucius Grisebach, Dominik Bartmann. Kunsthaus, Zurich, 1985.
Traum und Wahrheit: Deutsche Romantik (from museums in the Ger-man Democratic Republic). Essays by Jürgen Glaesemer, Willi Geismeier, Hans J. Neidhardt, Hans Chr. von Tavel. Bern, 1985.

1990 *Caspar David Friedrich: Seine Zeichnungen in der Hamburger Kunsthalle.* Text by Jenns Howoldt. 1990.
Caspar David Friedrich: Winter Landscape. Essays by John Leighton and Colin J. Bailey. National Gallery, London, 1990.
Caspar David Friedrich: Winterlandschaften. Essays by Friedrich Gross, Peter Rautmann, Werner Sumowski, Kurt Wettengl, Tina Grütter, Hans J. Neidhardt, and Karl-Ludwig Hoch. Museum für Kunst und Kulturgeschichte, Dortmund, 1990.
The Romantic Vision of Caspar David Friedrich: Paintings and Drawings from the U.S.S.R. Essays by Robert Rosenblum and Boris Aswar-ischtsch; catalogue by Sabine Rewald. The Art Institute of Chica-go; The Metropolitan Museum of Art, New York, 1990.

1993 *Caspar David Friedrich to Ferdinand Hodler: A Romantic Tradition—Nineteenth-Century Paintings and Drawings from the Oskar Reinhart Foun-dation, Winterthur.* Texts by Peter Wegmann, William Vaughan, Franz Zelger, and Matthias Wohlgemuth; edited by Margarita Russell. Los Angeles County Museum of Art; The Metropolitan Museum of Art, New York; The National Gallery, London; Frank-furt am Mein and Leipzig, 1993.

Monographs

1915 Andreas Aubert. *Caspar David Friedrich: Gott, Freiheit, Vaterland.* Edited by G. J. Kern. Berlin, 1915.

1921 Ludwig Justi. *Caspar David Friedrich: Ein Führer zur Friedrich-Samm-lung der Nationalgalerie.* Berlin, 1921.

1922 Otto Fischer. *Caspar David Friedrich: Die romantische Landschaft—Dokumente und Bilder*. Stuttgart, 1922.

1924 Willi Wolfradt. *Caspar David Friedrich und die Landschaft der Romantik*. Berlin, 1924.

1925 Kurt Karl Eberlein. *Caspar David Friedrich in seinen Meisterwerken*. Berlin, 1925.

1938 Herbert von Einem. *Caspar David Friedrich*. Berlin, 1938. 3rd ed., 1950.

1940 Kurt Karl Eberlein. *Caspar David Friedrich, der Landschaftsmaler*. Bielefeld and Leipzig, 1940.
Kurt Wilhelm-Kästner, Ludwig Rohling, and Karl Friedrich Degner. *Caspar David Friedrich und seine Heimat*. Berlin, 1940.

1941 Emil Waldmann. *Caspar David Friedrich: Almanach*. Berlin, 1941.

1942 Ludwig Grote. *Caspar David Friedrich: Skizzenbuch aus den Jahren 1806 und 1818*. Berlin, 1942.

1943 Ernst Sigismund. *Caspar David Friedrich: Eine Umrisszeichnung*. Dresden, 1943 (printed from a 1909 manuscript).

1944 Otto Schmitt. *Die Ruine Eldena im Werk von Caspar David Friedrich*. Berlin, 1944.

1953 Walter Bauer. *Caspar David Friedrich: Bild und Seele der deutschen Landschaft*. Munich, 1953.

1961 Erika Platte. *Caspar David Friedrich: Die Jahreszeiten*. Stuttgart, 1961.

1963 Gerhard Eimer. *Caspar David Friedrich und die Gotik: Analysen und Deutungsversuche aus Stockholmer Vorlesungen*. Hamburg, 1963.

1970 Werner Sumowski. *Caspar David Friedrich: Studien*. Wiesbaden, 1970.

1973 Helmut Börsch-Supan. *Caspar David Friedrich*. Munich, 1973. New York, 1974.
Helmut Börsch-Supan and Karl Wilhelm Jähnig. *Caspar David Friedrich: Gemälde, Druckgraphik und bildmässige Zeichnungen* (catalogue raisonné). Munich, 1973.

1974 Marianne Bernhard, ed. *Caspar David Friedrich: Das gesamte graphische Werk*. Introduction by Hans H. Hofstätter. Munich, 1974.
Gerhard Eimer. *Auge und Landschaft: Zeugnisse in Bild und Wort*. Frankfurt am Main, 1974.
Jens Christian Jensen. *Caspar David Friedrich: Leben und Werk*. Cologne, 1974.

1976 B. Hinz, H.-J. Kunst, P. Märker, P. Rautmann, and N. Schneider. *Bürgerliche Revolution und Romantik: Natur und Gesellschaft bei Caspar David Friedrich*. Giessen, 1976.

1977 Gertrud Fiege. *Caspar David Friedrich in Selbstzeugnissen und Bilddokumenten*. Reinbek bei Hamburg, 1977.

1978 Siegel, Linda. *Caspar David Friedrich and the Age of German Romanticism*. Foreword by George Evitine. Boston, 1978.

1980 Helmut Börsch-Supan. *Caspar David Friedrich: Werkverzeichnis*. Berlin, 1980.

1982 Gerhard Eimer. *Zur Dialektik des Glaubens bei Caspar David Friedrich*. Frankfurt am Main, 1982.

1983 Ingeborg Becker. *Caspar David Friedrich: Leben und Werk*. Stuttgart, 1983.

1985 Karl-Ludwig Hoch. *Caspar David Friedrich: Unbekannte Dokumente seines Lebens*. Dresden, 1985.

1987 Karl-Ludwig Hoch. *Caspar David Friedrich in Böhmen*. Dresden and Stuttgart, 1987.

1990 Joseph Leo Koerner. *Caspar David Friedrich and the Subject of Landscape*. London, 1990.

1991 Peter Rautmann. *Caspar David Friedrich: Das Eismeer*. Frankfurt am Main, 1991.

Dissertations

1929 Helmut Rehder. "Die Philosophie der unendlichen Landschaft: Ihr Ursprung und ihre Vollendung." Heidelberg, 1929.

1936 Klaus Leonhardi. "Die romantische Landschaftsmalerei Caspar David Friedrichs." Würzburg, 1936.

1937 Charlotte Hintze. "Kopenhagen und die deutsche Malerei um 1800." Würzburg, 1937.

1951 Stephan Waetzoldt. "Philipp Otto Runges *Vier Zeiten*." Hamburg, 1951.

1955 Erika Bülau. "Der englische Einfluss auf die deutsche Landschaftsmalerei im frühen 19. Jahrhundert." Freiburg im Breisgau, 1955.
W. Petrenz. "Die niederländischen Einflüsse in der Kunst Caspar David Friedrichs." Berlin, 1955.

1960 Helmut Börsch-Supan. "Die Bildgestaltung bei Caspar David Friedrich." Munich, 1960.

1963 Marianne Prause. "Carl Gustav Carus als Maler." Cologne, 1963.

1966 Willi Geismeier. "Zur Bedeutung und zur entwicklungsgeschichtlichen Stellung von Naturgefühl und Landschaftsdarstellung bei Caspar David Friedrich." Berlin, 1966.
Sigrid Hinz. "Caspar David Friedrich als Zeichner." Greifswald, 1966.

1971 Suse Barth. "Lebensalter-Darstellungen im 19. und 20. Jahrhundert: Ikonographische Studien." Bamberg, 1971.

1974 Peter Märker. "Geschichte als Natur: Untersuchungen zur Entwicklungsvorstellung bei Caspar David Friedrich." Kiel, 1974.

1975 Matthias Eberle. "Theorie der Landschaft." Berlin, 1975.

1978 H. Watanabe-O'Kelly. "Melancholie und melancholische Landschaft." Bern, 1978.

1979 Peter Rautmann. "Caspar David Friedrich: Landschaft als Sinnbild." Frankfurt am Main, 1979.

1981 Karl-Ludwig Hoch. "Caspar David Friedrichs Frömmigkeit und seine Ehrfurcht vor der Natur." Dresden, 1981.

1983 Mayumi Ohara. "Demut, Individualität, Gefühl: Betrachtungen über Caspar David Friedrichs kunsttheoretische Schriften." Berlin, 1983.

1986 Tina Grütter. "Melancholie und Abgrund: Die Bedeutung des Gesteins bei Caspar David Friedrich." Berlin, 1986.

Articles

1972 Helmut Börsch-Supan. "Caspar David Friedrich's Landscapes with Self-Portraits." *The Burlington Magazine* 114 (1972), pp. 620–30.

1973 Philip B. Miller. "Anxiety and Abstraction: Kleist and Brentano on C. D. Friedrich." *Quarterly Review of Literature* 18, nos. 3–5 (1973), pp. 345–54.

1981 Donat de Chapeaurouge. "Bemerkungen zu Caspar David Friedrichs Tetschener Alter." In *Pantheon* 39. Munich, 1981.

1986 Otto von Simson. "Caspar David Friedrich." In *Der Blick nach innen*. Berlin, 1986.

1988 Jörg Traeger. "Die Kirche der Kunst." In *Kunst um 1800 und die Folgen*. Edited by Christian Beutler. Munich, 1988.

1990 Wieland Schmied. "Caspar David Friedrich." In *Mecklenburg-Vorpommern: Merian*. Hamburg, 1990.
Hans Dickel. "Eiszeit der Moderne: Zur Kälte als Metapher in Caspar David Friedrichs Eismeer...." In *Idea: Jahrbuch der Hamburger Kunsthalle*. Hamburg, 1990.

1991 Wieland Schmied. "Zyklus, Geschichte und Transzendenz: Zeit und Ewigkeit in zwei Bildern Caspar David Friedrichs." In *Bilder der Philosophie: Reflexionen über das Bildliche und die Phantasie*. Edited by Richard Heinrich. Vienna and Munich, 1991.

INDEX